SURREAL PHOTOGRAPHY
CREATING THE IMPOSSIBLE

SURREAL PHOTOGRAPHY
CREATING THE IMPOSSIBLE

Daniela Bowker

ILEX

...olished in the UK in 2013 by

...h Street

...sex
...5
...x-press.com

...ted worldwide (except North America) by
...& Hudson Ltd., 181A High Holborn, London
...QX, United Kingdom

...r: Alastair Campbell
...e Publisher: Adam Juniper
...ng Editor: Natalia Price-Cabrera
...Tara Gallagher
...st Editor: Frank Gallaugher
...Director: James Hollywell
...esigner: Ginny Zeal
...r: JC Lanaway
...Manager: Katie Greenwood
...rigination: Ivy Press Reprographics

...ibrary Cataloguing-in-Publication Data
...gue record for this book is available from
...sh Library.

...8-1-78157-998-5

...and bound in China.
...6 5 4 3 2 1

...earning to Fly © Nikolai Gorski
...imming Palace by Bethany de Forest

Contents

Introduction

Photography is a tremendously inspiring, versatile, and exciting medium that allows us to slice a moment out of time and to preserve the memory of momentous occasions, from the personal to the international, in pictorial form. It's also incredibly varied; photojournalism is an indispensable element of the news media, capturing images of real-life events across the globe and telling stories in a hugely visceral way, while at the other end of the spectrum millions upon millions of wedding portraits, first photos of babies, and reminders of amazing holidays are taken every day.

And then there's artistic photography. Separated by intent from both strictly personal and strictly political photography, artistic photography is most often made with the aim of communication, inspiration, or expression. Of course, photography created as art is under no obligation to be realistic and perhaps one of the most exciting areas of artistic photography is surreal photography—a genre that flouts realism and revels in the strange. With the advent of digital tools surreal photographers today are bound only by their imaginations, locating their work at the forefront of expressive art. Each piece featured in this book represents a journey into the imagination, giving a wonderful insight into each photographer's vision, and hopefully inspiring you to create your own surreal masterpiece.

In this book we explore an entire range of surrealistic techniques, from compositing images to studio shooting to phoneography. Your perfect workflow can only be made for you, by you, but by giving you an understanding of all of the options out there I hope to make finding that ideal easier for you.

Surrealism is the fusion of the conscious with the subconscious, of dream and fantasy with the rational and the mundane, to create a world where anything is possible. As André Breton described it, it's the creation of "... an absolute reality, a surrealism."

A BRIEF HISTORY OF SURREALISM

Surrealism is a political and literary movement that developed from Dadaism, itself an artistic reaction to the horrors of World War One. Surrealism was influenced by Sigmund Freud's exploration of the subconscious and also Karl Marx's theories on class and revolution. The surrealists questioned the wisdom of blindly following societal expectations into "rational destruction," of which was the War was an example. In the view of the surrealists, real meaning lay in the human subconscious. Their pursuit of the surreal in their art and writing was intended to unleash the subconscious from repressive realism. While it was Guillaume Apollinaire who coined the term "surrealist" in 1917, it was André Breton who laid down the principles of the movement in a manifesto in 1924.

However, surrealism did not remain a radical, avant-garde political movement for very long. By the 1930s, surrealist art had breached the mainstream and its influence was felt in the theater, in fashion, in design, and in particular in advertising. This new dreamlike interpretation of the world that challenged notions of rationalist thought, headed up by the likes of Juan Miró, Salvador Dalí, Man Ray, and René Magritte, became widely celebrated and explored.

This book draws on the expertise of some of the most talented and innovative people in the business of image manipulation to present their surreal photographs and walk you through how they were made. They have prepared some fantastic showcases, supported by equally useful step-by-step explanations.

But that's not all. We'll also look at how you can turn a simple cameraphone shot into a swirling, otherworldly image at the swipe of a finger, and how to use whatever camera you have to create surreal photographs with the help of lenses, filters, and timing. We'll even go a little retro and explore the possibilities of using film cameras to create surreal universes.

Surreal photography can be as far removed from reality as you want it to be; it can be a five-degree, or a five-mile shift away from the real world, and you can achieve either with whatever camera you have on hand. It doesn't matter if your camera is your cellphone or the latest wonder-machine. What's important is the richness and depth of your imagination.

Relax by Maria Kaimaki

CHAPTER 1
GETTING STARTED

The first step in the creation of any surreal image will be a clear concept of the vision that you're trying to create. After you have this, you'll need to either take or source your base images to adapt, manipulate, and composite.

If you're taking your base images yourself, it's very easy to feel the need to keep up with the market when it comes to cameras. The speed at which photographic technology is evolving is mind-bending, but always remember that the most important element in the creation of a good photograph is the photographer—and her or his skill and vision—and not the camera. This is why I've included this chapter on cameras, to show you that any type of camera will be sufficient, whether it is a flagship DSLR, a film camera, a point and shoot, or even a cellphone.

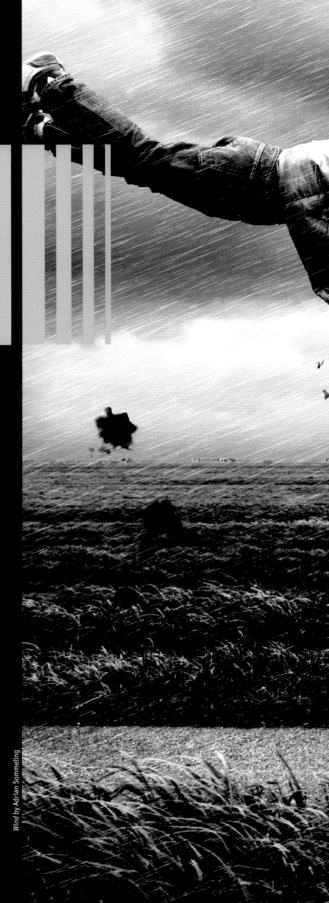

Wind by Adrian Sommeling

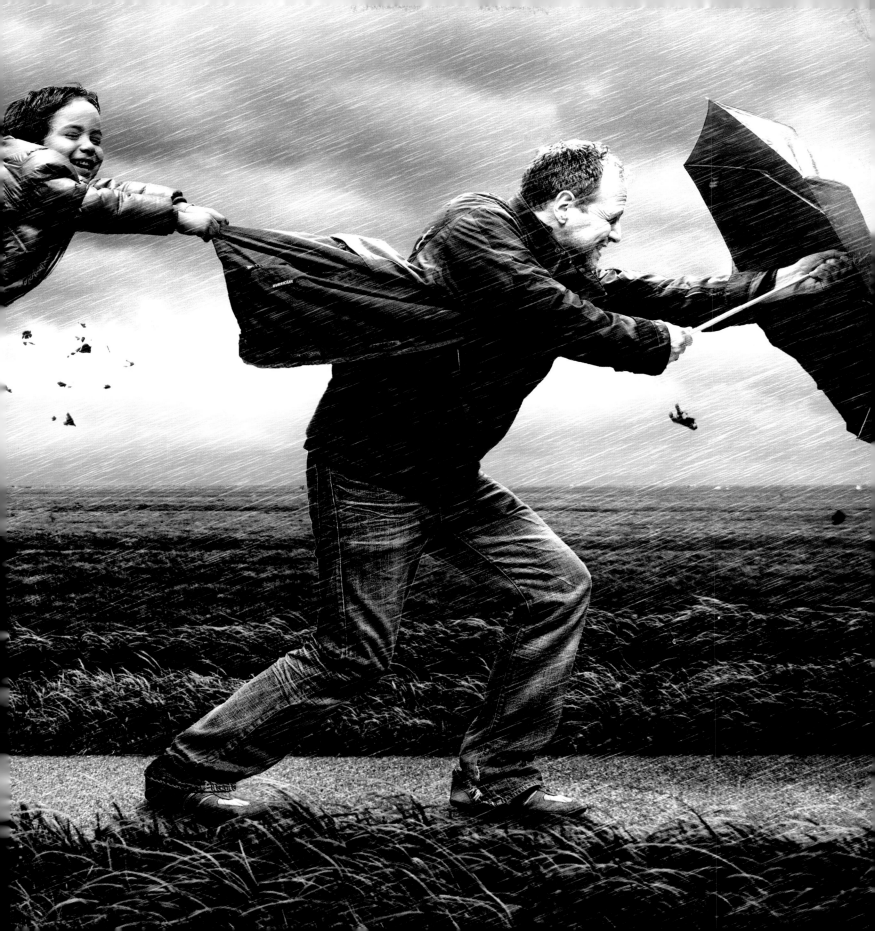

A concept of the surreal

It might help to think of the process

of creating a surreal image as a recipe:

here is what you want to create, these

are the things that you will need to

achieve it, and these are the steps

you will need to take in the process.

I first fell in love with photography because it allowed
me the opportunity to show people how I saw the world.
Whether they shared my vision wasn't so much the point;
what I loved was the chance to communicate it. Surreal
photography is, perhaps, all the more exciting because it
fuses the world around you—something that other people
are able to experience, even if they don't see it the same
way as you do—with something that is entirely unique to
you: your subconscious, your dreams, and your imagination.
What you experience as surreal, then, might be entirely
contrary to someone else's concept of the surreal.

This book explores two different methods of creating
surreal images: with your camera, and with digital
manipulation. In some respects, using your camera alone to
create surreal images might owe a little to chance—you can't
tell exactly how a cross-processed image will look until the
film is developed, for example. With other techniques, it will
take practice to become entirely familiar with the effects of
a fisheye lens or an IR filter so that you can shoot to achieve
the outcome that you want. The more you practise these
things, the more intuitive they will become. Not only that,
but the more that you immerse yourself in the world of the
surreal, the more ideas you will want to explore and develop.

Notebook by Daniela Bowker

When you use digital manipulation to create a surreal image, you might have taken a photograph that you feel can be altered to express a surreal vision, or you might have a surreal vision that you wish to create before you have any images. If you want to recreate your surreal vision from scratch, it's probably best to treat it as a project: map out what it is that you want to create, plan what you will need, how you will go about sourcing it, account for every item in the image and every step in the process, and cover every eventuality. If it sounds a long way from spontaneous creativity, that's because it is, but you don't want to be compositing your final image to find that you didn't shoot Little Red Riding Hood in her pristine red cloak, just her torn and muddied one, when actually you need both images.

Finally, don't think that surreal photography has to be one thing or the other, physical or digital. It doesn't mean you need to use an IR filter in isolation from the host of tools in your editing suite, or cross-process without the option to composite. The more that you explore all the options available to you to create surreal images, the more you will end up learning about how they can work in conjunction with each other, and the deeper your journey into surreal photography will be.

......................................

A Good Recipe
Creating a surreal image is a little like baking: you need a recipe to make a good cake.
Shoot stats:
Canon EOS Rebel XSi with a Canon EF 50mm ƒ/1.8 II lens at 50mm; ƒ/1.8 with a shuttter speed of 1/3200 second and ISO 200.

Cameraphones & compact cameras

While I don't go everywhere with my DSLR, the chances of me being caught without a camera are almost nil. I usually have a smartphone in my pocket and a compact camera in my bag, both of which are important components of my photo-taking arsenal and more than capable of producing images worthy of a little surreal transformation.

CAMERAPHONES

Cameras have been a ubiquitous component of the cellphone for years now; there are some phones that come without the ability to snap a quick picture, but you almost have to go out of your way to find one. Just as the technology in compact cameras and DSLRs has progressed, so too have the cameras in phones. The iPhone 5, the Nokia Lumia 900, and Samsung's Galaxy S III all come with 8-megapixel sensors, something you would have been hard-pressed to find in a flagship DSLR a decade ago. Their lenses offer apertures of $f/2.4$, $f/2.2$, and $f/2.6$ respectively—impressive, as some current compact cameras don't have lenses that fast. The improvements are only going to continue, but as of right now you can create perfectly acceptable surreal images with a good phone.

When it comes to creating surreal images from photos taken on a cellphone, the smartphone has the advantage over any other. For a start, it is generally easier to access the images taken on a smartphone—you can email them to yourself or save them to the Cloud—and the cameras in smartphones tend to be of superior quality. However, the killer feature of the smartphone is that you don't have to transfer the photo anywhere else in order to give it a surreal makeover. By virtue of any one of hundreds of applications (or apps) that are available for download, some for free and some at a small cost, you can transform an ordinary shot into something out of this world. We'll look at the best apps and what you can achieve with them in Chapter Two: Phoneography & Compact Cameras.

If you're a little apprehensive of using a smartphone to grab a potential surreal shot, don't be. It's a lens with a shutter and a sensor—you can work one of those! There are a few things you can do to help your phoneography on its way to surreal awesomeness, though.

First, make sure that your subject is well-lit. Cameraphones have small sensors, which can result in noisy, grainy images if they're taken in low-light situations. A lot of light will make all the difference.

Second, get in close, but avoid using the digital zoom function. You want your subject to fill the frame so that you don't have to crop it later and sacrifice image quality. The digital zoom will do terrible things to your image quality, so it's best left alone.

Third, keep still! This goes for any photography, but is especially important when using a phone because the small

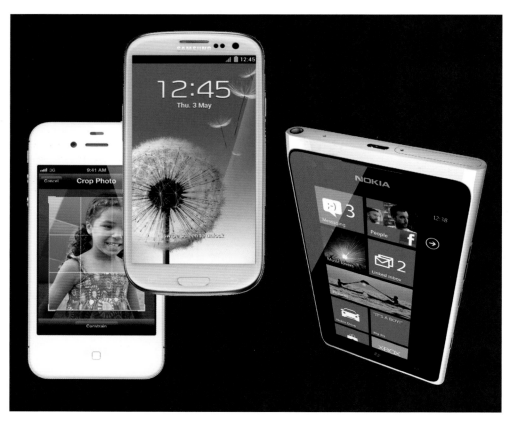

TOP: Olympus SH-25MR

This reasonably priced Olympus SH-25MR comes with 12 different filter effects. They might not make a surreal image by themselves, but it's certainly a start.

BOTTOM LEFT: Canon S110

The Canon S110 has full manual control, but is small enough to fit into your pocket. It's a great option if you're looking for a compact camera.

BOTTOM RIGHT: Pentax RZ18

This Pentax compact camera, the RZ18, has 12 digital filters, including a miniature effect and a toy-camera look, which you can apply to your images after you've taken them.

THE DEATH OF THE COMPACT CAMERA?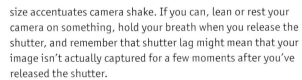

Sales of compact cameras have been declining for several years now, and the majority of observers put this down to the rise of the cameraphone. Why carry around two pieces of equipment that perform the same function when one will do? Many believe the death of the compact camera is imminent as between the cameraphone and smaller, lighter interchangeable lens cameras, they no longer fulfill a need. I don't think that the demise of the compact camera is as inevitable as some people make it out to be, but they certainly will become more niche, catering to people who want to carry rugged cameras halfway up mountains or across deserts, or those who want to try underwater photography. I wouldn't be without mine.

size accentuates camera shake. If you can, lean or rest your camera on something, hold your breath when you release the shutter, and remember that shutter lag might mean that your image isn't actually captured for a few moments after you've released the shutter.

Finally, give your lens a quick clean before you take a photo. Your phone lives in your pocket or your bag and spends plenty of time in your hand, bathed in grease, fluff, and dust—not what you want obscuring your image!

COMPACT CAMERAS

I always feel a touch indignant when someone sneers at a compact camera just because it's a compact camera. I don't think that deriding full manual control, impressive sensitivity ranges, plenty of megapixels, and the ability to shoot in Raw format in something that I can toss in a bag and sometimes even fit in a pocket, is entirely justified. Yes, compacts do come with their limitations, but I wouldn't be without one, particularly for situations when size or discretion is a consideration.

If you're intending to use your compact camera as your primary source of images for creating surreal photographs, then you really need to be using something that has the ability to shoot in Raw format. We'll take a look at different file formats presently, but in this instance it's important to know that shooting Raw will give you maximum flexibility in processing your images, which is vital when you are performing digital manipulations. Furthermore, if a camera is able to record files in Raw, the chances are that it will come with the kinds of controls that allow you to dictate how you want your photograph to look, not how your camera thinks it should look.

If this kind of camera isn't what you have or what you can afford, don't worry. There's still plenty that you can accomplish with photos taken using any other kind of compact camera. In fact, the vast majority of compact cameras on the market now come with an entire range of ready-installed filters. Before you've even transferred your photos from the memory card to your computer, you can get them halfway to a new surreal existence with an interesting effect, a cross-processed look, or an antique cast.

The world might have gone digital, but analog photography is clinging on for dear life, and it has its part to play in the creation of surreal images. It isn't so much that surreal photographers are using film cameras to capture the majority of photos they'll transform into surreal creations, it's more that film cameras offer two exciting prospective techniques for surreal images: cross-processing and multiple exposures.

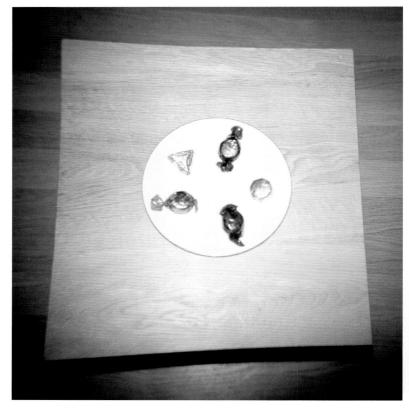

Chapter 3: Camera Technique is dedicated to exploring how cross-processing film and multiple exposures can be used to create surreal images, but if you're interested in achieving these effects, you'll need a film camera to do it.

If you're new to film photography or if you got rid of your analog equipment when the digital revolution came, you might be wondering how best to lay your hands on a film camera. The answer lies with a bit of patience and a bit of time spent scouring the secondhand market. Plenty of camera dealers have analog gems hiding away, and there's always eBay if you feel like some online bidding. It's possible to pick up a good 35mm compact, such as an Olympus Trip, for under $80 or an SLR plus a lens or two for well under $160. Though remember, let the buyer beware.

35mm film is still widely processed and you shouldn't have many difficulties finding a specialist camera store or chemist that provides the service. Alternatively, you could look into having your images developed by mail, which is something you might have to do if you use a slightly more exotic film, such as 120. There are many companies that offer a mail-order film-developing service, from which you can also purchase film. Remember to have your photos burned onto disc as well as printed when you have them developed, which makes it possible for you to use them as base images in digital composites.

Maybe, though, you're interested in experimenting with a so-called "toy camera" to see what surreal beauties you can snap. Toy cameras, with their light leaks, cheap plastic-y lenses, and unreliable metering have been all the rage for a while now. When you combine the idiosyncrasies of a toy camera with the effects of multiple exposures and cross-processed film, you have the means to create dreamlike, almost unbelievable surreal scenes.

Pinhole cameras are the most basic form of camera around; they are quite simply sealed boxes containing a sheet of unexposed photographic paper or film into which you introduce light through a small hole to produce an exposure, and therefore an image. In the right hands a pinhole camera can produce the most beautiful images that, with some luck and creative thinking, can be wonderfully surreal.

..
ABOVE: Square Not Square
Ooh, look at that pincushion distortion! All down to the cheap lens in a Holga.
Shoot stats: Holga camera with Ilford Delta 400 film.

Pinhole images tend to have long exposures so that enough light can reach the paper or negative to ensure an exposure takes place. As a consequence, they often enjoy a great sense of motion and interesting shadowing.

Making your own pinhole camera from a box and experimenting with developer in your bathroom might not appeal to everyone (find more on pinhole photography on pages 140–143), but not to worry, you can achieve pinhole-style images with a DSLR. You can buy pinhole body-caps from quirky online photography stores or even try making one yourself. Then it's just a case of experimenting with long exposures and a tripod!

ABOVE: Swirling Lines and Light
This image was taken by the Photojojo team with their SLR pinhole body-cap.
Shoot stats: Holga camera with Ilford Delta 400 film.
Image © Photojojo.com.

THE HISTORY OF LOMOGRAPHY

Lomos, Dianas, and Holgas are all well-known cameras names on the trendy photography scene. They are all types of "toy camera" marketed by the company Lomographische AG (though Holga is its own entity), under the name "Lomography." The Lomography LC-A is based on the Russian-made Lomo LC-A.

Lomo produced cheap, lo-fi compact cameras for the Russian market that caught the eye of Lomography's founders in 1991. Apparently, they loved the quirky, badly metered, occasionally blurry images that Lomos produced and signed a deal to sell them outside Russia.

Lomography, with its spontaneous philosophy that eschews the traditional principles of photography, has risen and risen in popularity. There is now an entire range of Lomography cameras featuring fisheye or ultra-wide lenses, multiple lenses, and colored flashes. And no, they're not as cheap as they used to be.

Interchangeable lens cameras

When it comes to supreme flexibility and superior image quality, interchangeable lens cameras are where it's at. Until 2008, an interchangeable lens camera would have meant an SLR, but the extremely exciting CSC has emerged since then. Smaller and lighter, it is a capable, but more compact alternative to SLRs. Both CSC and SLR cameras are incredible photographic tools and either will serve you well.

Compact System Cameras

CSC (or CoSyCa) stands for Compact System Cameras. You might also have heard them referred to as MILCs (Mirrorless Interchangeable Lens Cameras), EVIL cameras (Electronic Viewfinder Interchangeable Lens) or just "mirrorless cameras." Don't be deterred by the crisis of identity; these are very competent cameras.

CSCs offer the lens-changing flexibility of DSLRs, but through a vital adaptation are significantly smaller and lighter than a DSLR: they lack a mirror and a pentaprism. In a DSLR, it's the mirror and the pentaprism that allow you to see your scene through the optical viewfinder—CSCs have done away with the mirror, the pentaprism, and consequently the optical viewfinder, and instead have just an electronic viewfinder.

As the relatively new kid on the photographic block, some manufacturers are still dipping their toes into CSC waters, whereas others have concentrated extensively on research and development around the system. But the selection of cameras and lenses is growing—and fast. You can buy tiny compact-camera-sized cameras with interchangeable lenses or slightly larger ones that will give most DSLRs a run for their money, in which case a CSC could give you great value for money and the opportunity to shoot plenty of photos ready to be transformed into otherworldly images.

Olympus OM-D E-M5
the dust- and splashproof Olympus OM-D also boasts a 5-axis image stabilisation (IS) system to reduce blur, and a 1.44 million dot high-definition viewfinder.

Sony NEX-6
Sony has been one of the leading developers of the CSC and the NEX-6 is a great example of a high-quality CSC.

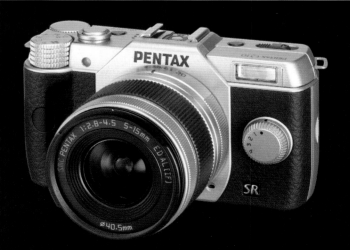

Pentax Q10
The Pentax Q10 is scarcely larger than a compact camera, but benefits from the flexibility of interchangeable lenses.

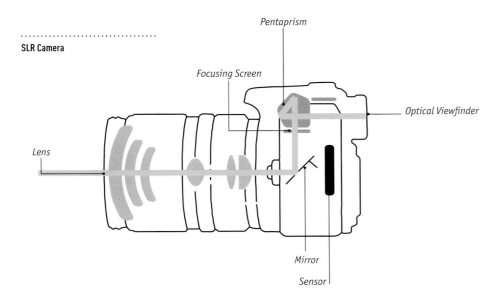

SLR Camera

Pentaprism

Focusing Screen

Optical Viewfinder

Lens

Mirror

Sensor

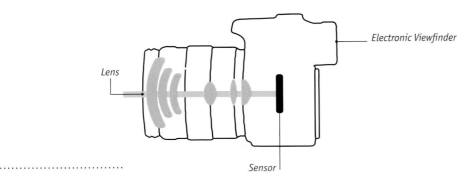

Electronic Viewfinder

Lens

Sensor

Compact System Camera
By getting rid of the mirror
and optical viewfinder found
in SLR cameras, manufacturers
have created smaller, lighter,
mirrorless CSCs.

DO MEGAPIXELS MATTER?

Megapixels have assumed the position of a layperson's (and a salesperson's) measure of a camera's quality. 14 megapixels good—16 megapixels better! They're easily quantifiable and comparable. But what is a megapixel, and do they really matter?

A pixel is a dot of information. The word "pixel" is a combination of "picture element." A picture comprises these elements, or dots of information, in lines running horizontally and vertically. One million of these dots, or pixels, is a megapixel. The more pixels you have, the more information is stored in your picture.

Megapixel count—or resolution—is important if you plan to enlarge or crop your images. The increased density of the pixels will ensure that your images don't appear grainy as the pixels are spread more thinly over the expanse of the picture.

The minimum resolution for CSC or DSLR (and most compact) cameras on the market right now is 10 megapixels. This is enough pixels to allow for generous enlargements and a good amount of cropping. I think we can safely say that we've pushed past the point where megapixels matter.

What does matter is the physical size of a camera's sensor. The gold standard of camera sensors (barring medium format) is the 35mm full-frame; it measures 36 × 24mm. This sized sensor is generally only found in professional grade DSLRs; advanced and entry-level DSLRs tend to have slightly smaller APS-H or APS-C sensors. As cameras get smaller, so do their sensors until you get to cameraphones with imaging chips that can be 25mm². Herein lies the problem; fitting X amount of megapixels onto a smaller sensor requires smaller photosites that are less sensitive to light. This in turn means more noise and lower image quality, hence "better" cameras having "bigger" sensors.

DSLR CAMERAS

The Digital Single Lens Reflex camera is top of the tree in the photography world. You might, however, be wondering why I'm bothering to discuss DSLRs here when they're big, heavy, expensive, and I've I made a point of emphasizing that it's the photographer that is the important factor in taking a photo, not the camera. Simply put, DSLRs are the best tools for the job, especially as they allow you, the photographer, the control that you need to take a photograph that is just as you want it to be, not how the camera thinks that it should be. DSLRs also offer the best range of lenses, good low-light capability, and have larger image sensors than other cameras, which all makes for better quality photographs.

If you're thinking of buying a DSLR, or any camera, it's important to hold it in your hands and get a feel for it. Shelling out anything between several hundred dollars for an entry-level machine and a few thousand dollars for a professional-grade camera means that it has to be something you will feel comfortable using. There's an extensive range of DSLRs on the market, so finding one that suits you might be more a case of having too much choice than not enough!

Remember, though, that a key benefit of any interchangeable lens camera is just that: the ability to change lenses. You will serve your needs far better to spend less on a camera body and more on lenses than you will buying yourself a top-of-the-range body, but being limited to the single kit lens that comes with it.

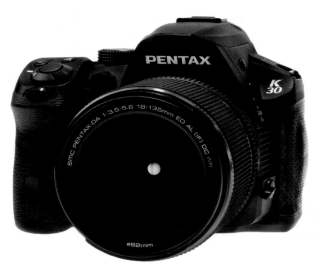

Pentax K-30
Pentax's K-30 is a weather-sealed DSLR that has a multiple-exposure function—very useful for building surreal images.

The formats in which your images come off your camera or out of your editing suite can be tongue-twisting acronyms. Here's a rough-and-ready guide to what's what.

Raw: A Raw file is the equivalent of a photographic negative, but in digital form. Raw is not a single file type like JPEG and TIFF, but is a generic term covering all manufacturers' Raw file formats, for example, Nikon's NEF, Canon's CR2, and so on. The data that it stores is "raw," or unadulterated, and comes direct from the camera's imaging sensor. Being an unprocessed image, it will be up to you to "develop" the files using an Raw processor. This might mean more work for you, but it does ensure that you have maximum control over the final presentation of your images. It also means that the files are quite large, but on the upside, the control that Raw affords you as a photographer is unparalleled. All interchangeable lens cameras and most high-end compact cameras will be able to record images in Raw format.

DNG (Digital Negative): The DNG format was developed by Adobe in an attempt to create an open-platform lossless Raw file. Raw is fantastic due to the control that it affords photographers, but "Raw" can mean different things to different camera manufacturers. The theory behind DNG is that it's a publicly available format that stores the same depth of information as a Raw file, but without the potential threat of not being able to access the data in the future due to changes in software.

In practice, very few camera manufacturers support the format, but you can always convert your native Raw files to the DNG format without losing any data.

JPEG (Joint Photographic Experts Group): JPEG files are significantly smaller than Raw files because the data has been processed and compressed. This is, then, both an advantage and disadvantage: they're easier to store and you can fit more of them onto your camera's memory card, but you lose a degree of control over your final image and there will be visible differences between the original and the compressed files. (These differences are known as "compression artifacts.") Most digital cameras will produce images in JPEG format, and when you save a final version of an edited Raw file, the chances are you will convert it to JPEG.

TIFF (Tagged Image File Format): TIFF files are a publishing and design industry-standard. They tend to be very large files holding extensive data in a lossless format. Some cameras export images in TIFF format, although Raw is preferable, but you are more likely to see TIFF files exported from an editing suite. Their advantage here is that they don't flatten the different layers that have formed the edited image.

PSD: PSD is Photoshop's native file format. Its primary advantage is that it maintains an image's layers, whereas other formats flatten layers. This is valuable as it allows for easier editing at a later date.

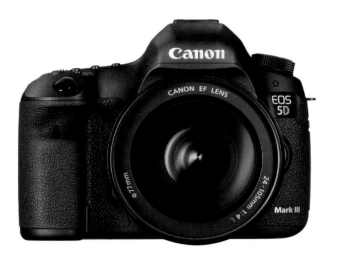

THE COMPARATIVE SIZES OF CAMERA SENSORS

Cramming more and more pixels onto smaller and smaller sensors doesn't necessarily lead to higher image quality.

36 × 24mm = Full frame
Usually found in flagship DSLR cameras, but can also be found in smaller DSLRs and even some compact cameras.

27.9 × 18.6mm = APS-H
Found in some Canon DSLR cameras.

23.6 × 15.6mm = APS-C
Found in Nikon DX-format cameras, other midrange and entry-level cameras, and some CSCs.

22.3 × 14.9mm = APS-C
Found in Canon "prosumer," midrange, and entry-level DSLR cameras.

17.3 × 13mm = Four Thirds
Found in Four Thirds and Micro Four Thirds system cameras.

13.2 × 8.8mm
Found in Nikon CX-format and high-end compact cameras.

8.8 × 6.6mm, roughly
Found in some high-end compact cameras.

7.6 × 5.7 mm
Found in some high-end compact cameras.

6.16 × 4.62mm
Found in many compact cameras, some smaller CSCs, and mobile phones.

There are quite a few other smaller-sized sensors out there, for example 1 × 1.8 inches and 1 × 2.5 inches. This is to give you an idea how they compare. And if you're wondering about the fraction measurements, that's convention and dates back to the sizing of television tubes!

Sometimes, you might find that a composite image you are working on is missing something. Being the land of the surreal, it could quite easily be a giraffe skipping over the ocean or the Eiffel Tower floating by on a cloud. However, you don't happen to have photos of either a giraffe or the Eiffel Tower in your portfolio and a quick trip to the Serengeti or Paris is out of the question. What to do?

Well, you could sink into a pit of creative despair and lament the fate of your never-to-be-realized vision, or you could succumb to rage and delete your creation, but luckily enough neither of these reactions is necessary. Stock agencies have a huge variety of images for sale to suit.

The range of stock agencies is also vast; in addition to the more expensive agencies such as Getty and Corbis, there are microstock agencies, (Fotolia, Shutterstock, and iStockphoto), which are regarded as being at the lower end of the market. Their business model is to sell lots of copies of images very cheaply. If you're looking for more specialist subjects, perhaps news, nature and wildlife, sports, or travel images, there are a host of agencies dedicated to supplying these photographs, too. Take a look at the reference section on page 192 for details.

Whatever you are looking for, you will be able to find it among the stock agencies' collections. Even better, you will be probably be able to purchase a picture of it on a plain background, making it easier to select and insert into your composite.

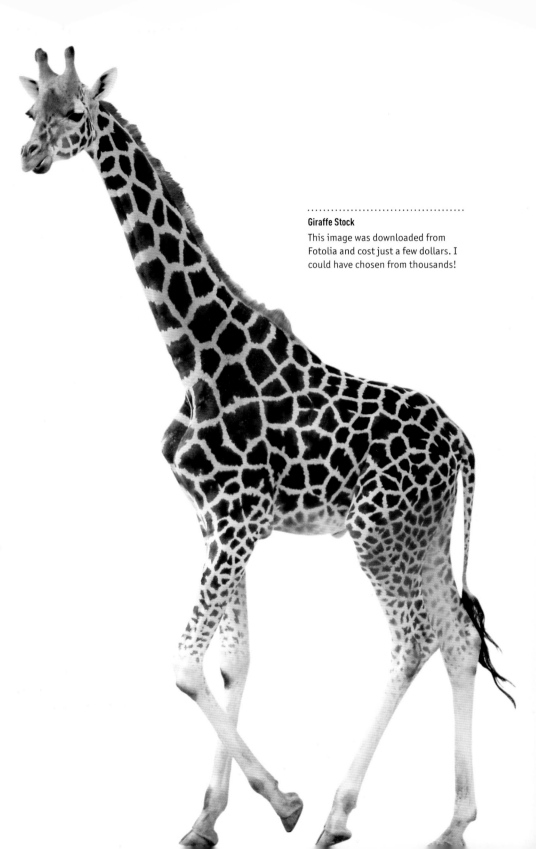

Giraffe Stock
This image was downloaded from Fotolia and cost just a few dollars. I could have chosen from thousands!

Purchasing an image from a stock agency is simple, and probably not as expensive as you might imagine. All agencies have their own methods of operation and terms of service, but the general principles are the same—you register an account, search for your chosen image, select the appropriate license, purchase the image, and then download and use it.

How much you pay for an image will depend on how you intend to use it, and therefore the type of license that you will require, and how large the image is. Some agencies offer subscription schemes as well as the ability to purchase one-time images. If you think that you might make use of stock imagery on a fairly regular basis, it might be worth choosing a particular agency and subscribing to a package.

Some images will be for sale royalty-free, others will be rights-managed. Royalty-free images have far fewer restrictions on where, when, and how often they can be used. Rights-managed photos tend to be higher quality, will likely cost more, and will be licensed with limitations as to where, when, how often, and for how long they can be used.

Even if you purchase a royalty-free image, you might have to select a license that reflects how you intend to use the final composite containing the stock image. If the final image is just for your own gratification, then a basic license will invariably be sufficient. However, if you intend to sell copies of the final composite, include it in a publication that has a print run in excess of a stipulated number of copies, or use it commercially in any way, you might find that you will need to select a license that will allow for this. It's worth reading the terms and conditions carefully, but thankfully most agencies set them out clearly, so you don't have to wade through a bog of legalese.

TO PAY OR NOT TO PAY?

There are a few stock agencies out there that offer their images—entirely legally—for download without payment. Whether or not you are comfortable using free images is a personal choice. For some people, it's a means to an end, especially if they're in a pinch, provided by photographers who are happy to do so freely. Others regard free stock as an insult to photographers; by offering work for free, it devalues the entire market and denigrates the craft.

The Eiffel Tower
There were thousands of images of the Eiffel Tower available; this one was from Fotolia. It came on white, making it easy to cut out, and cost a few dollars.

CHAPTER 2
PHONEOGRAPHY
& COMPACT CAMERAS

There are thousands of camera apps available for smartphones in Apple's App Store and on Google Play. Every day, new apps are being developed and released for sale, older ones are updated, and unpopular or obsolete ones are withdrawn from the market. But the principle remains the same: they can enable you to do some tremendous things with your casually snapped photos. Likewise, just about any compact camera that has hit the shops in the past 12 months has a vast of array of filters built into it that can be used to give a photo a surreal edge.

This chapter will look at what tools are on offer, what you can do with them to make your photos look amazing, and provides tips on how to create some deliberately surreal photography using the kit you build yourself.

Cashmere by Amy Weber

WHAT TO BUY?

There has been a veritable explosion of photography apps on the market since the social media revolution. Instagram went from zero to 1,000,000 subscribers within three months, and within 18 months of its release, its founders sold it to Facebook for $1 billion. Apps and photography are big business.

With literally thousands of programs available for download, ranging from the truly terrible to the must-have, how do you know which ones to spend your money on and which ones to avoid in your attempt to find the perfect program? Well, to start with you should try to keep it simple.

Snapspeed

Juxtapose

CutoutCam

Camera360

FX Photo Studio

PicSay Pro

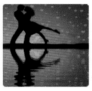
WaterMyPhoto

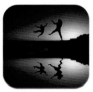
PhotoWaterReflection

Pixlr-o-matic

Photoshop Express

ScratchCam FX

PhotoGoo

TouchRetouch

FocalLab

Filterstorm

PicBoost

ESSENTIAL EDITING

It's tempting to launch into creating fabulous surreal images using your cellphone and a selection of specialized apps, but before you embark on the process of compositing, adding filters, and experimenting with different effects, you need to be able to perform the essential functions— cropping, straightening, rotating, sharpening, and adjusting the brightness, contrast, and white balance of your images. Plenty more adjustments might be made along the way, but your surreal image is only going to be as good as the original image or images comprising it, so it pays to get the simple stuff right.

My favorite apps for mobile editing are Snapseed and Photoshop Express (both are iOS and Android-capable). Both allow you to take photos in-app or import from your camera's library, both have intuitive, easy-to-use interfaces, and both also have a selection of effects filters. There is very little difference between the two, but if I had to choose, I'd likely opt for Snapseed. However, it should be noted that this is based on personal preference rather than objective judgment. The good news is that both apps are free. You can download them both, try them out, and then decide on your favorite.

TRY IT FREE

Quite a few of the paid apps offer a scaled-down free version, too. If you're not sure if a particular app is the one for you, see if there's a free version to test out first.

ABOVE: App-mania
There's an app for absolutely every photo-effect you could ever want, so the only thing you're limited by is your imagination!

RIGHT: Snapseed
Snapseed provides you with a great deal of control over your images, and is very easy to use.

CENTER: Photoshop Express
Adobe offers a free editing app, Photoshop Express. It's also easy to use and has impressive functionality.

FAR RIGHT: Juxtaposer
The lower layer is a mojito, and the upper layer, which is having the extraneous data erased, is the same rambutan as appears in the Snapseed screenshot. The idea here was to turn the inside of a slice of lime, sitting on the side of the glass, into a swirling rambutan.

MERGING AND COMPOSITING

Juxtaposer is one of my favorite apps for creating surreal images. Put simply, it lets you stick pieces from one photo on top of another to create a montage. You start by importing a base image and then layering a second photograph over it. Next, you use your fingers to resize, rotate, and erase any unwanted elements from the upper layer to reveal the base image and create a composite.

Using your fingers on a touchscreen to erase parts of an image with any degree of precision can be quite tricky and more than a little frustrating, but luckily, Juxtaposer allows you to zoom in and adjust the size and feather on the erase brush, which helps significantly. Practice will be needed to get it right, though.

When you've completed your first two layers, you can export your creation to your Camera Roll, email it to yourself or someone else, or upload it to Flickr, Twitter, or Facebook. If you get interrupted and don't manage to finish it in one sitting, you can save it and resume editing later. Or if you think that it needs more, you can import a third layer and carry on.

As Juxtaposer is an iOS-only app, Android users might be wondering what their options are here. I would suggest trying CutoutCam Pro. Rather than layering one image on top of another and erasing the upper layer's superfluous data, you cut a hole in the base image and insert a second image into it. You achieve the same effect, but via a slightly different means. PicSay Pro is also a highly regarded app that gives you an extensive selection of effects, including the ability to cut out parts of one photo and insert them into another.

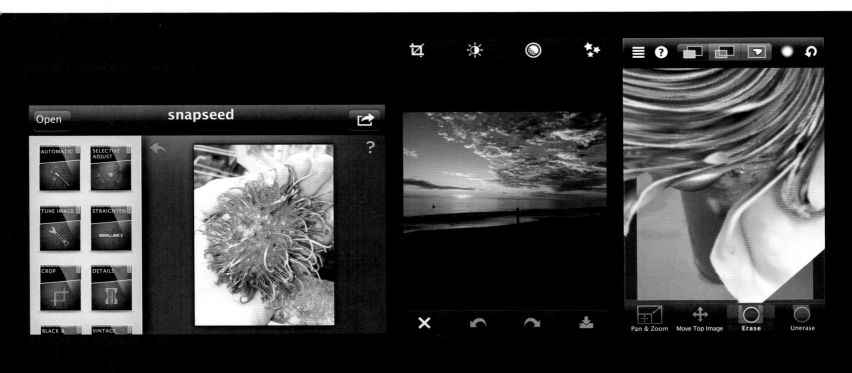

Choosing & using apps

DISTORTION AND MANIPULATION

Being able to distort an image, or a section of an image, is probably one of your most valuable options when creating a surreal composition. Swirls, blurs, and reflections are all useful things to have in your surreal compositing kit.

I've struggled to find an app that will allow you to selectively apply a swirl effect to an image. It's a case of cropping precisely what you want to make swirly, and then integrating it into the final image. Photoshop Express has a swirl effect, called "twirl," hiding away among the distort features under the Effects tab. However, the distort features, which include Blur and Pixelate, aren't part of the free package and you will need to purchase an upgrade. But Photoshop Express does have the advantage of allowing you to perform your basic edits and also apply various effects within the same application, and you can also choose if your image should spiral clockwise or counter-clockwise.

If you'd rather try a free swirl option, Picture Effect Magic and Camera Fun Free are available for iOS and Android respectively. Picture Effect Magic comes with both advantages and disadvantages: it creates the tightest spiral, but only in one direction, and I've had issues with its stability.

Paid-for swirling apps include iPhotoSwirl for iOS and Camera Fun Pro for Android. PicSay Pro, mentioned earlier in the merging and compositing section, also has a distortion feature.

If iPhotoSwirl allowed you to crop in-app, rather than before you imported your image, it would augment the Blur, Hue, Contrast, and Brightness tools—not to mention the filters and borders—that are already available. As it is, you have to cut down your image in another app first.

There's no stand-out swirl application for me; it's a case of finding the one that suits your needs the most, depending on your aesthetics and frequency of use.

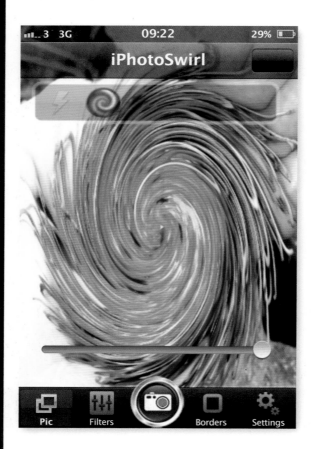

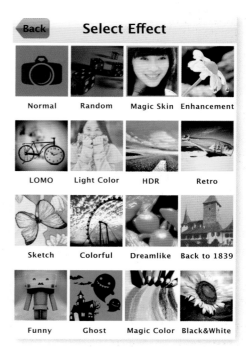

To introduce symmetry into your images, Camera360, which operates on both Android and iOS platforms, is the application to try. Camera360 offers a vast number of editing options, but if you head into the "Funny" effects menu, you can select from a horizontal mirror that can be angled either up or down, or a vertical mirror that can reflect either side of your image. There's also an Opacity slider that controls the strength of the reflection or the reflected image.

It is definitely worth exploring Camera360 for all of the editing functionality it offers, which includes blur effects, a range of hand-drawn filters, and an 1839 look. Don't just use it for mirroring effects!

There are two apps, one for Android and the other for iOS, that have been receiving rave reviews and are worth installing: Photo Water Reflection and Water My Photo. Both of them add a watery reflection to your photos, which could be the perfect finishing effect for a surreal image.

FILTERS

While applying a filter might be a quick way to add a sweeping sense of the surreal to an image, filters take on a different complexity when you use them in conjunction with other apps. Washing a color filter over my surreal creation is usually the final step in the process. I sometimes opt for something that is vivid and confronting, other times I use a more whimsical and dreamlike effect. If I can't choose, I can apply one of each and save two different images.

Many people I know swear by FX Photo Studio filters. The range is astonishing, with over 100 different effects for your images, from toy camera to vintage, through the use of the use of the glow and grunge filters. These filters can be layered until you run out of space, making for a huge number of possibilities.

Pixlr-o-matic is a less overwhelming filter gallery, but still has plenty of options and is available for free on both Android and iOS phones. It comes with 25 preinstalled film effects and 30 lighting styles. There are various frames, too, and if these options prove insufficient, you can purchase even more filters. It's my filter app of choice because it provides me with enough variety, but is also manageable.

LEFT: FX Photo Studio

There are quite literally hundreds of filters for your images in FX Photo Studio, and most of them can be independently adjusted. Not only that, but you can layer filter over filter. The possibilities are almost endless.

Most of these filters can be fine-tuned to some degree, too. You can dictate the "amount," or strength, of a filter, and the effect, contrast, blur, and brightness can all be controlled, too. I find that the range of options can be almost bewildering, but you can earmark your favorite effects and also create your own presets that combine two or more filters.

RIGHT: Pixlr-o-matic

The filter choices run on a filmstrip at the bottom of the screen; Pixlr-o-matic is easy to use and has enough choice without being too much.

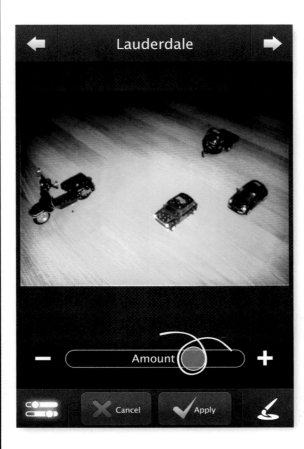

So, what can you achieve with a few apps and a little time? Here are some examples of effects I came up with using various apps.

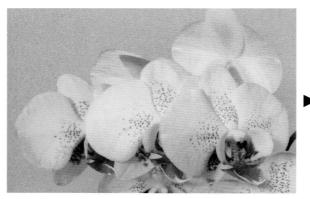

ALIEN ORCHID

A lighting effect applied in Snapseed and a film effect from Pixlr-o-matic gives this orchid an almost alien appearance.

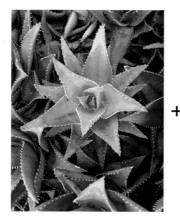 +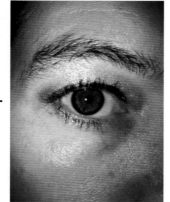

CACT-I

A cactus in my aunt's garden, my eye, a little merging with Juxtaposer, and a filter from Pixlr-o-matic gives you a creepy looking plant. Juxtaposer was used to combine both the cactus and the eye; then Pixlr-o-matic was used on the merged image.

+

Juxtaposer Snapseed

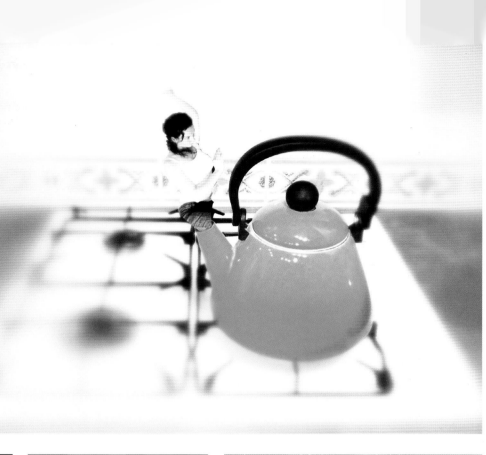

KETTLE

Some merging, a little graduated blurring, and some brightening with Juxtaposer and Snapseed ends with a genie emerging from a boiling kettle. Juxtaposer was used to merge the two base images; Snapseed was used on the final image to produce the final effect.

Snapseed Camera360

WaterMy
Photo

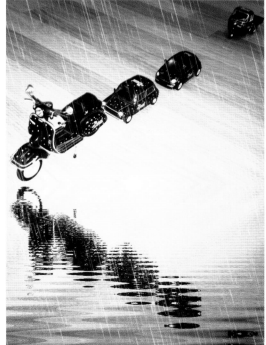

COCKTAIL

Shooting this glass just off-center then using Snapseed for a few quick tweaks combined with the left mirror in Camera360 creates a magical floating cocktail.

TOY VEHICLES

Even indoors these toy cars aren't safe from the rain with a bit of help from Water My Photo.

Quick & dirty with compact-camera filters

Nearly any compact camera that comes to the market now—and quite a few interchangeable lens models, too—wouldn't be complete without an array of special effects filters that can miniaturize, posterize, or do pretty much anything to your images in-camera. The exact range of special effects will vary from camera to camera, but among them you will usually find a fisheye, miniature, vintage, and toy-camera filter.

It's also worth remembering that the method of application of these filters varies across cameras. Some cameras will expect you to select your filter while you are shooting your images—adding it later isn't an option. Other cameras will enable you to apply the effect of your choice once you have your shot; you might even be able to layer several filters to achieve the result that you want.

Depending on your photo's subject, how you photograph it, and the filter or filters that you apply, you might find yourself exploring the deeper recesses of your imagination.

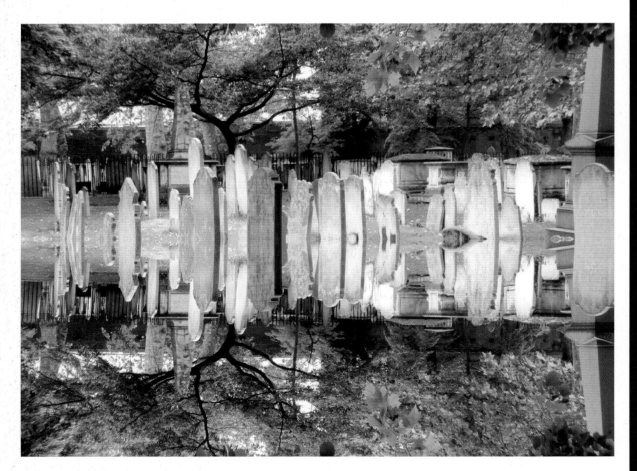

LEFT: Six Feet Under?
Using the Reflection Magic Filter effect on the Olympus SH-25MR has put a different spin on this photograph of a graveyard. *Shoot Stats: Olympus SH-25MR on Reflection Magic Filter setting.*

RIGHT: The Gherkin Through a Fisheye
This photograph of 30 St. Mary Axe (formerly the Swiss Re Building) in London was taken using an Olympus SH-25MR with the Fisheye Magic Filter effect. A beautifully oval building fondly known as "the Gherkin" has become almost spherical. *Shoot Stats: Olympus SH-25MR on Reflection Magic Filter setting.*

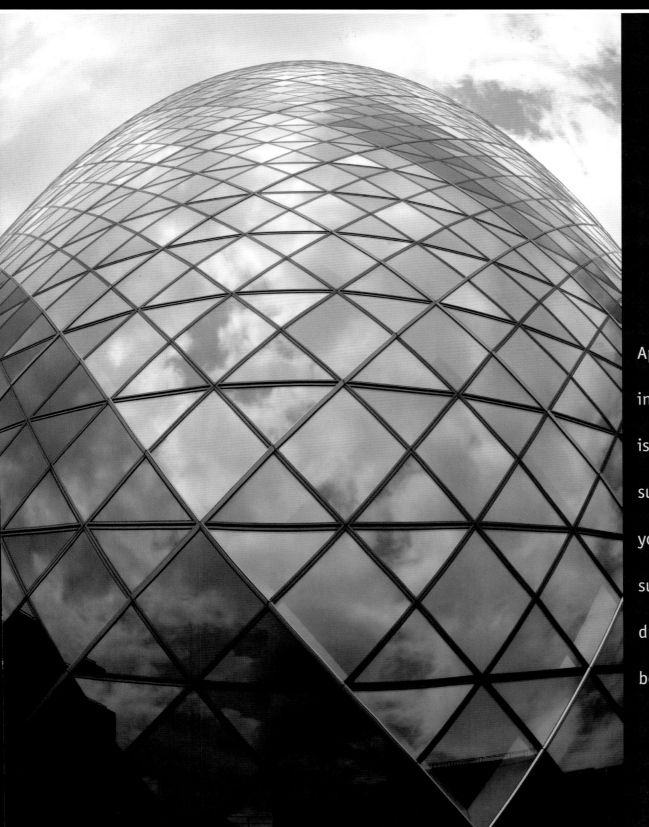

Applying a filter in-camera and in isolation might not be sufficient to transform your photo into the surreal creation of your dreams, but it could be a start.

Cross-processing

While digital might be the format of choice for most photographers now, from professionals to people snapping pictures on their cameraphones, film hasn't been entirely shunned and forgotten. That's good, because a little bit of creative photography combined with a touch of technical know-how and a smattering of chemistry gives you the opportunity to produce super surreal images. Go out with an analog camera, shoot what you like, and then have the film cross-processed. Tah-daa!

The idea behind cross-processing is pretty simple. Developing film requires chemicals. Depending on the type of film that you use, different combination of chemicals is required to process it. If you were to use color negative film—the type that leaves you with a negative—it would be processed with C-41 chemicals. Color slide, or reversal, film on the other hand (the type of film that produces slides you'd watch on a wall with a projector) needs E-6.

Unsurprisingly, if you were to cross-process your films you would switch the chemicals used to develop them. Color negative film would be given the E-6 treatment while color slide film would be developed using C-41.

The results? Images shot on color negative film, but processed with slide film chemicals will take on a muted, low-contrast appearance. Develop slide film with color negative chemicals and the results will be much more contrasty, with saturated colors and interesting casts. In short, you can achieve some fabulously surreal-looking photographs, for example skies can turn pink and pavements can show up green, by shooting everyday subjects and experimenting with their development.

If you'd like to push your analog surrealism a little bit further when cross-processing, you can also under- or overexpose and then compensate for it, too. You could deliberately underexpose all of your images on one roll of film and then ask for it to be "pushed"—or over-developed—by a stop or two when it is cross-processed. This will give you higher contrast images as well as unusual color casts and saturation from the cross-processing.

Should you do the reverse, overexpose in-camera and have the film "pulled" by one or two stops in development, you'll have images that are lower contrast.

Film shot on any type of analog camera can be cross-processed for a slightly surreal effect, but it's the so-called toy cameras that can really add an extra special splash of other-worldliness to their images. The photographs taken with toy cameras tend to have light leaks and color bleeds, so if you add some cross-processing color oddity, you'll easily achieve a fantastical result.

Any decent photo lab will know exactly what you mean if you ask to have your films cross-processed and the development pushed or pulled by a couple of stops. All you need to do is get your hands on an analog camera, a selection of different films, and get snapping!

BELOW LEFT: My Niece
It isn't especially surreal, but this image does give an idea of the effects you can achieve by using a toy camera and treating your images to a cross-processing makeover.
Shoot stats: Holga camera with Fujifilm Fujicolor Pro 400H film.

BELOW: Dolly
The acid colors and the effect of some light leakage from the camera give this photograph of an abandoned doll a slightly unreal look.

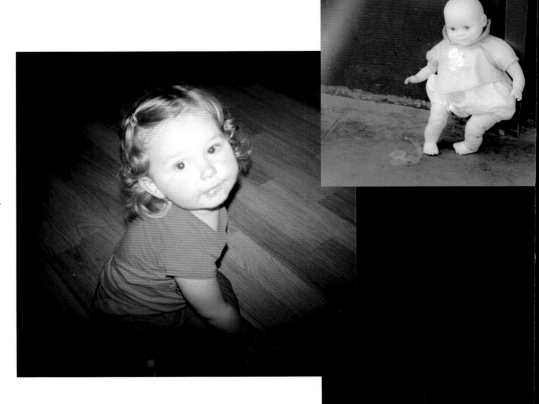

Multiple exposures

Multiple exposures have been around since the dawn of photography. The theory is simple: the same frame of film is exposed to light twice or more to create a merged image of the same scene with different features or two completely different scenes. Naturally the practice isn't quite that simple, but it isn't that difficult, either.

The general rule for a double exposure is to underexpose both images by 1 stop. If you are trying a quadruple exposure, it's an exposure compensation of -2 stops, and -3 stops for eight exposures. This all assumes the light levels between each shot are fairly similar. Don't forget that you don't have to alter the aperture in order to achieve the correct exposure; adjusting your shutter speed will also do the job.

If your multiply exposed image is of the same scene with, for example, the same person appearing in it in several different positions, then you will need a tripod to achieve this. It might help to remotely release the shutter, too, as the remote release helps to prevent miniscule movements of the camera that can ruin the multiple-exposure effect.

Multiple exposures do not have to be of the same scene. You can use the technique to superimpose people into positions in incongruous places, to create interesting lighting effects in your shots, and to experiment with different colored gels over your flash or filters over your lens. Also try rotating your camera to achieve monstrous or ghostly portraits, leaning buildings, or uncanny landscapes. Think of multiple exposures as the editing-suite-free version of image compositing!

Some analog cameras have a specific multiple-exposure function that allow you to expose the same frame of film several times. However, you can rewind film in cameras that have manual winding mechanisms, enabling you to expose a frame a second (or third or fourth . . .) time. As every model of camera operates differently, there's no definitive guide to rewinding your film by one frame; you'll have to either read the manual or experiment!

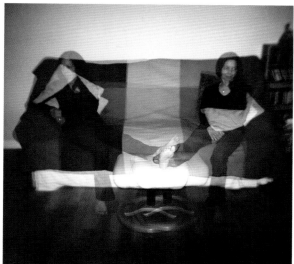

DOING IT DIGITALLY

The appeal of multiple exposures has prompted several camera manufacturers to include a multiple-exposure function in their cameras. They even come with "auto gain" to help you get your exposure correct. However, if your digital camera isn't multiple-exposure-capable, all is not lost—two of *Surreal Photography*'s contributors explore this topic in Chapter 7: A Surreal Gallery. On pages 116–121 and pages 178–181 Jess Rigley and Miss Aniela respectively discuss how they digitally manipulate their images to create a multiple-exposure effect.

LEFT: My Holga
My Holga was ridiculously cheap, and is a lot of fun to use. Creating multiple exposures with it is so easy that you can sometimes do it by mistake if you forget to wind on the film! However, it takes 120 film which isn't widely processed, so to get my images exposed I have to use a mail-order service.

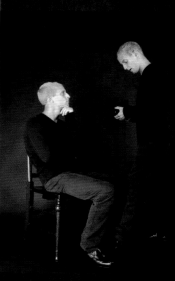

ABOVE LEFT: Multiple Mom
My mother often comments that she needs to be able to split herself in two; I think I've accomplished that here.
Shoot stats: Holga camera, double exposure on Ilford Delta 400 film.

ABOVE: Multiple-exposure Portrait
Portraits incorporating multiple versions of the subject can be anything from great fun to downright eerie.
Shoot stats: Canon EOS 60D with a Sigma EX 17–35mm f/2.8–4.0 lens at 17mm; f/11 with a shutter speed of 1/180 second and ISO 100.
Image © Haje Jan Kamps.

CHAPTER 3
CAMERA TECHNIQUE

The creation of a surreal image does not necessarily have to begin and end in an editing suite. Physical photographic techniques can be just as effective in producing an otherworldly, dreamlike image as hours spent in Photoshop. In this chapter we'll explore how you can use different lenses, filters, and exposure times—individually and in combination—to achieve a range of fascinating effects.

Floating On By by Daniela Bowker

Lenses

There are two particular lenses that you might wish to utilize for surreal image-taking due to the great distortions they give: the fisheye and the tilt-shift.

FISHEYE

Fisheye lenses are non-rectilinear, ultra wide-angle lenses. They were originally developed for meteorological usage to study cloud formations, as their extreme angle of view—in some cases up to 180 degrees—was able to take in the whole sky. In order to capture such a wide angle of view, they distort their images significantly. It's this distortion that makes them a valuable addition to the surreal photographer's toolkit.

Anything towards the center of a fisheye photo will appear magnified, while the entire image will curve as it reaches the edges of the frame. In some cases, the image itself will end up being circular. By taking a portrait with a fisheye lens, you can give your subject a comically large eye, or make her or his nose monstrous, whereas a landscape shot with a fisheye might have a curved horizon or bent trees.

There are two predominant types of fisheye lenses: circular and full-frame. A circular lens will, unsurprisingly, create an image that's circular in the frame with entirely dark corners. A full-frame fisheye lens covers the entire frame, so it doesn't produce blackened corners.

By combining the line-bending and foreshortening effects of a fisheye lens, you have the opportunity to create beautiful surreal images, or something that is comically distorted and not entirely realistic.

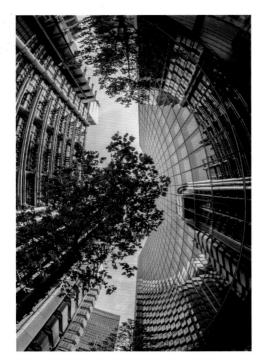

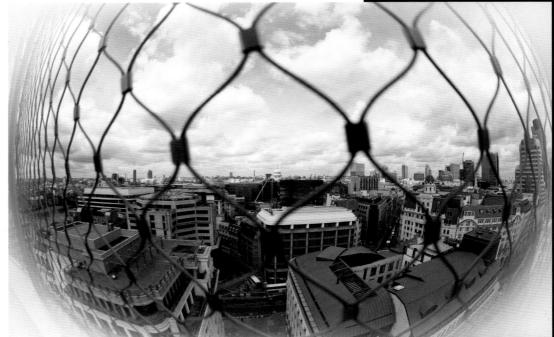

Lenses are the second most important factor behind good photography, after photographers themselves. What you can achieve with a different lens, or the impact of a good one on a photograph, is remarkable.

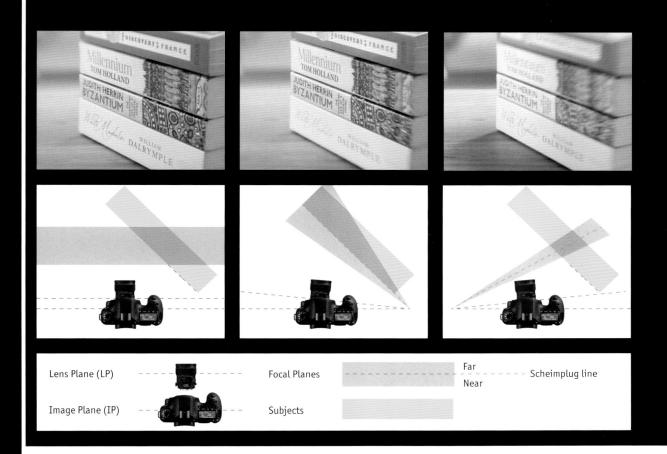

Lens Plane (LP) — Focal Planes — Far — Scheimplug line
Near
Image Plane (IP) — Subjects

TILT-SHIFT

It isn't just the fisheye lens that can be used to capture surreal photographs by slightly distorting our view. Tilt-shift lenses are a fabulous means of allowing you to simulate miniaturized scenes. You can photograph a stadium and make the players on the field look like dolls, while a busy intersection photographed with a tilt-shift lens can make cars and people appear tiny. The parasols in beach scenes can resemble the paper umbrellas you get in cocktails, and an Alpine village photographed from above with a tilt-shift lens might not look like anything other than a model.

Buying a tilt-shift lens is an expensive undertaking, but there are cheaper alternatives. You might want to start by renting or borrowing a lens to see how you feel about it. If you decide that you love tilt-shifting, but that between $1,000 and $1,500 for a lens is a bit too much to spend, take a look at Lensbaby's range for some more affordable options.

If you want to get a bit more technical, tilt-shift lenses work by adjusting the plane of focus in relation to the image sensor. With a "normal" lens, the plane of focus (where all the light rays converge, and the image is sharp) in an image runs parallel to the sensor.

The "tilt" part of a tilt-shift lens rotates the angle of the focal plane relative to the sensor; not only is the plane of focus then at an angle, but it also becomes a wedge shape. It means that you can get objects in both the foreground and background of a scene in sharp focus at relatively wider apertures—which is its common use in landscape photography. In surreal photography, however, it can be tilted in the opposite direction, resulting in everything on either side of the wedge that's in focus being blurred. The result mimicks the extremely shallow depth of field that is usually found only in macro photography; and so when viewing such a scene, the human visual system interprets the results as a miniaturized scene.

LONG EXPOSURES

Long exposures are often associated with evocative images of cities at night and streets illuminated by the lights of passing cars, but in fact they aren't as restrictive as you might think.

There are two vital factors to effective long-exposure images: patience, and a good tripod. If you don't already own a tripod, I'd advise you to invest in one, whether or not you intend to work with extended shutter speeds. They are invaluable for all kinds of studio work as well as portraiture, time lapses, any kind of photography when you don't want to be near the camera (wildlife photography for example), and if you don't want the camera to move, whether for one shot or between multiple shots.

When it comes to long exposures, tripods are vital for ensuring that you have a crisp and blur-free image by maintaining the camera's stability for the duration that the shutter is open. The length of time that you can keep a camera steady while hand-holding it is a lot shorter than you think.

Go on—indulge me for a moment. Get out your camera and take a series of images, starting with a shutter speed of one hundredth of a second. Gradually lengthen the exposure time. At which point do your images start to go slightly fuzzy around the edges?

As for patience, it isn't just about those few seconds while your camera's shutter is open and you're standing there feeling slightly redundant. Setting up a long exposure shot can take time, from finding your location to erecting your tripod. Then you will need to experiment with the settings on your camera to ensure that you get the perfect exposure.

Patience also means being prepared to wait while the perfect shot comes along. *London Town Meets Tron,* shown opposite, was the product of a very cold evening spent on an overpass in East London. There were plenty of other good shots from that night's shooting, but I was specifically listening for any emergency vehicle sirens to capture the effect of their flashing lights.

Long exposures are not limited to low-light situations, either—they are also a valuable means of capturing motion in an image. A motion-blurred photograph might not in itself constitute a surreal image, but the effect can certainly contribute to an overall surreal composition. Remember—many of the techniques explored in this book can be used in conjunction with each other to help you realize your creative vision; you don't need to limit yourself to just using one thing or another.

BEWARE OF OVEREXPOSURE

You might need to use a much smaller aperture than you would have anticipated (even for night shooting) when working with long exposures. A slow shutter speed can let in far more light than you might think, leading to an overexposed image if the aperture is too large.

RIGHT: London Town Meets Tron

This image was shot on an overpass in East London late one evening. The exposure lasted 30 seconds, which ensured that I captured the blue lights of the emergency vehicle from the bottom of the frame to the top. I was only able to prevent the image from being overexposed and revealing too much of the environment (rather than just the lights in motion) by using an aperture of $f/32$.

Shoot stats: Canon EOS Rebel XSi with Sigma 70–200mm f/2.8 lens at 97mm; f/32 with a shutter speed of 30 seconds and ISO 100.

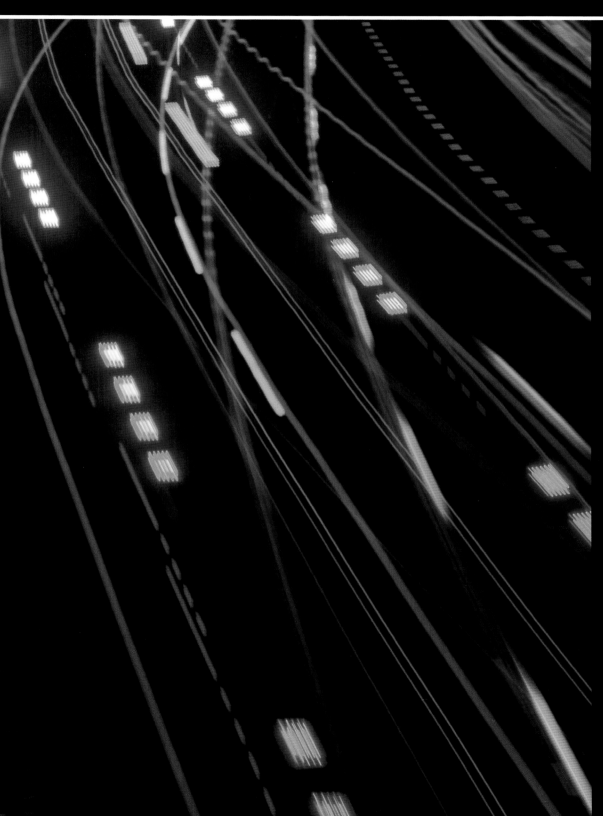

A long exposure will allow
you to capture everything
that is there in front of
your eyes, and will also
allow you to see what was
previously invisible—the
light stretched out by time.

The light that we're able to see, referred to somewhat uninspiringly as "visible light," is a small part of an entire radioactive spectrum of wavelengths that's measured in nanometers. Visible light ranges from violet, at roughly 400 nanometers, to deep red, which measures around 750 nanometers. There are, however, other types of radiation that we can sense, if not see, such as infrared (IR) and ultraviolet (UV), and both of these present interesting options when it comes to surreal photography.

The spectrum of IR wavelengths ranges from 750 nanometers—where visible, deep red falls off—and stretches to 20,000 nanometers. The human eye might not be able to detect these wavelengths, but they're still there, and if you have the right equipment, you can capture them with your camera. I use nothing more sophisticated than my Canon EOS Rebel XSi, a 50mm prime lens with a Hoya R72 filter, and a tripod. This kit isn't able to capture much in excess of 1,300 nanometers, but still records nice images.

Cameras are designed so that they are insensitive to IR light, with what's known as a "hot mirror" inserted in front of the sensor to protect it and reflect IR light back toward the source. However, these hot mirrors aren't 100% effective, and by filtering out visible light using an IR filter, you can record IR images. The filter that most IR photographers seem to favor is the Hoya R72; these are widely available, but do ensure that you purchase the correct one for your lens.

The difficulty that you'll likely encounter when trying to focus comes as a result of the IR filter; as it blocks out the majority of visible light passing through the lens, it tends to leave you with a dark viewfinder, so you don't have anything to work with when you're focusing your lens. You have two options you could pursue to overcome this: set up your shot without the filter and then apply it, or trust your autofocus, though a crucial point to note is that autofocus doesn't

work with an IR filter on the lens, so if you use this method you need to use an IR-adapted camera. IR light focuses at a different point to visible light, so you'll need to adjust the focus slightly. Older lenses often have a separate focus mark for IR, but most new lenses do not. The easiest workaround to correct the problem is to use a smaller aperture or bigger depth of field to compensate.

Setting up your shot and then placing the filter over your lens is a little awkward, but seeing as you'll be using a tripod anyway (more on that in a moment), it won't be wasted time. Working in this way is more likely to help you achieve the image that you want than relying on a combination of the camera's autofocus and stopping down sufficiently to let the autofocus find its "sweet spot." Only by experimenting and trying both methods will you find what works best for you.

To get the exposure correct, you will need to use a slow shutter speed, probably between ten and 30 seconds, to allow enough IR light to reach the sensor to expose it sufficiently. This is where your tripod comes in, as you'll

IR ADAPTED

If you decide that you're totally in love with IR photography, you might want to invest in an IR-adapted camera, which has had the hot mirror removed. Until then, though, an IR filter for your lens should do the job. Oh, and a tripod, you'll definitely need one of those.

BELOW: False Color
A strong red or magenta cast is normal for an IR image straight from the camera, but that can be corrected with a little manipulation, in this case with Lightroom.

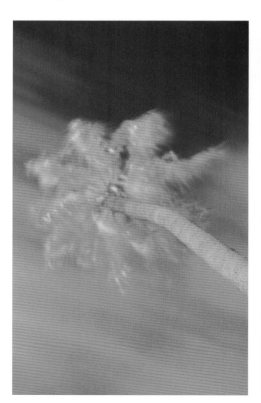

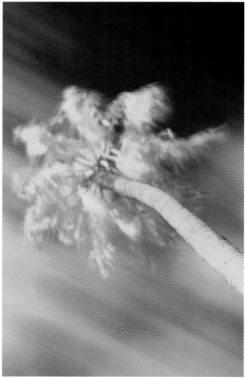

never manage to hold your camera steady for that length of time. Long exposures also have a tendency to noisiness, so use as low an ISO as you can manage.

Don't be surprised if your IR photos emerge from your camera with strong red or magenta casts; this is known as false color. It's normal and is simple to fix in an editing suite by altering the red and blue color balances in the image. You might need to amend the contrast to complete the image, too.

Some lenses are prone to producing "hot spots," or patches of much brighter exposure that are usually, and most inconveniently, in the center of the image. There's very little that you can do about this except to try a different lens. Prime lenses are less prone to hot spots, but there are no guarantees.

ABOVE: Floating On By

Drifting clouds, white trees, and an orange sky: IR in Australia.

Shoot stats: Canon EOS Rebel XSi with Canon EF 50mm f/1.8 II lens at 50mm; f5.6 with a shutter speed of 30 seconds and ISO 100.

ULTRAVIOLET

UV photography tends to be less common than IR photography; it's tricky, much like IR, but it doesn't always yield the breathtaking images of IR. However, alone or in combination with other techniques, it could be just what you need to create your perfect surreal image.

UV light has a wavelength that's shorter than visible light at around 400 nanometers, but isn't as short as X-rays at 10 nanometers (hence ultraviolet). Plenty of UV light is available from the sun, so don't think that you need to go out and buy yourself a black light if you'd like to try UV photography; you just need a filter that will block out visible light and allow your camera's sensor to detect the UV light. However, UV photography is far more successful on a bright, sunny day because there will be more UV light bouncing around.

There are quite a few filters on the market to facilitate UV photography, but also a lot that block UV light, too. When you purchase a filter, make sure that you have the right type: a UV pass or transmission filter. The UV transmission filter will be black or at least dark, whereas UV blocking filters are usually colorless.

Similarly to IR photography, you will need to use a long exposure in order to produce an image. Consequently, you will need to use a low ISO to help reduce digital noise and a tripod to ensure that your images are sharp.

Flowers are the archetypal UV subject, as they have wonderful markings that are only visible in the UV spectrum, but people make good UV subjects, too, especially when smeared in sunscreen. Sunscreen in general makes for fun pictures, as it is designed to block UV light and therefore appears matte black in photos.

If you find that UV photography is something that you want to explore more, it might be worth investing in some UV-emitted lights, or think about trying UV-fluorescence photography. This uses UV-emitting lights that have been protected by a glass filter, called an exciter filter, and is shot in a dark room with a black background. In addition, your camera will require a barrier filter to block out any extraneous UV, save for that which is fluorescing.

ABOVE: R72 IR Transmission Filter

Want to try your hand at IR photography? You'll be needing an IR filter.

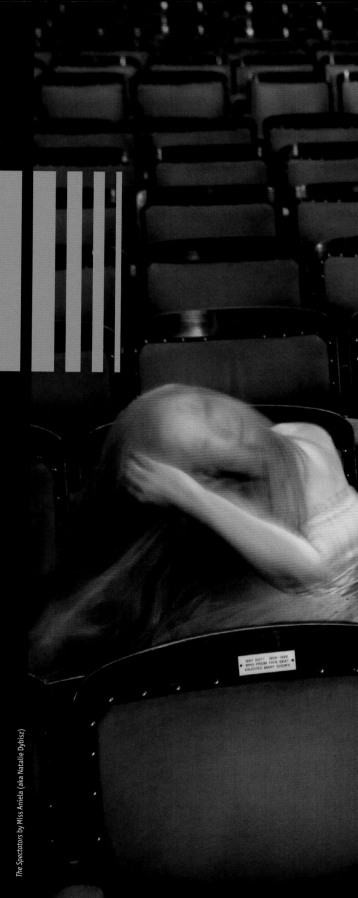

CHAPTER 4
A DIGITAL DARKROOM

For any photographer who shoots digital, whether or not they want to have a go at creating surreal images, some kind of editing package is essential. It can be the slightest of edits—a straighten, a small crop—that elevates a good image to something really special, but equally, editing software can be used to create your very own fantasy world. This is the realm of serious image manipulation.

Knowing the basics of the tools that an editing suite puts at your disposal is essential before you start attempting to create images. This chapter will help you to find your feet and navigate your way through the buttons, sliders, and drop-down menus of your editing suite.

Although Photoshop forms the basis of this chapter, most of the tools it employs and the skills it demands are transferable to the various other editing packages.

The Spectators by Miss Aniela (aka Natalie Dybisz)

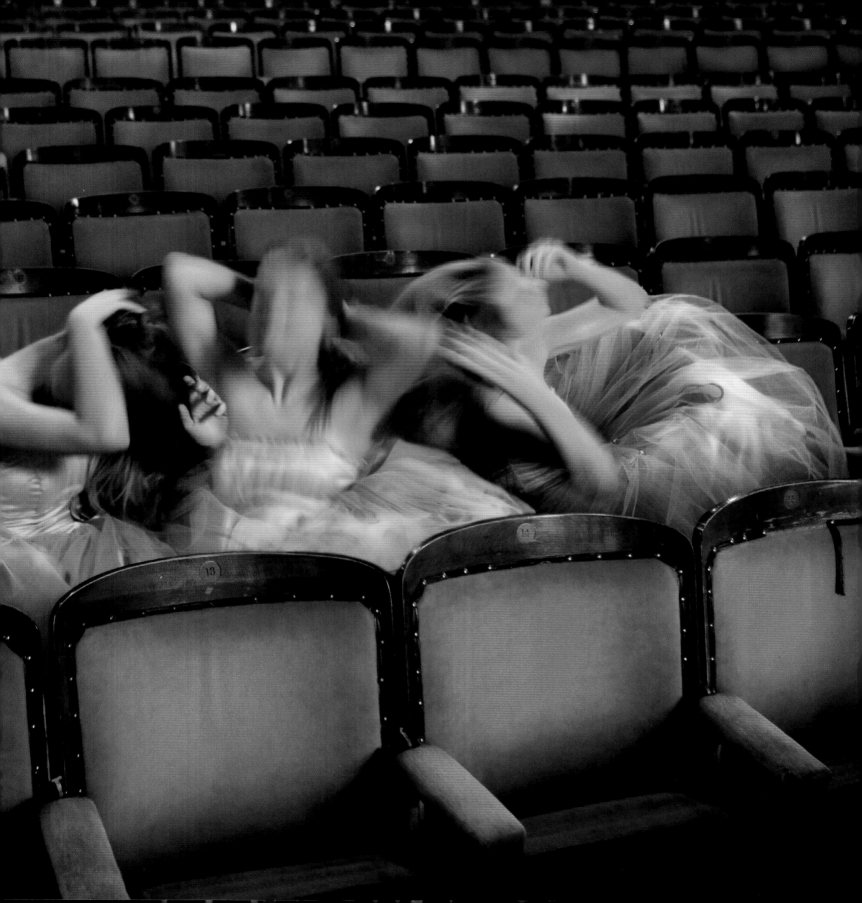

The range of different post-production packages out there is enough to send you cross-eyed and give you a headache if you think about it for too long. They stretch in price from free to hundreds of dollars, which means that whatever your needs or your budget, you should be able to find something suitable.

If you're just starting out it's probably worth beginning with one of the free packages to get a feel for just how much you're going to be using it and precisely what your needs are. Even the free packages come with quite a considerable range of tools, offering you a decent introduction. If you reach a point where you find yourself frustrated by your editing software being too slow or not providing you with enough options, then you can think about laying down some cash for something more sophisticated.

THE FREE OPTIONS

When you are starting off with surreal manipulation—and digital photography, for that matter—there's no need to go out and buy the most expensive editing package on offer, or even spend money on one at all. Specially buying the full version of Photoshop when you're just starting off would be a little like turning up to your first tennis lesson in full tennis whites, expensive sneakers, and with a brand new racket. Until you're certain that tennis is the sport for you, you would be just fine practicing with a secondhand racket. Similarly, there are plenty of good free options out there when it comes to editing suites.

GIMP

GIMP (GNU Image Manipulation Program) has been around a long time. It started life as a college project in 1995, but has grown since then and is now one of the leading freely distributed image manipulation programs available. GIMP was written and developed on a Unix platform, but operates on both Mac and Windows systems, and was designed to be extended and augmented with plugins and extensions. As a consequence, a community of highly knowledgeable and loyal GIMP users has flourished around it, which is a great advantage to using it. On the flipside, one small disadvantage is that the user interface can be confusing.

The original idea behind GIMP was to offer a Photoshop alternative, and its functionality reflects that with its range of brushes, selection and extraction tools, channels, a gradient editor, and layers. Although GIMP doesn't support Raw images straight from the download, you can install a plugin, UFRaw, that does. In conclusion, GIMP offers you everything that you might want from an image manipulation package, though with a slightly idiosyncratic interface.

Paint.NET

Paint.NET was another program developed as a no-cost alternative to a big-name package; this time, it was Microsoft's Paint. As a consequence, Paint.NET only operates on Windows machines. It supports layers, has an unlimited undo function, and enjoys plenty of special effects features. Paint.NET's functionality probably isn't quite up there with GIMP's and Photoshop's, but it is a decent package that comes for free.

Much like GIMP, a loyal user base has grown up around it, with support, tutorials, and an extensive range of plugins that add functionality to the program.

THE MID-RANGE OPTIONS

Adobe Photoshop Elements

If you decide to spend a little cash on an editing suite, the first option you might want to consider is Adobe Photoshop Elements. Where Photoshop is regarded as a professional package that has a matching price tag, Elements is aimed at amateurs and serious hobbyists. It does almost everything that Photoshop does, comes with Quick and Guided Edit modes to help you along, and the price won't leave you wincing.

Elements is designed so that from the moment you transfer an image from your camera to your computer until you upload it to the web or send it for printing, everything that you'll need is easily accessed. It's also built on the same platform as Photoshop, so if you do decide to upgrade, you'll have an idea of what you're doing when you get there.

Corel PaintShop Pro

For Windows users, Corel PaintShop Pro is a well-respected editing package. It offers an extensive range of features as well as a workflow management system to help you to organize your images. If you don't require all the functionality of Photoshop, but still want a powerful editing package, PaintShop Pro is a worthy alternative.

Pixelmator

Pixelmator is an editing app designed exclusively for the Mac operating system. It's incredibly slick to look at and offers a range of tools to rival any other editing package out there, except Photoshop. You can use it to select, paint, draw, retouch, add filters, correct color, and do it all in layers.

It doesn't have all the functionality of Photoshop, but that's why Photoshop is the industry leader. However, it is excellent value for money and unless you're a professional, will likely provide you with all of your editing needs.

THE BEST OPTIONS FOR EXTENSIVE USE

Photoshop

The industry standard for image editing over the past 20 years has been Adobe's Photoshop. It isn't just a part of a photographer's arsenal, it is also used extensively by designers and other creative professionals. It offers its users ultimate control over their images, with its color manipulation capability, use of layers, and diversity of filters.

When you open Photoshop the functions are so extensive and the integration with other design and publishing packages so neat that it will leave you thinking that there is almost nothing that it can't do to a photograph. Of course, the corollary to this is that it can be overwhelming for a new user, its learning curve is steep, and it doesn't come cheap.

If you think that you might be manipulating images extensively, then you will at least want to consider investing in Photoshop. However, before purchasing it consider whether you're doing enough manipulation to justify the expense, and whether you could learn the ropes on a less extensive, demanding system. You might find that one of the alternatives is sufficient for your needs.

Adobe Lightroom

For photographers who want comprehensive processing power over their images, but don't necessarily need the heavy-duty image manipulation capabilities of Photoshop, Lightroom is a highly regarded option. Lightroom isn't designed to enable compositing (it's primarily designed to streamline the Raw-processing workflow for large batches of images, though it has evolved considerably over the years), however, it will afford you extensive control over your digital images, from straight editing to faux cross-processing to IR development. Unless my aim is to create a multi-layered, heavily manipulated image, Lightroom is my photographic editing suite of choice.

Without its layers capability, Photoshop wouldn't be nearly as effective. Layers are what give you the ability to edit non-destructively, so that any adjustment that you make can be easily amended or even removed altogether without having an impact on your other edits, or your original files. The most common description of the layers function is that it resembles a stacked pile of transparencies, each containing information that makes up the final image and can be altered individually. You can amend or remove one of your layers without affecting your other layers. How many layers can each image have? As many as your processor can handle.

The advantage of working with layers is that you can continue to adjust each one until you are satisfied with the overall result. Each layer affects only those underneath, and you can change the stacking order; each layer can also be made more transparent if wanted. Layers are virtually essential for compositing, and have every advantage except that they increase the size of the file. A basic layer, available on most programs, simply superimposes one picture or effect over a base image. A Layer Mask is linked to a layer and hides, or masks, part of the layer from the image. Any effect applied in an Adjustment Layer is stored in a separate layer, is easily editable, and does not change the original layer.

NAME YOUR LAYERS

You can name layers individually, so rather than having to try and remember that Layer 23 adjusts the luminosity of the unicorn's coat, you can call it "Unicorn Coat Luminosity."

ADJUSTMENT LAYERS

To demonstrate the effect of Adjustment Layers, we'll use a photo of my sandals languishing on a beach.

1) The photo was taken handheld at sunset, so it's a touch on the dark side. That, however, is easily corrected.

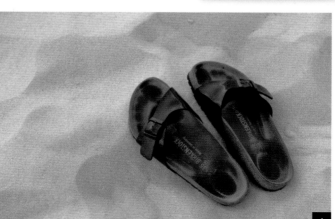

2) From the Adjustments panel I can steadily work through the range of functions, each on a separate layer, to edit my photograph and improve its appearance.

I won't necessarily make an adjustment using every option presented to me, but if I were to, each one would be on a separate layer and thus would be independently modifiable.

3) In this instance, I'm going to adjust the Brightness/Contrast, Levels, Curves, and Hue/Saturation. As I work through my editing process, I can adapt each layer's adjustment in sequence, and then modify each as I need to, without it having an impact on the other edits.

4) If I'm unsure that the adjustments I've made to one particular layer are having the effect that I initially anticipated, I can hide it by clicking on the eye icon to the left of the layer. On this image, I've hidden the contrast layers showing how the image would look with all the other adjustments except for the contrast edits.

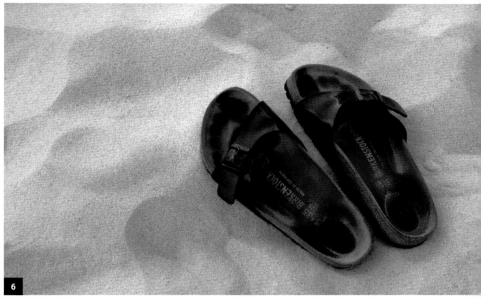

5) Here, I've reinstated the Contrast Adjustment Layer, but removed the Levels and Curves layers. I think I need both of those, too. If I conclude that it's not what I want, I can delete the layer. I won't have lost any of the Raw information in my image and I won't have affected any of my other edits.

6) When I'm happy, I can save my image, or continue to manipulate it, play with it, and turn it into something far more surreal!

A VERY QUICK INTRODUCTION

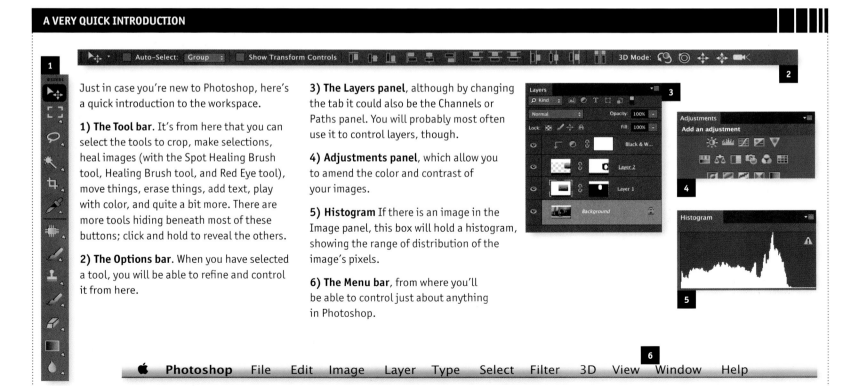

Just in case you're new to Photoshop, here's a quick introduction to the workspace.

1) The Tool bar. It's from here that you can select the tools to crop, make selections, heal images (with the Spot Healing Brush tool, Healing Brush tool, and Red Eye tool), move things, erase things, add text, play with color, and quite a bit more. There are more tools hiding beneath most of these buttons; click and hold to reveal the others.

2) The Options bar. When you have selected a tool, you will be able to refine and control it from here.

3) The Layers panel, although by changing the tab it could also be the Channels or Paths panel. You will probably most often use it to control layers, though.

4) Adjustments panel, which allow you to amend the color and contrast of your images.

5) Histogram If there is an image in the Image panel, this box will hold a histogram, showing the range of distribution of the image's pixels.

6) The Menu bar, from where you'll be able to control just about anything in Photoshop.

FILL LAYERS

Fill layers are located under the Layers menu: *Layer > New Fill Layer*. They allow you to create a layer of solid color, a consistent pattern, or a graduated effect. Importantly, they don't affect the layers beneath them, which makes them useful when creating new backgrounds for your composite works. There are hundreds of different options of patterned backgrounds, and if you count the different possibilities of color and gradient, the possibilities verge on the infinite.

We will return to look at different types of layers, how to use them effectively, and how to combine them, throughout this chapter.

1) You can select from one of Photoshop's preinstalled Gradient Fill options, or you can apply your own gradient to your background. In this instance, I've applied my own gradient values to a solid color fill layer.

2) The Gradient Fill dialog box allows you to select the variation of gradient that you'd like (for example, a linear gradient that runs across the screen or a radial one that emanates from a central point), the precise angle at which you'd like your gradient to run, and how diffused it is across the frame. If you're not careful, you could find yourself spending hours experimenting with nothing but gradients!

3) The default gradient setting that appears when you open the Gradient Fill dialog.

4) I've altered the angle of the gradient to run diagonally across the frame, but that's about it.

5) By increasing the Scale value, I've diffused the gradient across the frame.

6) This is the Reflected style option; I could have chosen Radial, Angle, or Diamond, in addition to Linear.

Levels & Curves

It's a very rare thing to encounter a photograph that is perfect straight out of the camera. So often, an image will benefit from some minor tweaking, specifically of the "Three Cs": crop, color, and contrast. It isn't necessarily about stripping great swathes off of your images, or radically altering their color makeup, but a touch here and there can make all the difference. When you are experimenting with surreal imagery you might find that making less-than-subtle changes will help you to achieve your desired effect.

LEVELS

Photoshop's Levels and Curves functions are key players when it comes to controlling the tone and contrast of your images. Levels (*Layer > New Adjustment Layer > Levels*) is the simpler of the two tools. It controls the black, white, and gray levels of an image, helping to give more punch to slightly flat or dull images.

1b) The Levels histogram explains why the image seems a little flat with that dead zone in the darks.

1a) If you take a look at my original photo of two of the Twelve Apostles, a rock formation off Australia's Victorian coast, it's a perfectly acceptable image, but a little on the flat side.

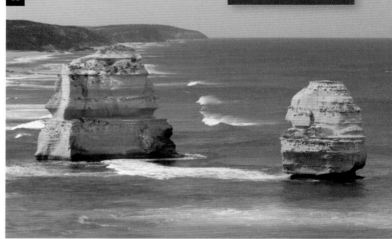

2a) By moving the black slider to the right, which eats up the unused area, and slightly adjusting the gray and white pointers, there's more tonal differentiation in the image, making it a lot more lively.

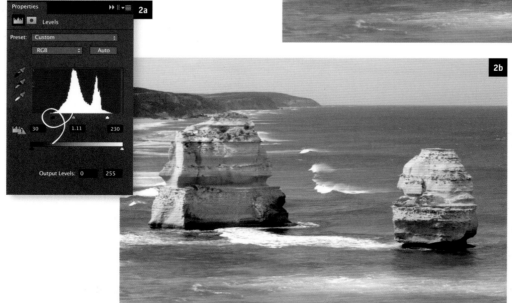

2b) There is a trade-off, however. Compare the shadowing at the lower right-hand base of the right-hand rock. You'll notice that by bringing more emphasis to the mid-tones, I've sacrificed some detail in the shadows. In this instance, I think it's an acceptable exchange, but I wouldn't want to push it too far.

1) There's not that much wrong with my original image from this touching pool taken in the aquarium in Seattle, but I'm sure that a little more definition could be brought to the dark areas and some more punch to the mid-tones.

2) By selecting points in the image that I think could benefit from more definition, and adjusting their corresponding points on the tonal curve accordingly, I've been able to increase the overall impact of the colors in the image without losing detail in the highlights. Awesome!

CURVES

The Curves tool (*Layers > Adjustment Layers > Curves*) is designed to control the distribution of tonal values throughout the image. In terms of controlling contrast, Curves is far more precise than Levels. Rather than offering you three specific points of control, like Levels, Curves provides you with up to 14. This allows you more precision when adjusting the contrast (as you can select a given point that you want to adjust from the image), and helps you to prevent the loss of detail in some areas of the image at the expense of gaining it in others.

The adjustments to the aquarium image left were all made using the RGB curve, which affords you control over all the colors in an image simultaneously. However, Photoshop also lets you adjust the red, green, and blue Tonal Curves in an image independently of each other—select this option from the drop-down box at the top of the Curves panel. This gives you more precision when you're making standard edits to an image.

ADJUSTING THE RED, GREEN, AND BLUE TONAL VALUES INDEPENDENTLY

There is no right or wrong way to go about this sort of editing; it is entirely dependent on your eye, your tastes, and the effect that you want to achieve.

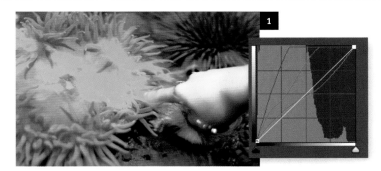

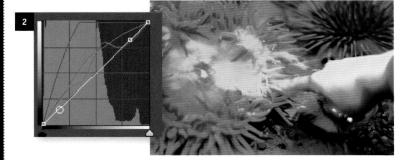

1–2) To give you some examples of what you can create by fiddling with the red, green, and blue Curves in an image, here are two different looks, along with their histograms so that you can see the sorts of changes I made.

Making selections

The ability to select and isolate individual elements of an image is a vital skill when creating surreal images. You might want to apply an edit to just one area of an image, in which case you will need to isolate it from everything else, or you might want to completely move or remove a particular photo. Photoshop provides you with a plethora of ways to make selections within an image; which one you use will depend on the item that you're selecting, its background, and your own preferences.

MARQUEE TOOLS

If you are selecting simple shapes, using the Marquee tools is probably the easiest option. The Rectangular Marquee isolates square or oblong blocks from your images in seconds.

For subjects that are round or oval, you can use the Elliptical Marquee tool. This isn't a tool that I find myself clicking on a great deal, but if you need to produce a perfectly round selection (make sure to hold down the Shift key when you're selecting), it can be useful.

- Rectangular Marquee Tool
- Elliptical Marquee Tool
- Single Row Marquee Tool
- Single Column Marquee Tool

1) The original image of the sailboat was lovely, but I thought that the sea could look a touch bolder.

I selected it using the Rectangular Marquee tool, created a new Adjustment Layer from it, and then altered the Levels slightly. It's not an overwhelming change, but I think it makes the image better.

2) The adjusted image.

- Lasso Tool
- Polygonal Lasso Tool
- Magnetic Lasso Tool

LASSO TOOLS

Photoshop comes with three Lasso tools: the standard Lasso tool, a Polygonal Lasso, and a Magnetic Lasso. If you're competent at drawing freehand, then you might work well using the standard Lasso tool. By holding down the ALT key, you can trace along a straight line, and press the backspace key to delete a freshly drawn straight-line section.

The Polygonal Lasso allows you to make selections bordered by straight lines by clicking from point to point. If you need to include a freehand section—for example to round a corner—hold down the ALT key and drag. To complete your selection, join up to the starting point, or double click to release the tool.

I'm quite a fan of the Magnetic Lasso tool, despite the indifference of many other Photoshop users. Trace the outline of the subject that you want to select and it snaps itself onto the subject's edges. If you're working with a subject that has complex edges, and especially if it's on a high-contrast background, the Magnetic Lasso is very effective. You can adjust the frequency with which the Magnetic Lasso attaches fastening points around a selection (the more frequently it places a point, the longer a selection will take, but the more accurate it will be), and assign a contrast value to help define edges on lower contrast images. Combine it with Quick Mask, Refine Edge, or Refine Mask (more on those soon), and you should be able to achieve an accurate selection relatively painlessly.

1) I used the Magnetic Lasso tool to trace the outline of a lionfish that I photographed while he (or maybe she) was lurking menacingly at the bottom of an aquarium. You can see from the outlined selection that the Magnetic Lasso worked just fine. While the effect took me some time to complete, I doubt that any other method would have been faster, or less frustrating.

2) The isolated image.

Making selections

QUICK SELECTION

For shapes more complex than rectangles and circles, Quick Selection is probably the fastest and simplest selection method in Photoshop. You'll find it in the Tool bar on the left side, sharing a button with the Magic Wand.

The Quick Selection tool is great for selecting simpler forms very quickly, but it also handles more complex outlines capably, especially if they're on a contrasting background. If you do happen to make any slips or spills, they can be tidied up easily using the Add To or Subtract From function, which you'll find in the Options bar towards the top of the screen.

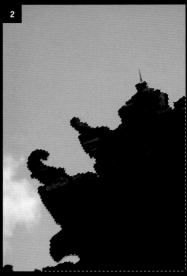

2) I used the Quick Selection tool and started in the bottom right-hand corner. It took fewer than 30 seconds.

3) By selecting an Adjustment Layer straight from the selection, I won't alter the sky. A few tweaks here and there, as well as a crop, and the image is much better.

1) The Quick Selection tool sweeps over an area using a brush with an adjustable tip to find the defined edges of a subject. I don't want to lose the beautiful blue sky of this image by altering the overall exposure or contrast. Instead, I can isolate the too-dark temple and carry out my edits on that specifically.

4) Final image

MAGIC WAND

If you're selecting a subject that is roughly consistent in color, for example a pink flower on a green background, using the Magic Wand is likely your best option. You click on a pixel of the particular color that you want to isolate, and the Magic Wand selects all the pixels of that color. By adjusting the tool's tolerance, you can determine how much variation in color away from the original pixel the tool is prepared to tolerate. A tolerance of 0 doesn't allow for any variation; 255 on the other hand, gives a huge latitude.

You can ensure that only pixels in your desired color that are adjacent to each other will end up in the selection by checking the Contiguous box in the Options bar. If you have a photograph of a strawberry bed, for example, and you want to select one particular strawberry, check the Contiguous box; to select all of the strawberries, uncheck it.

COLOR RANGE

If you need to select a specific shade quickly or want to pick out a color within a selection, you can use the Color Range tool, found under *Select > Color Range*. You can choose from the six preselected colors in the drop-down menu, or select your own using the Eyedropper tool. By adjusting the Fuzziness slider, you can increase or decrease the range of the selected color.

The Color Range tool includes a skin tones function in its drop-down menu, which is useful for selecting common skin tones across an image. Should you want to make adjustments to an image excepting people's skin, you can use the Color Range tool to select skin tones with the Invert button selected.

Using the Magic Wand to Isolate Colors

This image of my blue Holga on a perfectly complementary orange background is an easy image to isolate. With a tolerance of 170 set and the Contiguous function checked, the Magic Wand was primed to select colors close to where I waved it. As this meant that it would only select pixels adjacent to each other and not from all over the image, it took under a minute to isolate the camera.

More on selections

QUICK MASK

After you've made a selection, especially one with intricate edges like this lionfish, you might want to clean it up before doing anything else with it.

1) By pressing "Q" on your keyboard, you will activate the Quick Mask function. This will mask everything that you haven't selected in a red shroud—rubylith—and allow you to clean up the edges. What is masked depends on the tool preferences, and the default is to select masked areas.

3a

3a, b) When you're done, press "Q" again, and you're ready to go!

2) Zoom in on the image and you will be able to see where your selections have been less than accurate. Then use the Brush tool to make your adjustments.

 Paint with black to conceal parts of the image and white to reveal it. By adjusting the size of the brush, you will be able to make your alterations with greater precision.

3b

REFINE EDGE AND REFINE MASK

Using the Refine Edge or Refine Mask commands (they are essentially the same tool) is probably the most effective means of achieving a clean, precise selection after you've done the initial work.

1) By clicking on the Refine Edge/Refine Mask menu option (it's a single option that changes from Refine Edge to Refine Mask depending on whether you've made a selection or mask), your selection will pop up on a white background together with a dialog box. The Magic Wand tool did a good job of selecting my blue camera from an orange background, but there are some discrepancies. In this instance, I've applied a Layer Mask to the selection of my camera, so I'll be working with the Refine Mask tool to help remove the orange fringing from around its edges.

2a, b) The Refine Mask options will help to remove the orange fringing and give a cleaner finish to the selection. By using a combination of the Edge Detection Radius slider and the Shift Edge function, I'm able to eliminate most of the extraneous orange. It's often a good idea to feather the edge of the image by between a half and one pixel, too. It helps to prevent a selection from looking as if it has been superimposed onto a background if and when you move it elsewhere.

3) When you've made your selection (if you're making a selection to cut out and place elsewhere, as opposed to working with a Layer Mask), you have two options after you've isolated and removed your selection from its background (*Select > Inverse* and then delete). You can insert it directly into a new background, using the Move tool. Or you can save it as a new PSD file for multiple uses, and position it on its new background by using the Place function (*File > Place*). I always feel that if I've gone to the trouble of isolating and extracting the image, I might as well file it for future use.

MASK COLOR

If your image contains lots of red, pink, or orange tones, working with a rubylith mask isn't very easy, but you can change the mask color. Double click on the Quick Mask tool; it will open an options dialog box so that you can select a new, more appropriate, mask color.

When the Content Aware Move tool was unveiled in Photoshop CS6, there were whispers that it resembled magic, and I have to say, it is a very nifty piece of technology. If you are working with images on plain or consistent backgrounds, the Content Aware Move tool makes shifting a subject from one place in an image to another place a breeze, while enlarging an item takes seconds.

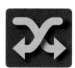

CONTENT AWARE MOVE

Look to the Tool bar and hiding behind the Spot Healing Brush, you'll see a tool with a symbol that resembles two crossed arrows; this is the Content Aware Move tool.

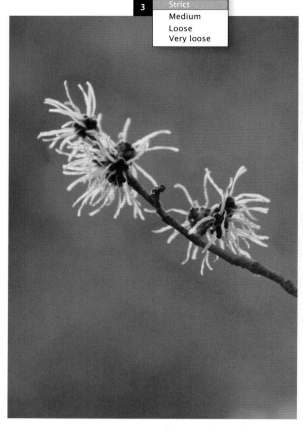

1) I've chosen a fairly innocuous image of some witch hazel to demonstrate the tool's capabilities. While I actually like the composition here, it might not suit everyone's tastes, so I'm going to move the plant higher into the frame.

2) I select the tool, outline the plant, and then I drag it to its new position in the frame. After a few moments of thinking, Photoshop relocates the plant and replaces the hole where it used to be with a replicated background. It's by no means perfect, but it is super easy and effective.

3) In the Options bar, you have the ability to select between a Very Strict and a Very Loose Adaptation, with three points in between. This determines how the replicated content adapts to its new position and how precisely the background content is recreated. As a general rule, you might find that tighter selections need a stricter Adaptation setting, but it pays to experiment. Don't forget, you can always undo and redo your moves.

CONTENT AWARE EXTEND

When you have selected the Content Aware Move tool, if you look to the Options bar, you can switch the Mode between Move and Extend. When you are in Extend mode, it gives you the opportunity to make things grow!

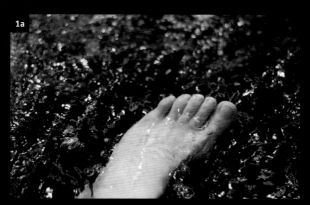

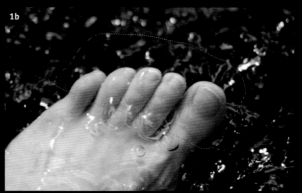

1a, b) This is me, cooling my small but well-proportioned feet in a freshwater stream. I'm going to use the Content Aware Extend option to elongate my toes.

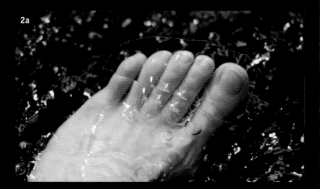

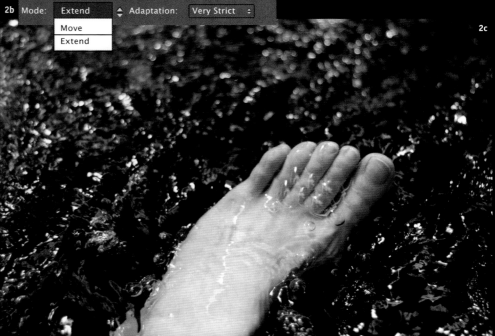

2a, b) A few clicks and a drag later, however, and my toes have become comically large. In this instance, I set the Adaptation to Very Strict and, with this, was aware that I couldn't stretch my toes too far before they started to replicate themselves.

Color

Adjusting the color of your images is one of the Three Cs of fundamental image editing, along with cropping images and changing contrast. Photoshop provides you with the tools to adjust the hue and saturation levels of your images, making them bolder or more faded depending on your preferences. Photoshop allows you to correct the white balance to ensure that your white really is white and that you don't have peculiar color casts affecting your photos, and also lets you have some fun with zanier colors.

HUE AND SATURATION

Hue is a fancy word for color. Blue, green, and red are all hues. Hues come in different tones, or variations in light and dark. Saturation determines how intense a color is. You can control both hue and saturation in your images using an Adjustment Layer: *Layer > New Adjustment Layer > Hue/Saturation*. When you're performing normal edits, you will probably want to exercise caution when making any adjustments to an image's saturation. If you go too far, it can look garish and unrealistic. When you're experimenting with surreal imagery, however, a little unrealism can go a long way toward helping you get the effect you want.

You can have all sorts of fun with the Hue slider, and from this dialog box, if you click the Colorize button and play around with the Hue and Saturation sliders, you can give your images an overall tint. To give you an idea of the impact of saturation, here are some variations on the same image of fish in Wan Chai market, Hong Kong.

1) A minor tweak to the Saturation, the sort that I'd customarily make to an image.

2) The Saturation level has been increased by 60 points on this image, which gives it a garish and cartoon-like effect.

3) Reducing the Saturation by 45 points produces a subtler, quieter photograph.

4) The Saturation has been pushed to +60 and the Hue raised to 180, in the blues.

5) The Saturation and Hue have both been moved into negative figures to give everything a pinkish-red cast.

6) Here, I've clicked on the "Colorize" button and then pushed the Saturation to 25 and the Hue to 91 for a green effect.

REPLACE COLOR

Violet egg yolks, yellow oceans, and blue leaves are all possible with Photoshop's help. As soon as you have mastered the basics of making a selection, changing the color of an object is a cinch.

1) Here I've taken a photograph of some oranges in the early morning light, intending to turn one of them vivid pink.

2) First I selected my orange of choice—just the one—using the Quick Selection tool.

Then I engaged the Replace Color tool: *Image > Adjustments > Replace Color.*

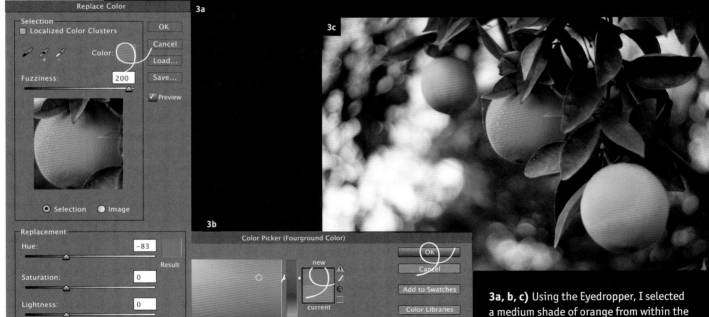

3a, b, c) Using the Eyedropper, I selected a medium shade of orange from within the fruit for the Selection box. I moved down to the Replacement box and clicked on Result. This opened a second dialog box from which I selected the vivid pink color to replace the orange. Happy with my selection, I clicked OK, and that was that.

Masks

Compositing, or the process of combining different images or elements of images to create a new whole, is one of the most oft-used skills when creating surreal digital art. Knowing how to select and isolate subjects from an image is imperative to good compositing, and we've already laid the foundations of that understanding. But how do you actually go about combining the different parts to create the finished article?

We looked briefly at moving and placing selections on pages 52–57, but there are other methods of moving and placing elements of an image.

CLIPPING MASKS

Wrapping your head around the idea of a Clipping Mask can be a bit of a challenge at first. After trying lots of different analogies, I decided that a paper clip was the most satisfactory. A Clipping Mask attaches together two (or more) layers. It holds them in place so that the contents of the upper layers cannot impinge on any of the other layers in the image, except those to which they are fastened.

For example, if you had a series of images stacked on top of each other and you wanted one of those to present as black and white, but not any of the others, you would clip a Black & White Adjustment Layer to the layer that is meant to be black and white.

We'll use an image of some opera glasses to explore this idea further.

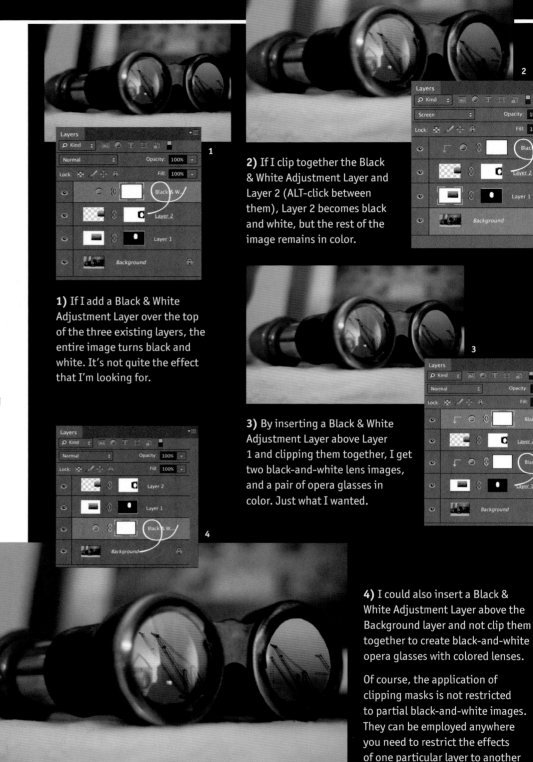

1) If I add a Black & White Adjustment Layer over the top of the three existing layers, the entire image turns black and white. It's not quite the effect that I'm looking for.

2) If I clip together the Black & White Adjustment Layer and Layer 2 (ALT-click between them), Layer 2 becomes black and white, but the rest of the image remains in color.

3) By inserting a Black & White Adjustment Layer above Layer 1 and clipping them together, I get two black-and-white lens images, and a pair of opera glasses in color. Just what I wanted.

4) I could also insert a Black & White Adjustment Layer above the Background layer and not clip them together to create black-and-white opera glasses with colored lenses.

Of course, the application of clipping masks is not restricted to partial black-and-white images. They can be employed anywhere you need to restrict the effects of one particular layer to another given layer.

LAYER MASKS

A Layer Mask will allow you to place one image over another and mask selected areas of the upper layer from view. Effectively, this allows you to see through it to the image below, thereby creating a montage. Of course, you're not restricted to just two layers when it comes to compositing; you can include as many as you need, and as your computer can handle.

At the very beginning of the book, I talked about the importance of having a concept for your surreal creations. Knowing just what you need and how you are going to create your montage will make your life a great deal easier as you start to composite.

1a

1b

1a, b) When I decided that I wanted to insert an incongruous reflected industrial sunset scene onto the lenses of a pair of opera glasses, the preparation involved examining just how light reflects off of glasses, to ensure that the final result was realistic.

As a result of my experiments with a flashlight and a pair of glasses, I realized that the size of the opera glasses' lenses meant that I would have to import the sunset image twice, and insert it individually over the lenses.

2) I started by making the opera glasses my Background layer, then imported the first sunset layer and added a Layer Mask by clicking on the Add Layer Mask button at the bottom of the Layers panel. I decreased the sunset layer's Opacity to 39%. (Scale images at *Edit > Transform > Scale*; hold down the Shift key to maintain proportions when adjusting the size.)

2

3

3) Happy that my layer was in the right place, I selected the Brush tool, selected the mask, and began to paint away the excess from the sunset image. Just as with the Quick Mask function, paint with white to reveal the upper layer, and paint with black to erase the upper layer. I zoomed in close and used a relatively small brush with a mid-size feather to get the edge that I wanted. When I was satisfied with my handiwork, I played around with the Opacity and Blending Mode options to finalize the effect I wanted. We will look at opacity and Blending Modes shortly, but in this instance I set the Opacity to 100% and opted for a Screen blend.

4

4) With the second lens, it was a very similar process, except that I positioned the image of the sunset differently across the lens. I selected the Screen blend again, and adjusted the opacity until I was happy with the result.

Finally, I saved my image as a PSD file and then a JPEG and felt very proud of myself.

Clouds, Drop Shadows, & Lighting Effects

CLOUDS

Hiding away beneath the Render button in the Filter menu are the options to add Clouds and Difference Clouds to your images.

1) In this instance, I'm going to add some soft clouds to the perfect blue sky behind the Duomo in Pisa.

2a, b, c) I make a quick selection of the Duomo and invert it, to ensure that it, too, isn't covered in clouds. Then I apply the Cloud filter (*Filter > Render > Clouds*) and reduce the filter's Opacity to 15%; I'm looking for gentle fuzziness here, not a perilous thunderstorm. The cloud pattern is generated randomly, so if the first pattern that envelops your image isn't quite right, you can regenerate it by pressing Command-F on a Mac or Control-F on a Windows machine. That's all there is to it!

3) The Difference Clouds option needs to be applied in addition to the Clouds filter, and can be applied multiple times to create a more veinous look to your clouds.

CLOUDS FILTER

Don't forget, the Clouds filter doesn't necessarily have to be applied to skies. You can apply it anywhere that you want to produce a mottled tone, or something that resembles sunlight passing through dust. The Opacity slider will help to ensure that the effect doesn't resemble a misplaced cumulonimbus, though!

DROP SHADOWS

Unless you're creating an image intended to reference *Peter Pan*, who famously lost his shadow, placing shadows in your composites helps to elevate them from the ordinary to the special. Although we might not necessarily pay attention to shadows in our everyday lives, we subconsciously expect their presence, and images that should have them, but don't, will look wrong. Thankfully, Photoshop makes it easy to insert a shadow into an image.

1a, b) Working on the layer where the object is to which you'd like to attach a shadow, select the Drop Shadow option from the Layer Style menu (*Layer > Layer Style > Drop Shadow*). A dialog box will appear that will allow you to determine the appearance of your shadow, from the angle of the light falling on your object to the distance that the shadow spreads from the object, to the shadow's opacity.

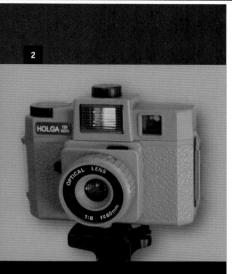

2) When I added the shadow to this image of a camera, I opted for a relatively soft light coming from the upper left. I used fairly large Distance and Size values with an opacity value of 50%, which left a diffused shadow falling downwards and to the right.

If I had wanted the lighting effect to resemble a spot beam shining from the upper right, it would have been simple enough to amend the settings accordingly.

LIGHTING

The Lighting Effects option (*Filter > Render > Lighting Effects*) will allow you to relight your photographs after they've been shot. You can select from Point, Spot, and Infinite lights, which recreate effects similar to a light bulb, a directional light, or the sun, respectively. You then get to select the light's color, intensity, and size, as well as the exposure, and how it reflects in your image. This might seem like trickery for photographers who've made a mistake lighting a shoot, but it can be useful when compositing to cast beams of light onto selections, as well as change the look and feel of an image.

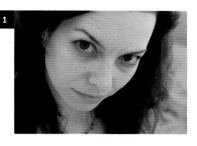

1) To look at what Lighting Effects can achieve, we'll start with a self-portrait of me that was the last photo taken on a fairly long shoot.

2) By using a moderately intense Point light with no ambient spread, I've been able to draw more attention to my face and less to the background.

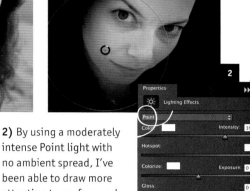

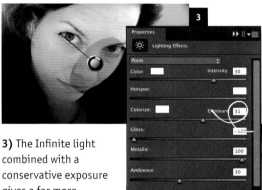

3) The Infinite light combined with a conservative exposure gives a far more natural lighting look.

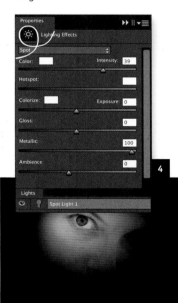

4) With the Spot light, I've been able to produce a far more dramatic effect that only partially lights my face and keeps the rest of the image in darkness.

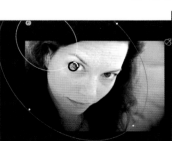

5) And then I could add another Spot light and change the color (to lilac in this instance).

BRUSHES

There is a mind-boggling selection of brushes available to you in Photoshop. Apart from being able to switch between round points and round angles, flat curves and flat fans, crayons, pencils, pastels, chalk, and charcoal, wet sponges and dry brushes, as well as spatters, sparkles, and leaf stamps, there are palettes of other kinds to choose from, including brush size, bristle density, bristle thickness, brush angle, "ink" flow, and pencil softness.

BLENDING

Opacity is a function that has popped up previously throughout this chapter. It describes how the pixels of one layer will interact with the pixels of the layers beneath it—most often, you'll simply use it to set how opaque or transparent a layer should appear. When you have layer stacked upon layer to create a composite image, the sort of interaction that governs how your pile of layers appear to merge together is significant.

However, opacity is not the only factor that can influence this blending of layers together; Photoshop comes with a selection of different Blending Modes, too.

A whole book could be dedicated to Blending Modes alone, given how many different Blending Modes there are, the variation that can be applied to each one via opacity, and that the different properties of different layers will present inconsistent results for every mode. Mastering the effects of different modes through experimentation will serve you well, but here are a few examples to get you started.

A QUICK WORD ON THE AIRBRUSH

The word "airbrush" is synonymous with Photoshop, and unfortunately, airbrushing has a generally negative reputation, less because of its efficacy than its association with overuse in magazines and media imagery. But ignoring this, it's an effective tool.

The Airbrush tool can be used to enhance definition in an image by adding subtle highlights and shadows. Spray gently with white to create highlights, introduce shadow with black, and control the effect using the Brush Size, Opacity, and Flow options.

RIGHT: Brush Opacity

Each brush has been sampled at 100% Opacity and Flow in the first column; 50% Opacity and 100% Flow in the second; and 100% Opacity and 50% Flow in the final column, except for the Leaf tool which has been dragged along like a brush, rather than used as a stamp as in the sixth line. First was the round point brush with a size of 25 pixels; then the flat angle brush at 50 pixels; the wet sponge was sized at 55 pixels, and finally the chalk at nine pixels.

Column 1 Column 2 Column 3

ABOVE: Brush Options

On top of all of the other options, you can select your color and opacity, too. Still not enough choice? You can write your own brush preset or purchase one written by someone else.

This is the original image.

I selected the central walnut and painted it purple. Normal blend, 100% Opacity.

Normal blend, 50% Opacity.

Exclusion blend, 100% Opacity.

Hard Mix blend, 100% Opacity.

Vivid Light blend, 100% Opacity.

Saturation blend, 100% Opacity.

Dissolve blend, 67% Opacity.

The Liquify tool is *potentially* one of my favorite Photoshop functions. It's not that I use it a great deal, nor that I find it especially easy or intuitive to interact with—in fact I rarely use it and tend to get frustrated when I do. But I do love what it is capable of rendering. I enjoy being able to make things melt: molten walls, dripping furniture, and in the example that I've given here, gooey ice cream.

FINDING THE LIQUIFY TOOL

You will find the Liquify tool sitting directly under the Filter menu (*Filter > Liquify*). When you open it, it takes you to a new window where, in basic mode, you are presented with seven tools to modify your image: Forward Warp, Restore, Pucker, Bloat, Push Left, Hand, and Zoom. You can also adjust the size of the brush. The advanced mode includes Mask and Presentation options, some brush adjustments, and three further tools: Twirl, Freeze Mask, and Thaw Mask.

MANUALLY LIQUIFYING

There's a strong temptation when manually using the Liquify tool to push the limit a bit too far. Thankfully, the restore button makes it easy to undo your overzealous alterations without losing the changes that have actually worked. I think my effort to the left looks fairly natural.

Although I wanted to dribble a trail of vanilla down the side of the cone, that would have been more distortion than the pixels of the image could sustain and it would have resulted in an ugly mess. For the ice cream, it was preferable to work with a relatively large brush, about 200 pixels, and to use fairly short brush strokes. It was also important to remember that the ice cream wouldn't just drip downwards, but would expand and spread a little, too. Mostly, I used Forward Warp here, but the Twirl and Pinch tools also came into play to produce a slightly melted (but not by too much) ice cream.

Tool Options
Brush Size: 250
Brush Density: 50
Brush Pressure: 100
Brush Rate: 80
Stylus Pressure

AUTOMATICALLY LIQUIFYING

If you want to cheat with the Liquify tool,
it's entirely possible. Just click Command-F or
Control-F and the automatic Liquify mode will
magically melt your subjects for you. You can
compare my manually melted ice cream on the
opposite page with the Photoshop version above.

COLOR AFTER LIQUIFY

If you try to liquify an image to which you've already
made adjustments in the color files, such as Levels,
Curves, and Hue/Saturation, you'll be presented with a
plain white screen. Make those adjustments after you've
performed your liquefaction. You can, however, Crop
and Heal before liquifying.

A LIGHT TOUCH

Liquify isn't just for melting things. It can be
used to tweak the lines of an image slightly, as in
the image above where I used the tool to give my
brother the slightest hint of a smile, instead of the
look of intense concentration that was actually on
his face. Only the lightest of touches was needed as
too much and his smile began to resemble a Joker-
like grimace—really not a good look!

CHAPTER 5
AT THE TOUCH OF A BUTTON

Many editing packages come with a range of presets that allow you to transform your images so that they resemble something from outer space rather than planet earth. This chapter will look at what presets are available to you, as well as show you how to write your own.

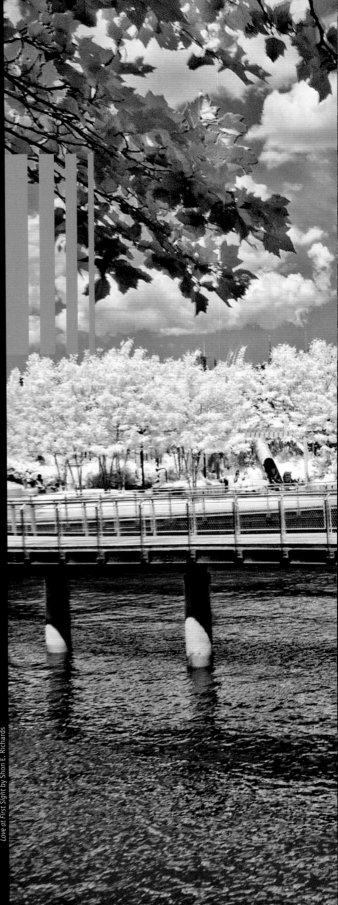

Love at First Sight by Shon E. Richards

The idea that you can press a button and apply a transformative filter to your images isn't something that has sprung fully formed from the minds of app developers or was even originally aimed specifically at smartphone photography. Open up Photoshop and you will find a dizzying array of filters that can pixelate your image in seven different styles, add 14 different fashions of blur, watercolorize it, spherize it, or texturize it—and that's just to start. Photoshop's alternatives also have their own catalogs of filters, and just like standalone filter apps for your phone, you can purchase filter apps for your desktop, too.

Furthermore, you can also make your life easier by using Presets and Actions, which are preprogrammed settings or series of actions that you can apply to your tools or images.

What you can achieve at the touch of a button is quite spectacular, especially if you have the vision to combine these preinstalled effects with your own edits.

Presets: Presets have thus far been mentioned briefly in connection with other software tools; they are basically ready-programmed settings for various tools. We previously saw how Photoshop has a vast selection of brush presets, and we touched on the idea that you can write your own if there are particular settings you find yourself using regularly, or import those written by other people. However, presets don't just apply to brushes or Fill Layers.

Filters: Filters make for a quick and easy way of transforming your images, but just as with the methods that we explored earlier in the book, they don't have to be used in isolation from your other editing tools and techniques. Using any filter as a part of your surreal-imaging armory will enormously expand the possibilities. Part of the fun of creating surreal images is exploring the options for yourself, but here are a few of my favorite filters to get you started!

Plastic Wrap
You could decide to cover your entire image with plastic using the Plastic Wrap filter (*Filter > Filter Gallery > Artistic > Plastic Wrap*), but by using the Magnetic Lasso to isolate the bird, I was able to apply the filter effect to the bird alone.

PRESET MANAGER: If you head to the Presets Manager (*Edit > Presets > Presets Manager*), you can select a preset from the drop-down menu fo any of the following tools: Brushes, Swatches, Gradients, Styles, Pattern Contours, Custom Shapes, and Tools

PRESETS: To each of these, you can thousands of other built-in selectio or load an imported selection. Prese are just another thing that Photosh allows you a vast degree of control o your image editing.

Frosted Glass

My condensation-covered wine glass takes on a different look when a Frosted Glass filter is applied over it. You can find the glass effects under *Filter > Filter Gallery > Distort > Glass*.

There's another drop-down box in the Glass menu that allows you to select from Blocks, Canvas, Frosted, or Tiny lens, and the Distortion, Smoothness, and Scaling sliders allow you control over the final impact of the effect.

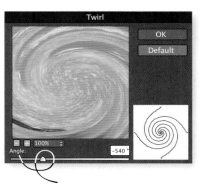

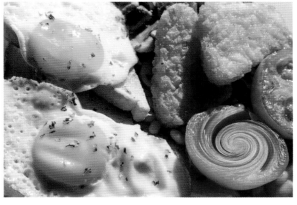

Twirl

By using the Magnetic Lasso to select the tomatoes and then applying the Twirl filter (*Filter > Distort > Twirl*), I've been able to transform my standard fried breakfast into something slightly more unusual. The angle slider at the bottom of the dialog box enables you to decide how tightly you wish the twirl to turn, and in which direction.

Solarize

The Solarize filter gives your images a peculiar lighting effect. You can find it under *Filter > Stylize > Solarize*. Unlike many of Photoshop's other filters, there is no control over its strength or impact. You hit the button and wait to see exactly how it will render your image!

Texture: There is a selection of different textures that you can apply to your images straight from the Filter Gallery: *Filter > Filter Gallery > Texture*, and then choose from Craquelure, Grain, Mosaic Tiles, Patchwork, Stained Glass, and Texturizer. Within the Texturizer option you can select from Brick, Burlap Sacking, Canvas, and Sandstone textures.

2a, b) I've kept the Scaling, which controls the size of the canvas weave, as small as possible and the Relief, which determines how thick the fibres of the canvas would be, relatively subtle. The more that you increase the Relief, the more obscured the original image becomes. If I wanted to I could ramp up both of those values and make it look unrealistic.

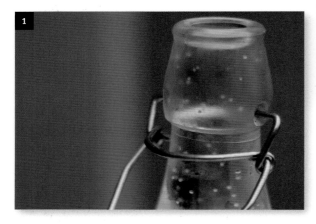

1) Each of the texture choices has a finer degree of control that you can exert; for example, the Craquelure option allows you to control the size of the space between the cracks, how deep the cracks run, and how bright they are.

However, if these options don't provide you with the texture that you want, some filter options allow you to import your own texture from a PSD file. When you've selected your filter, choose Load Texture from the dialog box and then load your texture of choice.

In my example, I've made it appear as if a bottle of water is backed on canvas.

3) It is of course perfectly possible to apply a texture to just a selection of an image. Here, I've isolated the water bottle and overlaid it with the Craquelure effect.

4) Furthermore, because I have applied the filter in a separate layer, I am able to control how the Filter layer blends with the original layer. This is what it looks like at 50% Opacity.

Blur: There is a catalog of different blur options sitting in Photoshop's Filter menu. You can help to bring a sense of movement to an image with the Motion Blur filter, soften and lighten highlights, darken and sharpen shadows with a Gaussian Blur, give the illusion of making a depression in something soft, create ripples in a pond with Radial Blur, or miniaturize an image with the Tilt-Shift blur filter.

1) Miniaturizing images with the Tilt-Shift blur filter usually works best when a scene has been shot from above: street scenes, valleys, and sports stadiums are favorites. Here, I've manipulated a photo of some chalk pavement art along with the boxes of chalk.

2a, b) The mechanism for adding a tilt-shift effect is similar to that of a graduated filter. There is the focus band, two bands on either side of that which are slightly out of focus, and the external stripes of blur. The bands of focus don't have to run parallel to the horizontal frames of the image; you can pivot them at will, as well as alter their position in the image. In this instance, they're running diagonally from the upper left corner to the lower right corner. The width of the bands can also be adjusted to determine how much is in focus and how much is blurred.

3) Use the Blur slider to control how blurry the blurred areas are, and the Distortion slider to choose the shape of the blur. If you push the distortion value to +100, it will give you linear blur; -100 creates a radially blurred effect.

 To give the image its finishing touches, I overbrightened it, upped the contrast, and over-saturated the colors. It all adds to the feel of unreality in the image.

In addition to filters, Photoshop also has Actions. At their simplest, Actions are shortcuts for editing processes that you undertake regularly. Photoshop comes with some Actions already installed, but you can also write your own and download those written by other people, either for free or for a small fee, to apply to your photos. If you find that you always perform a particular series of edits to every photo, for example increasing the contrast by 20% and the saturation by 5%, you might want to write an Action that will apply those particular changes to your photos with one click.

Actions are stored in the Actions panel (*Window > Actions*), and can also be accessed by pressing the arrow button beside the Histogram/Navigator panel. To apply an Action, select the one you want from the list and click the "Play" button at the bottom of the panel. That's it—your image should be sepia-toned, or have a vignette, or feature a wooden picture-frame effect.

The benefit of the Action tool is that it allows you to record a more complicated series of edits, too. Rather than having to individually render a cross-processed effect on every photo, once you've found a cross-processed look that works for you, you can write and record it as an Action, and apply it whenever you want with one click.

1a, b) To record your own Action, open the Actions panel (*Window > Actions*) and press the Create New Action button. It's at the bottom of the panel that resembles a turning page.

Name your Action, and then press the Record button.

2) Proceed to edit your image to create the effect you want. When you're finished, hit the Stop button on the Actions panel.

Now you'll have your very own action, ready to apply whenever you want it.

My cross-processing effect is slightly more subtle than Photoshop's, with gentler Curves and an altered overall contrast. I created it by adding a new layer and adjusting the image's Tonal Curves, moving the individual red, green, and blue channels as well as the RGB channel until I achieved the effect that I wanted.

In this case I reshaped the blue curve into an inverted "S" shape, pulling down the highlights and increasing the shadows. Both the red and green channels were reshaped into "S" curves, the red one steeper than the green. Finally, I tweaked the overall Contrast Curve by pushing up the highlights and pulling down the shadows. This wasn't an effect that just worked with the first few adjustments that I made. It was a case of trial and error, sometimes making bold alterations and at other times small adjustments, until I was satisfied with the look.

You might not like either cross-processing effect, but it always helps to have options that give you the chance to experiment and create your own.

TONAL CURVES

For more on Tonal Curves see page 51.

The Original Image

My Cross-processing

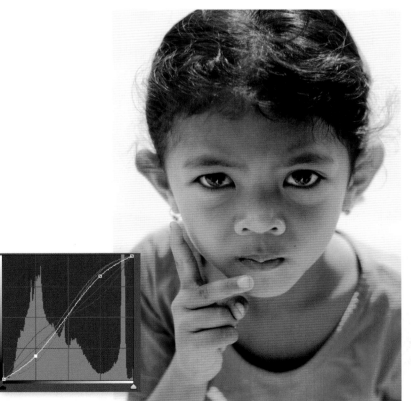

Photoshop's Cross-processing

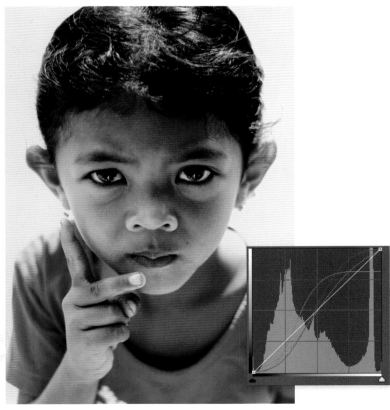

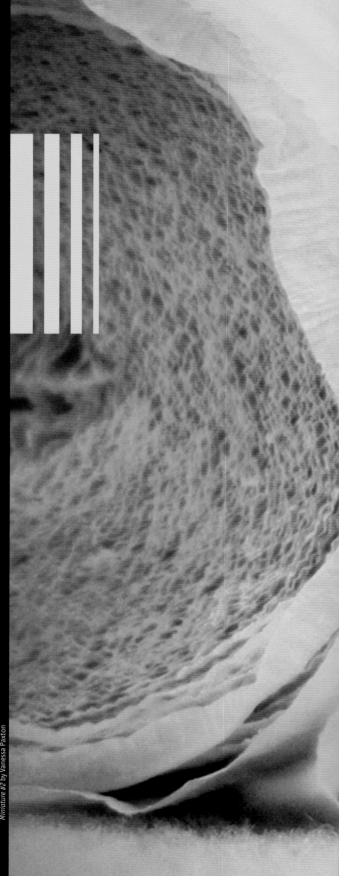

CHAPTER 6

A SURREAL GALLERY

In this gallery, some of the leading lights in surreal photography share their images and their techniques. Whether you are using an iPhone or a top-of-the-range DSLR along with the latest version of Photoshop, there will be something here to inspire and inform you.

Some images show the world we know from a new perspective, others transport you to a fantasy realm. There are dark and brooding creations as well as those bursting with energy and color. Enjoy!

Miniature #2 by Vanessa Paxton

Urban Vulture Tracy Munson

Urban Vulture was created entirely on an iPhone 5. Don't feel that it has to be either Instagram or Photoshop! The Apple app store is supersaturated with camera and photo-editing apps and most effects can be created with any number of different apps or techniques. I've tried about 200 apps in total, but in this walkthrough I use some of my favorites.

This photo of downtown skyscrapers had been bothering me for a while. I loved the warm light and the way that the buildings looked like they were made of gold, but I felt that the picture needed something else; it was a great background, but needed some other element to create interest. Distorting the buildings created a surreal feeling that I liked, and the effect reminded me of how buildings look when they are reflected on the tinted windows of a building opposite. I needed an element for the open space in the middle, so I began looking for the perfect centerpiece. I thought of balloons, people, objects—all sorts of things—but when I remembered the image I'd taken of a vulture, it seemed so fitting with the image of the business district and its gilded appearance that I knew I had to use it. I think of the vulture as a corporate scavenger, speeding through the golden city with talons outstretched to grab whatever it can.

PhotoGoo *TouchRetouch*

Juxtaposer *FocalLab*

Filterstorm *PicBoost*

1: THE BACKGROUND

1a) I started out with the drive-by shot of some skyscrapers in downtown Toronto. To make them look wavy and distorted, I used a free app called PhotoGoo.

1b) I dragged my finger across the screen to smear the image, and happy with the result, tapped the icon showing the arrow pointing to the right and saved the image to my Camera Roll.

2: LOSING DISTRACTIONS

2a) The power line running across the bottom of the shot was distracting. I used the TouchRetouch app set to the Brush tool to get rid of it. To use, tap on the Paintbrush icon and a slider will appear that allows you to adjust the brush size. Zoom into the image and begin to paint over the unwanted item until it is covered by a red mask, preferably in one pass. When you start to paint, a close-up window will pop up.

2b) Hit the triangle button on the bottom of the control panel, and *voilà*! The unwanted item has disappeared.

3: THE SECOND IMAGE

3a) The next element in my image was a photo that I took with my DSLR of a turkey vulture coming in to land on a lamppost. To remove the lamppost I used TouchRetouch again. This time, I was less impressed with the results when I used the Paintbrush tool; it filled in the tail area with a lot of sky, which just looked wrong. I needed to tell the app what to use to fill in the background.

3b) Instead, I used the Stamp tool, which is the option second from the right on the bottom toolbar. This tool brings up a double circle that you place over the part of the photo that you want to clone.

3c) I painted over the part of the image I wanted to remove, and it copied from the area where the cursor was sitting. I wasn't terribly fussy about the accuracy of this, because I knew that I would be adding more textures and effects later.

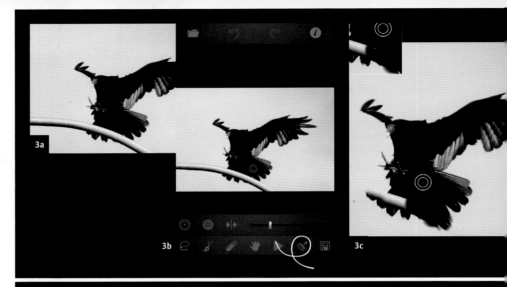

4: MERGING THE TWO IMAGES

I now needed to merge my images. For this, I turned to Juxtaposer, which is my favorite app for this type of image blending. I like how the Masking tool handles and being able to save the masked image as a stamp to use again is another nice feature.

4a) First I imported the background layer—the buildings—and then the top layer, the vulture.

4b) I selected the brush I wanted to use and zoomed into the image, then erased the sky from the top layer.

4c) I then maneuvered the bird into position, and saved.

4d) I also saved the masked top image (the vulture) as a stamp for use later on.

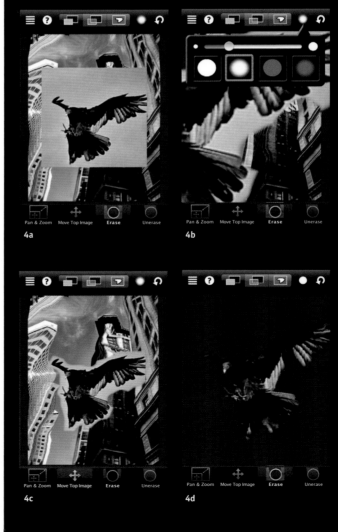

5: ZOOM BLUR

To add a zoom-blur-style effect and increase the sense of motion even further I turned to FocalLab.

I loaded the photo and selected the Zoom Blur option, which applies a blur effect, but leaves the center in focus.

I dragged two fingers around the image to adjust the focal point and the area where the zoom effect will radiate from. The amount of blur is adjustable via a slider—a very useful feature.

6: MAKING ADJUSTMENTS

I didn't want to leave the buildings blurred, because that would make it seem as if we were zooming toward the bird, and not the other way around. To blend the blurred image with the focused version, I used the Filterstorm app.

6a, b) I loaded the photo into the app and selected the button that resembles a sun. From the drop-down menu I selected Add Exposure, which then prompted me to select a second, sharp image to combine with the first from my Camera Roll. Using the Fit to Image function under the Double Exposure heading, the two images were aligned one on top of the other.

6c) I then used the Brush and Eraser tools to paint away the top image to reveal the lower one.

7: ADDING TEXTURE

Last of all, I needed to add some texture, which would also help to hide the low resolution and any sloppy areas of masking. I eventually chose a texture from PicBoost, after experimenting with a selection of apps and filters. It's really a case of trying on different looks until you find the one that fits. Apps like Pixlr-o-matic with their Randomize option can be a lifesaver when you're feeling creatively uninspired and unsure of where you want to go with your next edit.

8: FINALLY

At this point I realized that I didn't like this edit. There wasn't enough detail in the vulture and he was too low in the image. What can I say? I'm just not a "measure twice, cut once" kinda gal! I started again, repeating the same steps, and at last I got the effect I wanted.

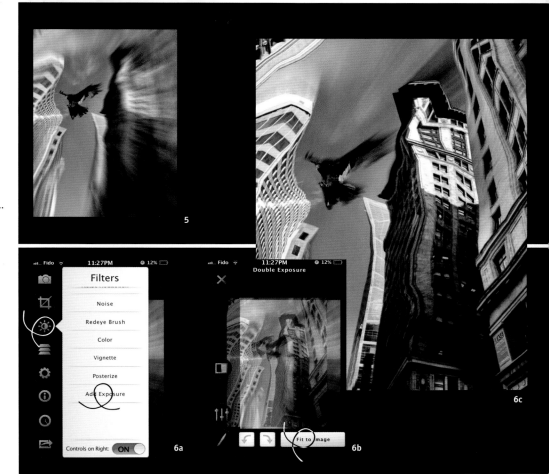

The final image

One Step & Then the Next Gets You Where You're Going Janine Graf

The day that I created *One Step & Then the Next Gets You Where You're Going*, I honestly did not have a preconceived final result in mind. Although my final effect was not a conscious choice to begin with, after running my chosen image through a particular iPhone app, I realized where I wanted to take the composition.

It was a beautiful day in downtown Seattle and this image of a woman walking across the street was one of many pictures I just randomly snapped.

I liked the lines and color of this accordion section (below right) from a metro bus, so I snapped the image in the hope that it would become useful some time, though obviously it's not too interesting on its own.

Whenever I can I like to take pictures of random scenes or objects with the idea that, manipulated in the right apps, you can deconstruct and then reconstruct them into something creative and interesting. Even the dullest of images can be manipulated in a wonderful way, so don't be too quick to discount a particular shot.

Tiny Planet Photos *ScratchCam FX*

Juxtaposer

1: FIRING UP TINY PLANET PHOTOS

I loaded the image of the metro bus accordion section into an app I like called Tiny Planet Photos and bumped up the resolution of the image to 2,000 pixels using the slider at the bottom of the screen.

2: CREATING A SWIRL

There are only two swirl options in Tiny Planet Photos: Sphere and Tube. To swirl this image in the way I wanted I selected the second option, Sphere, the button on the right.

Width and height of the transformed image (The larger the transformed image, the more processing time is required.)

2,000 pixels

1

Processing...
18%

2

3: KNOWING WHERE I WAS GOING

As soon as I saw the outcome of the swirl effect, I knew what direction I wanted to take the composition. I was happy with the result so I saved the image.

4: ERASING WITH JUXTAPOSER

4a, b) I decided to do my erasing with Juxtaposer. I loaded the Tiny Planet Photos-altered metro bus accordion image into Juxtaposer as the base layer, and set the streetscape as the upper image.

4c, 4d) After zooming in on the top image to make it easier to see what I was doing (you use a pinch-and-zoom action with your fingers to do this) and selecting an appropriate brush size to ensure that I made accurate adjustments, I started to erase the top image in order to isolate the pedestrian and her shadow. I use a Nomad Brush to help with this sort of detailed work. I highly recommend it; it's a paintbrush stylus that you can purchase online. I have the "Short Tip" series and find this tool invaluable.

Throughout the course of erasing I zoomed in and out many times in order to get into those tight places. Don't be afraid to zoom in or move the top layer around; you will be able to position your top layer perfectly when the time comes.

5: REPOSITIONING WITH JUXTAPOSER

Once I isolated the subject in my top image, I used the Pan & Zoom feature to bring the base image back to full size. Then I moved the top image into position, using the Move Top Image button, and adjusted it to the size I wanted. Satisfied, I saved the image to my Camera Roll.

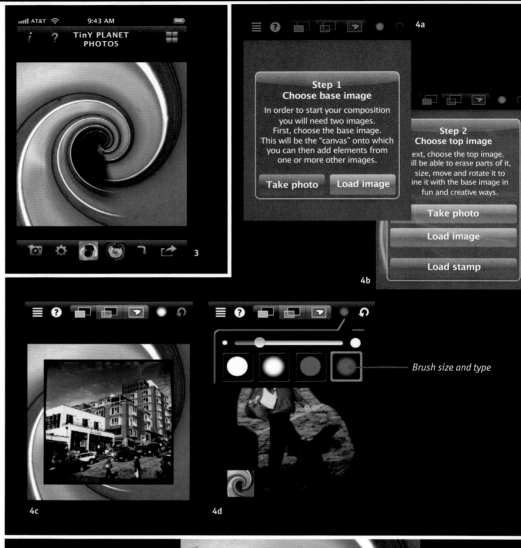

6: MOVING TO SCRATCHCAM

Next I turned to my favorite app for adding texture and color: ScratchCam. This app has an amazing assortment of effects that you can either randomly or selectively apply. I often start with random and then fine-tune the color and texture myself. If you hit upon a combination you like, you have the option to save that combination for future use.

I fired up ScratchCam and selected the Album icon to upload the saved image I had just finished in Juxtaposer. ScratchCam then immediately applied random color, texture, and scratches.

7: COLOR IN SCRATCHCAM

As I wanted to have some control over my color and texture, I selected the edit icon on the far bottom left and then selected colors. I scrolled through the colors until I found one I liked, which was coincidentally very close to the original image color. Using the slider bar on the top of the screen, I drew back on the color just a bit.

8: TEXTURE IN SCRATCHCAM

After selecting a color I was happy with, I moved on to texture. Using the Textures and Borders button, I scrolled through the available textures and borders and settled upon a texture that added a nice element of stone (you will see here that I used the slider bar at the top again to pull back the texture a bit). In this image I did not use any additional scratches from the Scratches section; that option/layer was turned off.

9: SAVING THE FINAL IMAGE

I saved my image by selecting the Edit option again and then the Send icon on the far bottom right of the screen. I chose to save my image to my album.

10: FINALLY

Here is the final piece. The inspiration for this image comes from my love of taking long walks—sometimes too long. Just when my feet and legs start to ache I chant to myself, "One step and then the next . . ."

The final image

Cashmere Amy Weber

Cashmere is based on a photograph of Ziggy Smalls, my miniature lionhead rabbit. He's very friendly and curious, and makes me smile. I love taking pictures of him and then compositing his image into different backgrounds before using different brushes and textures to add a whimsical touch. I also love the way his white fur contrasts with his surroundings.

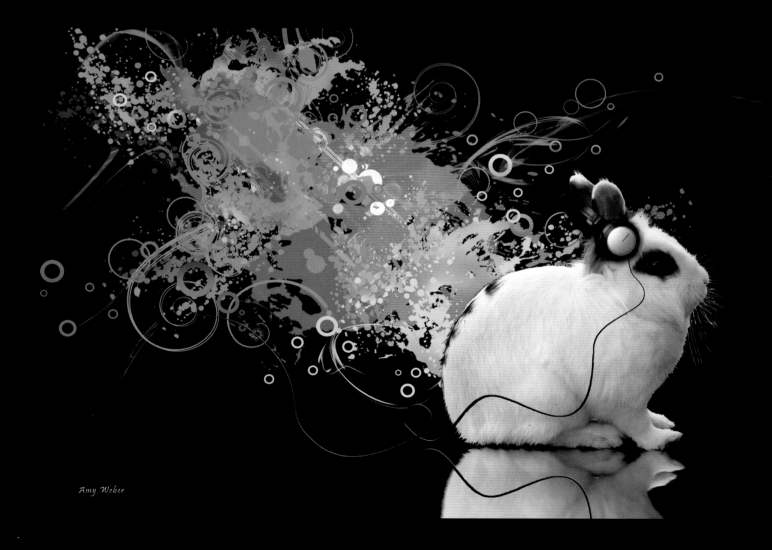

Amy Weber

BASE IMAGES

I wanted to start with an image that would look good when enlarged, so I had to pick a close-up with clarity and definition. The image also has personal significance because it is one of my favorites of my beloved pet.

TOOLS

Photoshop

1: PREPPING THE CANVAS

I created a new Photoshop document with a canvas size of 12 × 18 inches and opened up the image of Ziggy by selecting *File > Place*. In this instance, the image was opened as a Smart Object. Ensure that your Smart Object is fully editable and then name the layer.

2: SELECTING THE RABBIT

I zoomed in 200% and used the Pen tool to make an accurate selection around the outline of the rabbit. Remember, you will need patience for this step! You can select the entire bunny or work like I did, in sections.

1

2

3: LOADING THE SELECTION

Once I made my selections I opened the Paths palette and selected Load Path from the bottom of the palette. "Marching ants" indicate that a selection was made. I then deleted the background. Note that if you select the background in sections (as I did), you should hit delete. If you select the subject, invert your selection first and then hit delete.

3

4: ADDING THE HEADPHONES

I opened the image of the headphones and selected the headphones using the same technique I used to cut out Ziggy.

This time I needed to resize the image to fit the rabbit. Making sure that I was in the correct layer, I selected the Transform option (*Edit > Transform*) and resized the picture. By holding down the Shift key and clicking and dragging one of the corner anchor points, I retained the proportions of the image. To rotate the headphones, I simply hovered the mouse over one of the corners. The arrow turned into a curved arrow and gave me the option to rotate the image.

I erased the portion of the headphones that belonged behind the rabbit and merged the layers together by selecting *Layer > Merge Visible*. I was happy with my results, but if you think the contrast or Levels need to be altered to enhance your image, create a new Adjustment Layer and make your edits.

I renamed the layer with the headphones "BunnyHeadphones."

5: CREATING THE BLACK BACKGROUND

I created a new layer by selecting *Layer > New Layer*. I then changed my foreground color to black by clicking the small black-and-white icon next to the color swatches. I selected the Paint Bucket tool and filled the background with black by clicking on the canvas.

6: CASTING A REFLECTION

Next, I selected the rabbit and copied it to a new layer. I did this by CMD-clicking (CTRL-clicking on a Windows machine) on BunnyHeadphones in the Layers palette and then selecting the rabbit with *Edit > Copy*. I created a new layer, named it "Bunny Headphone Reflection" and pasted it to the new layer.

To lose the marching ants, I pressed CTRL-D (CMD-D on a Mac). Next, I chose the Bunny Headphones Reflection layer and went to *Edit > Transform > Flip Vertical*. I used the Move tool to position the rabbit, and the arrow keys to nudge him into place. From here, I placed a Gaussian Blur over the image by selecting *Filter > Blur > Gaussian Blur* and moved the Radius slider to about 4.0.

7: DRAWING THE HEADPHONE CORD

In a new layer, I went back to the Pen tool to start creating the cord for the headphones. I clicked and dragged to create a curved line that became the cord.

After I created my line, I went to the Brush tool and selected a hard round brush in a size 4. I made sure that my foreground color was set to black. I selected the Pen tool again, right-clicked on the line, and selected Stroke Path from the drop-down menu. I made sure that the Brush tool was selected and clicked OK.

8: ADDING A LIGHT SOURCE

To add shading to the cord, I double-clicked on the Headphone Cord layer and the Layer Style dialog box appeared. I checked the Bevel and Emboss box and turned up both the Opacity and the Fill Opacity to 100%.

Next, I copied and pasted the cord to a new layer, and just as I did in step 6, created a reflection for it.

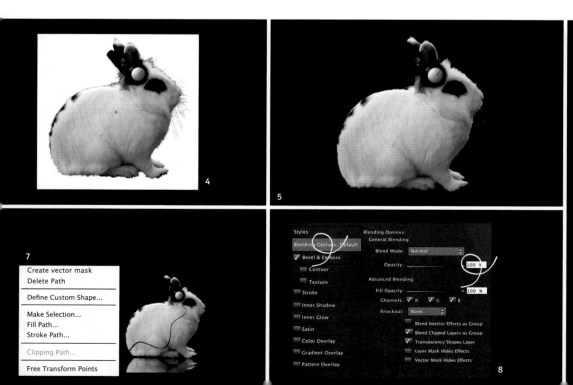

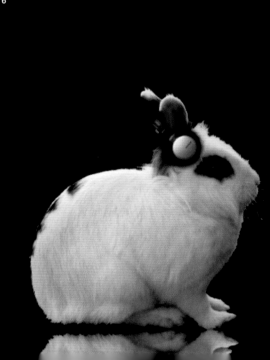

9: ADDING SPLATTERS

I downloaded a selection of splatters from cgtextures.com to bring interest to the background, then copied and pasted the largest of the splatters into a new layer.

I began to customize the splatter by selecting *Edit > Transform > Scale* and resizing and reshaping it.

Next, I removed the white background behind the splatters by selecting the Magic Eraser tool and zoomed in closer to remove the small white areas within the splatter. I selected the splatter itself by CTRL-clicking (the equivalent command on a Mac is CMD-click) on the icon of the splatter in the Layers palette, and used my brush to add color.

I varied the opacity and color of the brush and continued to add more layers of splatters to make it interesting. I ensured each splatter was on a different layer so they could be edited independently.

Finally, I clicked and dragged the splatter layers so they were underneath the layer containing the rabbit.

10: ADDING SHAPES

From within the Custom Shape tool, I selected the Circle Frame. This is in the drop-down menu on the Options bar, toward the right. I began by creating circles of different sizes, each on a new layer.

To create a gradient for some of the circles, double-click on the layer, which will bring up the Layer Style dialog box. Select the Gradient Overlay option and make your selections.

..

11: BRUSHSTROKES

Photoshop has a huge range of brushes, and you can create your own brush presets. If you can't find or make something that meets your needs, head over to brusheezy.com, where you can download many more options.

Select the Brush tool, and if you've acquired some preset brushes, go to the Preset Manager to import them (*Edit > Presets > Preset Manager*). You will then be able to access your new brushes from the brushes palette. As you add brush strokes to the image, don't forget to create a new layer for each brush.

For this image I selected brushes that gave the impression of movement and imitated streams of light. After downloading the brushes, I created a new layer and set the foreground color.

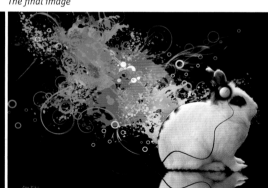

The final image

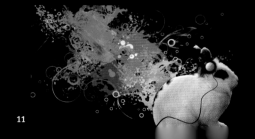

Wingardium Leviosa Megan Wilson

The choice of title is inspired by the *Harry Potter* series, as in the books, "wingardium leviosa"* is the spell of levitation. At the same time, the teacup and saucer remind the viewer of *Alice in Wonderland*. These stories inspired me to create something that was both interesting to look at and exhibits the whimsical feeling that the books represent.

Creating a levitation effect isn't as hard as you might imagine. It all starts with your initial shoot. Once you have planned what you are shooting and where, you need to set up the shot to optimize the levitation effect later.

Since I knew I would be making a series of photographs and blending them together, I purposely shot in manual mode to ensure consistent focus and exposure across my series of images. Using a tripod was also necessary to enable me to shoot from the same position for every frame. This made the photos more straightforward to process.

When I created this piece I took four photos. Two of them were of me holding up the saucer and the teacup, the third was of my hand reaching out, and the fourth was simply the background.

Using Photoshop, I navigated to the Lasso tool and cut out the teacup, the saucer, and my hand. The trick to the levitation effect is the blending of multiple images. Using the background image as my base, I layered and blended the other three photos on top and removed the unwanted areas (such as my hand holding the teacup and saucer), and then used the Clone tool to fill in the missing fragments. When removing unwanted areas or using the Clone tool, I find a soft brush will help blend the photos together and avoid sharp, jagged edges that end up looking distracting.

When I was satisfied with my image blending, I continued to process the composite by adjusting the color and lighting. Finally, *Wingardium Leviosa* was a complete creation!

Wingardium Leviosa was inspired by *Alice in Wonderland*, and the mystery and magic of J.K. Rowling's *Harry Potter* series.

* The phrase "wingardium leviosa" is a quotation from J.K. Rowling's *Harry Potter* series, first introduced in *Harry Potter and the Philosopher's Stone* (published in some countries as *Harry Potter and the Sorcerer's Stone*).

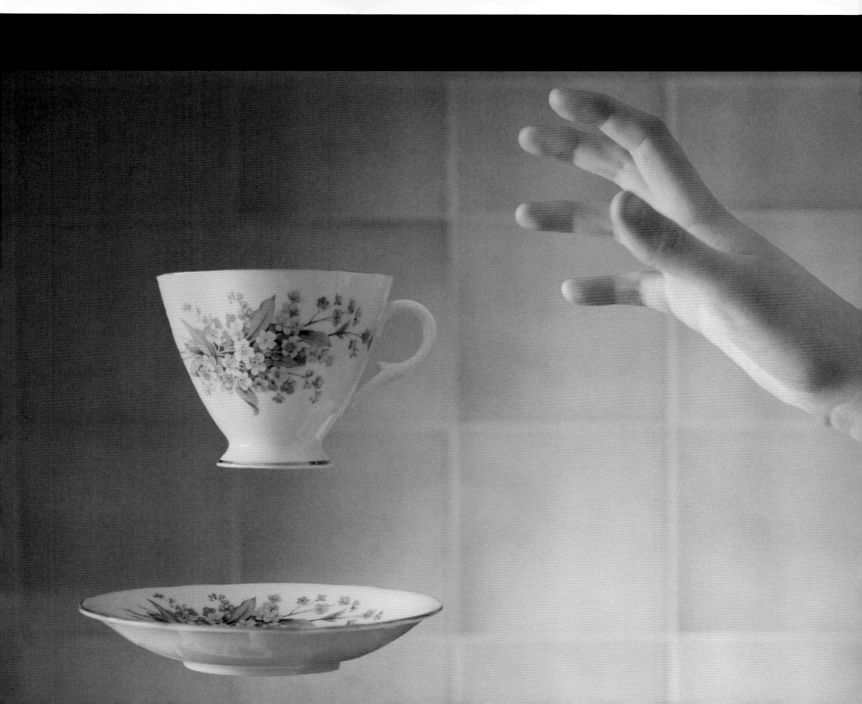

The Weight of Time Julie de Waroquier

My ideas come to me spontaneously, with the compositions appearing clearly preformed in my mind. However, to make sure that an idea that occurs to me has the potential to become a real picture, I usually draw a sketch of my vision. It tends to highlight any possible issues that I might encounter on a photoshoot, and so is a useful tool to help compose the whole picture.

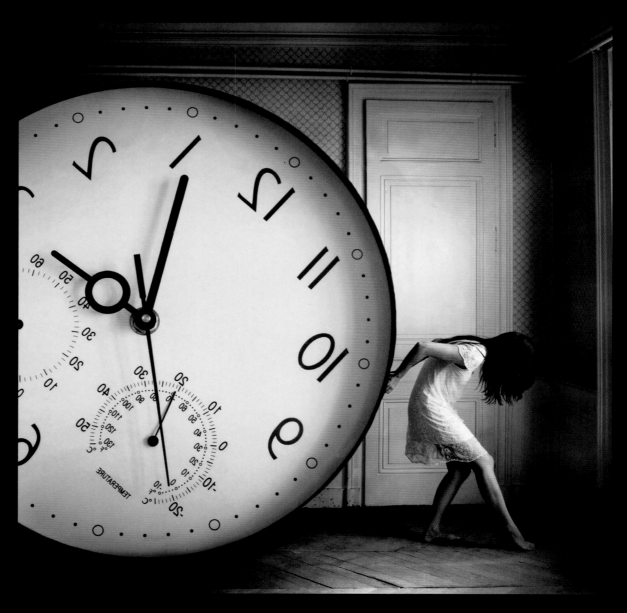

These images were taken specifically for this project using my Nikon D700. I chose a room with a high ceiling as a location, which would allow me to insert an over-large clock into the final composition.

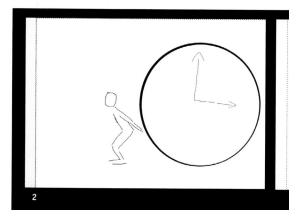

GIMP

1: DRAW A SKETCH OF THE IDEA

For this picture, the concept was quite simple; the weight of time, symbolized by a huge clock, is about to crush the female subject.

2: MAKE SURE THAT THE COMPOSITION WORKS

If you choose to sketch beforehand, your sketch doesn't have to be detailed; for this picture I drew mine quickly using GIMP. It was helpful because I realized that the composition was more effective with the character on the right side. This accentuated the weight of the clock, and the clock hands following the lines of the character made it look more dynamic. The goal of this step is to ensure that the picture works as a whole, and can be read and understood easily.

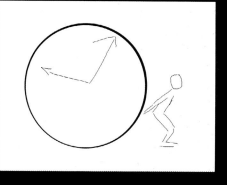

2

3: LIGHTING

I decided to use the natural light coming through the window. This kind of lateral lighting creates nice contrasts and remains soft, so it is perfect for complex compositions. The more complicated your composition, the less complicated your lighting should be in order to have a picture that works.

3

4: SETTINGS AND ANGLE

I wanted an overall view of the room, because seeing the walls from top to bottom and from the corners of the room would accentuate the huge size of the clock. Therefore, I used an 18–55mm lens at 18mm, giving me a wide angle and including the entire room in the frame. I chose neutral settings (an aperture of ƒ/3.5 and a shutter speed of 1/60 second as seen in the below histogram), because I didn't want anything unusual in the exposure.

5: THE IMAGE OF THE CHARACTER

As I don't in reality own a gigantic clock, I needed to manipulate a series of images to achieve my desired final result. First, I took a picture of myself standing as if I were holding the clock. I used a tripod and the self-timer on my camera, and simply posed in front of it.

At this stage in the process, you can't be certain that the photomontage will work, because you can only imagine the final version, not actually see it. In this instance, what I was trying to achieve worked, but sometimes during the editing process you will realize that the combination you have doesn't fit, and you'll need to reshoot your base images.

6: THE PICTURE OF THE CLOCK

Next, I photographed the clock. When you create a composite like this using several pictures, try to keep the same settings, lighting, and location to help the final image look coherent.

In this case I did, however, move closer to the clock so that it wouldn't appear too small or far away in the base image. I also turned it around so that it would be pointing the direction I wanted it in the final image.

7: COMBINING THE IMAGES

Then, I began the editing process. First, I combined the two images into one. Using GIMP, I opened one as the background picture and the second in a new layer (*File > Open as new layer*). I now had one file with two layers that I could move using the Move tool.

8: USING LAYERS AND LAYER MASKS

In order to position the different elements of the image where I wanted them, I had to move the layers around. In this instance, I moved the clock to the right-hand side. Changing the opacity of the layers helped me to see things better. When I was satisfied with the position of the elements, I added a layer mask by right-clicking on the layer and selecting Add a Layer Mask, in black. This hid the layer picture and added a black box next to the thumbnail of the layer.

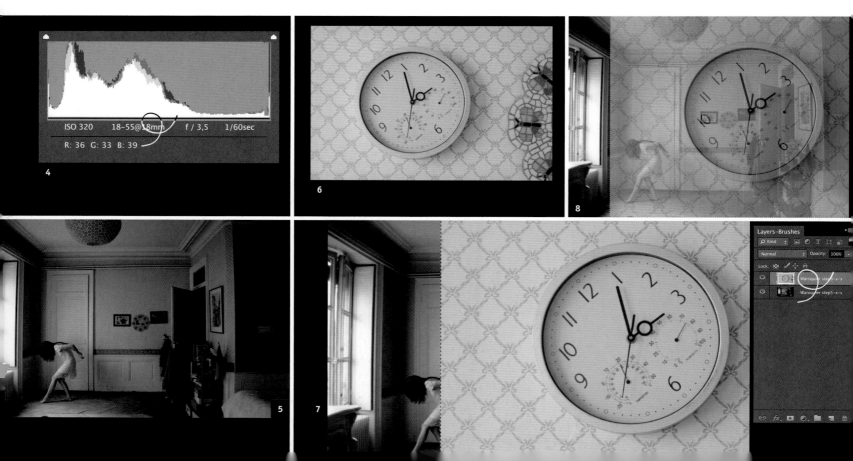

9: CUTTING OUT

Note that the Layer Mask indicates which parts of the layer will be visible in the final image. When it is all black, nothing will be visible. By painting over the mask with a white brush, you will reveal parts of the layer in the final version. For my image I used the white brush to reveal the clock.

10: MORE ACCURATE CUTTING OUT

At first I used a large brush, which isn't very precise. I zoomed in closer and chose a smaller brush to refine my selection. Remember that if you accidentally reveal too much when you're cutting out, you can paint over the area with black to hide it again.

11: ADDING SHADOW

However accurate your cutting out is, the effect will never look natural without shadows. For this image, I needed to add a shadow to the giant clock. I added a new layer (*Layer > New Layer*) and selected a black brush. I then reduced the opacity and painted the shadow in beneath the clock. Rather than using the Normal blending mode on this new layer, I chose Multiply, which inlays the black into the picture. I added the shadow in several layers to produce a more realistic look.

12: THE FINAL COMPOSITION

When I completed the cut-out, I took an overall view of the image that allowed me to make my final adjustments. On reflection, I decided to crop the image and flip it on its vertical axis.

13: COLOR EDITING

My final step was to edit the color. I used the Curves tool (*Colors > Curves*), which allowed me to adjust the colors in the highlights and shadows. In general I find that the best way to achieve the effect that I want is to play around with the different red, green, and blue channels. In this instance, I added vintage greenish and yellow hues. I really liked the strange, atmospheric quality this gave my final image.

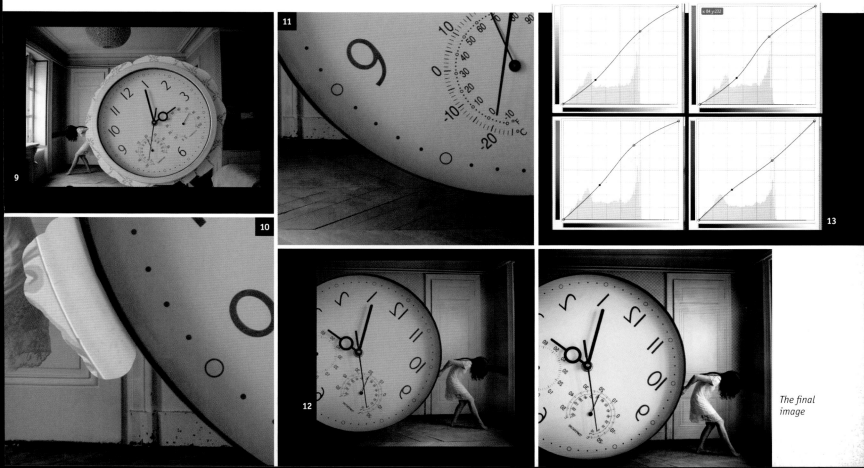

The final image

Miniature #2 Vanessa Paxton

The concept behind this image was simple: a miniature girl in a normal-sized world. I thought that it would be interesting to use photography to bring to life the story of *Thumbelina* with some images inspired by the concept. This image comes from a series of seven; for each one I photographed myself in the same location as the scene I'd later be inserting myself into. I did this so that the lighting conditions for my character and the background images would be the same. Keeping the lighting conditions the same is key if you don't want your figure to look out of place in your compositions.

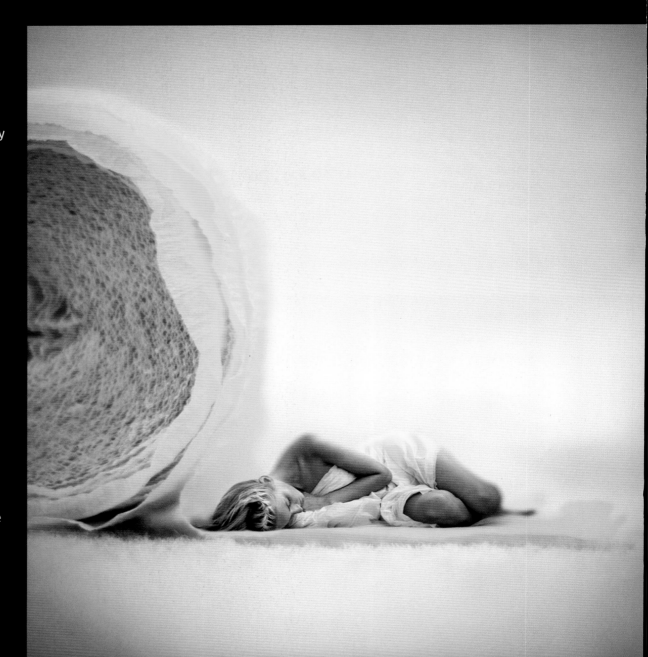

I chose to shoot these particular images in my bedroom because of the large amount of natural light it gets. I knew that I wanted to interact with an object in the environment because it makes the images more believable, but it didn't really matter what the object was. I chose a yellow party streamer to form the background because I had a matching yellow tablecloth that I could wrap myself in for the self-portrait.

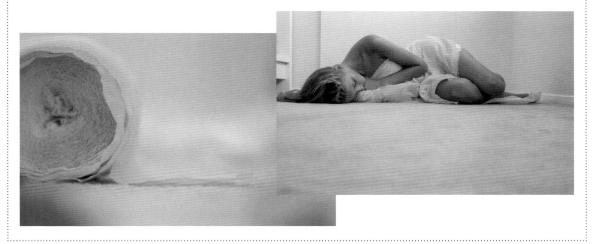

Photoshop

1: IMPORT YOUR IMAGES

I imported both the scene and the images of the character into Photoshop, set the scene as the background image, and saved the image that contained the figure as Layer 1.

2: SCALING THE SCENE

I then dragged the image of the figure into the scene and brought up the Transform tool (*Edit > Transform*).

2a) I scaled the image to 50% of its original size by changing the Width and Height values in the Options bar indicated by the "W" and "H."

2b) Next, I changed the opacity in the Layers panel to 65% so that the background layer was visible through the layer containing the figure. This made it easier to position accurately. I then double-clicked to lock in the transformation when I had the figure about the right size and in the right location, and set the opacity back to 100%.

3: CREATING A LAYER MASK

The next step was to click on the Layer Mask icon to create a Layer Mask over Layer 1.

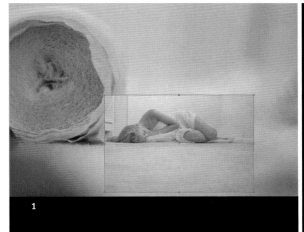

1

3

2a W: 50% H: 50%

2b

4: SELECTING THE FIGURE

4a) Using the Magnetic Lasso tool, I outlined the figure.

4b) Once I completed my selection, it was surrounded by marching ants. I then chose *Select > Inverse* to invert the selection.

I converted the Layer Mask to black (CMD-I on a Mac machine, and CTRL- I on a Windows machine). Refining my selection by painting with black or white on the Layer Mask revealed or concealed more of the scene image.

4c) The end result looked like this.

5: CROPPING THE IMAGE

When I was satisfied that the figure was in the right place and that the cut-out was refined enough, I cropped the entire image by selecting the Crop tool from the Tool bar. For all my images in this series I used a square crop.

6: CONTRAST AND BRIGHTENING

I was happy with my image so far, so I flattened the layers (*Layer > Flatten Image)*, and then duplicated the background layer (*Layer > Duplicate Layer*).

6a) I created a new Levels Adjustment Layer (*Layer > New Adjustment Layer > Levels*) and clipped it to the Background copy layer (to do this ALT- click between the two layers in the Layers panel). I moved the black slider to the right to darken the image, and moved the white slider to the left, lightening the highlights.

I felt that this particular image needed to be brightened, so on the Output Levels I moved the blacks pointer inwards until I was happy with the look.

6b) I then created a new Brightness/Contrast Adjustment Layer above the Levels layer (*Layer > New Adjustment Layer > Brightness/Contrast*) to brighten the image, and moved the Brightness slider to the right.

When I was content with my adjustments, I merged the layers together by selecting *Layer > Flatten Image* and once more duplicated the background image to make a new layer.

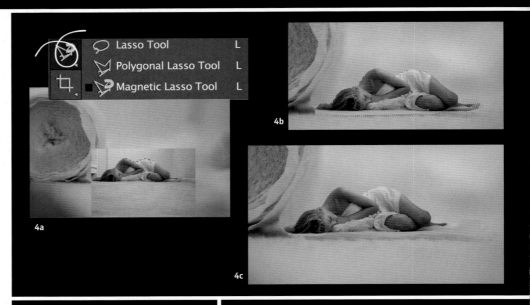

Lasso Tool L
Polygonal Lasso Tool L
Magnetic Lasso Tool L

4a

4b

4c

Crop Tool
Slice Tool
Slice Select Tool

5

RESIZE WITH SCALE

You can resize the figure whenever you need to by selecting *Edit > Transform > Scale*.

Properties

Levels

Preset: Custom

RGB Auto

32 1.00 221

Output Levels: 30 255

6a

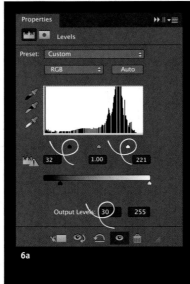

6b

ADJUSTMENTS
Brightness/Contrast

Brightness: 27

Contrast: 0

Use Legacy

7: APPLYING SOME LENS BLUR

I wanted to apply some lens blur to simulate a fall-off of focus, so I chose the Lens Blur option by going to *Filter > Blur > Lens Blur* and applied a touch of Radial Blur to the background.

I also added some noise, because I think that a little bit makes edited images look more natural.

..

8: CREATING A VIGNETTE

I flattened the image again and then made a new layer (*Layer > New Layer*). I selected the Soft Light mode from the Options bar.

I set the Opacity to 20% and used a white brush to highlight the character's hair and lighten the image. This helped to create a vignette that draws in the viewer.

I then intensifed the vignette by switching to a black brush and painting the edges of the image.

..

9: FINE-TUNING

On reflection, the red blur from another streamer disrupted the harmony of the image. I removed it by duplicating the background layer and then selecting the Selective Color option, under *Image > Adjustments > Selective Color*.

9a) It so happened that the default color was red, which was the color I needed to remove. I reduced the reds in the image and brought in as much yellow as possible.

9b) Next, I adjusted the color balance by choosing *Image > Adjustments > Color Balance*. Here, I selected the mid-tones option first and used it to bring back more yellows; I did the same with the highlights option.

9c) As you can see, this affected the color balance of the entire image.

9d) This isn't what I wanted, so I applied a Layer Mask, inverted it, and then painted with white to reveal just the bottom left corner. This meant that the selective color adjustment applied to just that too-red area, not the entire image.

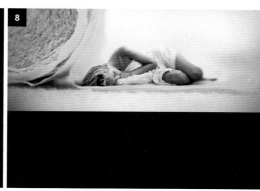

CLIPPING MASKS

You can read more about clipping masks on pages 62–63.

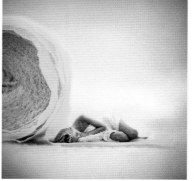

The final image

Relax Maria Kaimaki

An infrared (IR) filter is a powerful tool that can serve as a window to the alternative reality of a parallel world. If photography is about painting with light, then IR photography is about painting with invisible light.

It isn't just an IR filter that can transform an ordinary scene into a surreal one. Sometimes it can be something indefineable about a place that lends itself to this interpretation.

This tree stands right in the middle of nowhere, on the side of a narrow, winding country road that leads to an almost-forgotten little village. The place itself seems, in a way, out of time and out of place. It has its own life, and its own seasons. It is very different from the rest of the countryside around it. When you are sitting there alone with your thoughts no disturbance from the world will reach you since there is no cellphone signal and traffic is sparse.

IR photography is not for snap-shooters; it requires time and patience to set up your shot. In this instance I made sure to visit the location when it was flooded with bright sunlight and the texture of the tree's foliage was well-illuminated. I set a custom white balance on my camera by shooting a patch of well-lit grass and calibrating my camera to recognize green as IR white. I composed my frame carefully with my camera on a tripod and also took a shot without the filter, which I planned to later combine with the IR image. I then locked the focus—important, as the camera cannot focus through the dark filter—and mounted the filter.

It took a couple of test shots to find the correct exposure, which turned out to be an aperture of $f/13$, a shutter speed of 1.3 seconds, and a sensitivity of ISO 200, and a short wait, too, for that serendipitous cloud to enter my frame, but basically that was all there was to it.

When I looked at my LCD screen, the leafy green tree in front of me seemed gilded with snow. In post-production I added a few finishing touches. I swapped the blue and red channels, which is common procedure with IR images, and used the normal image to mask over the bench to retain its natural bright color.

This place has always been very special to me, but conventional photography had never seemed capable of capturing its quiet beauty. When I encountered IR filters I thought that this was the only fitting way to capture the unreal quality of this place.

Autumn Mood Gwladys Rose

I was inspired to create this surreal image while looking at a self-portrait where my mood seemed melancholy. I started to visualize an image that expressed an autumnal mood. Fall is my favorite season because it offers such a variation in color, particularly warm colors. The way I was dressed in the self-portrait seemed to fit with this idea, exactly suiting a crisp fall day. To me, a surreal scene is a scene that shows you something in a context that you wouldn't usually expect. To achieve that perspective in this image I decided to find a slightly different location that would also reinforce the melancholy mood of the picture. I settled on the idea of a desert, and after a lot of searching found the perfect location in a

I prefer to use my own images for my work; it allows me to feel as if I'm the ultimate creator. Some of these were archived images while others I took specifically for this project.

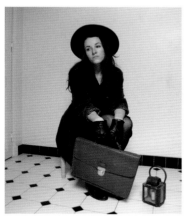

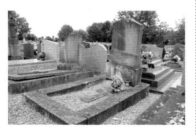

Photoshop

Wacom Tablet (Intuos 4m)

1: CREATING THE DOCUMENT

I opened Photoshop and created a new document. I often use a square format, but for this picture I made a document 4,100 pixels wide by 4,000 pixels high with a density of 600 ppi (pixels per inch).

1

2: THE GROUND

I respect a ritual for my images, and always create the landscape (inclusive of the ground and sky) first. I imported the image of the ground (*File > Import*), and renamed this layer from "Layer 1" to "Ground." This helped me to instantly identify the ground layer as the number of layers comprising the image grew.

Using the Transform tool (*Edit > Transform*), I adjusted the image's height a touch.

2

Autumn Mood Gwladys Rose

3: THE SKY

After I settled the ground, I imported the sky. I followed the same process as for the ground, but renamed this layer "Sky."

4: BREAKING THE HORIZON

Looking at the landscape, the horizon felt too linear, too straight, and I decided that I needed to introduce a break in the blandness. Luckily, I had also photographed a dune while I was exploring the quarry where I took my base images.

I made a Quick Selection of the dune and refined the selection by deleting the unwanted background and using the Rectangular Marquee tool.

5: ADJUSTING THE BRIGHTNESS AND COLOR

5a) The dune was standing out too much from the rest of the background; I needed to correct its brightness and color to help everything work together. I named the new layer "Dune," created a Brightness/Contrast Adjustment Layer (*Layer > New Adjustment Layer > Brightness/Contrast*), and corrected the brightness there.

5b) Next, I made a Color Balance Adjustment Layer to control the color balance. I experimented with the tools until I found a color combination that worked.

3

4

5a

5b

6: MERGING THE GROUND LAYERS

When I was satisfied with the look of the landscape, I merged together the dune and ground layers by selecting them and then choosing *Layer > Merge Visible*. Before I merged the layers I ensured that there were no unwanted elements, such as trees, reappearing in the layers. Sometimes when you are superimposing images and merging layers, previously hidden things can pop back up. In this instance, there were some rogue trees. I selected them using the Rectangular Marquee tool, then deleted them and continued with the merge.

7: ADJUSTING THE CONTRAST

I decided that the contrast needed to be increased, so I gave it a quick tweak upwards.

8: ADDING THE PROTAGONIST

When I was satisfied with my landscape, I went ahead and added my character, my portrait of myself.

I selected the figure using the Quick Selection tool, copied the selected area, and then pasted it onto the landscape.

This selection needed to be refined; I did this by using the Eraser tool (set to 30 pixels) along with my graphics tablet. If you don't have a tablet, your mouse will do fine.

CUTTING OUT

Photoshop offers you a huge choice of methods for cutting out elements of images and refining them; we looked at some in Chapter 5: At the Touch of a Button. Use the method that you find the most comfortable and works best with the element you're cutting out.

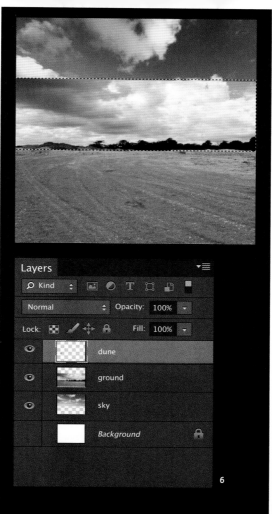

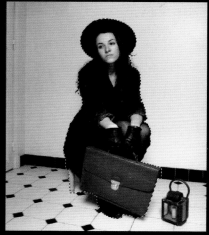

9: CREATING A SHADOW

I painted in a shadow to make the image of the protagonist more realistic and prevent the composite from looking obvious. As there was no particular light source in this image, I decided to paint the shadow beneath and slightly behind the chair.

I selected the Brush tool with a 100% black foreground color, 30% Opacity, and a round brush with a diameter of 100 pixels. Again, I used my tablet to draw the shadow, but you could use a mouse if you don't work with a tablet.

10: ADDITIONAL HAIR

10a) I wanted to create some movement in the character's hair, and did so by introducing some locks from a photograph of a wig. I used the Quick Selection tool to cut out some extra hair, and then copied and pasted it into place on a new layer.

10b) You can see that the extra hair does not match the color of my hair in the self-portrait. To make it match, I used the Color Balance tool (*Image > Adjustments > Color Balance*) and raised the levels of red. I also cleaned up the selection using the Eraser tool.

10c) To create the impression of a moving head of hair, I duplicated the layer several times and modified the look of the hair with the Warp tool (*Edit > Transform > Warp*). When I was satisfied, I merged the modified-hair layers with the layer containing the character.

11: DISTORTING THE SKY

11a) I felt that the sky looked far too realistic for a surreal image, so I decided to distort it. I duplicated the sky layer and then used the Liquify tool (*Filter > Liquify*) to adjust it.

11b) To introduce some clouds I used the Clone Stamp tool.

I duplicated and deleted clouds until I had the result that I wanted.

11c) Then I increased the contrast to make the sky more impressive.

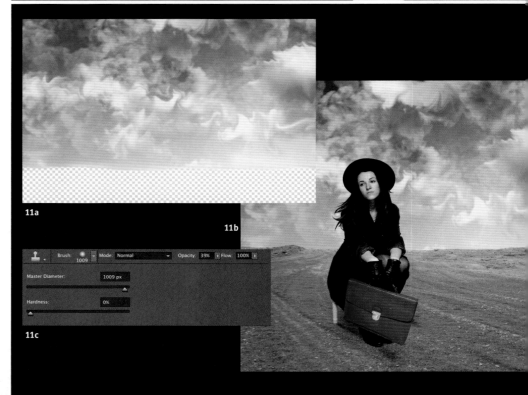

12: THE LEAFLESS TREE

To introduce the leafless tree to the scene, I opened the document containing the tree, selected it using the Quick Selection tool, and then pasted it into my scene. As the selection was initially very rough, I spent quite some time refining it with the Quick Mask tool and my graphics tablet.

I wanted this tree to be as surreal as it possibly could be. First, as it looked far too blue, I worked with the Color Balance tool to desaturate it, and warm up its shade. I also duplicated the layer it was on, rotating it to add some more branches.

Finally, I created the hand-like branches by duplicating one of its extremities and drawing a shadow at its base.

...

13: THE ABANDONED GRAVES

By adding some gravestones I was able to fill the empty gap on the right side of the image as well as enhance the melancholy mood.

13a) I opened up an image of a cemetery and began to select some of its elements.

13b) I selected only the front of this grave and deliberately excluded the door before I pasted it into my scene. I love the idea of open doors in the middle of nowhere.

13c) I reduced the size of the door using the Transform tool before erasing a small portion of the bottom left corner with the Erase tool and rotating it, again using the Transform tool, so that it gave the impression of sinking into the ground.

Using the Color Balance tool, I increased the red and yellow tones so that it blended better with the sandy ground.

I followed the same process to add the other graves.

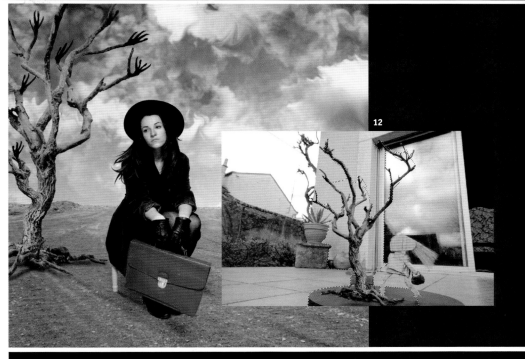

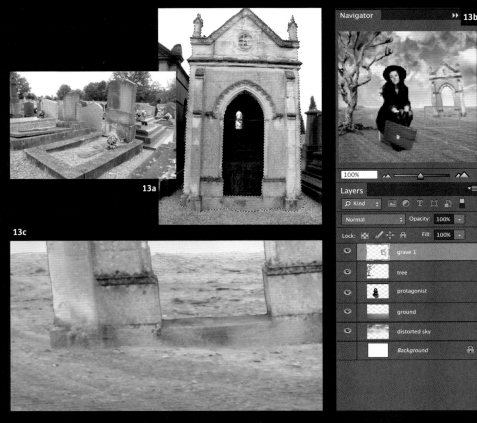

14: THE RED APPLES

14a) I liked the subtle wrongness of the idea of a dead tree with apples hanging from it and windfalls at its roots. To create this part of the scene I went to the market, bought the reddest apple that I could find, and photographed it.

14b) I then used my tablet, together with a round-head brush set to a small diameter and weak opacity, to draw some black strings from which to hang the

apples. As I did not want to decorate the tree too much, I only hung three apples from it, but I decided to scatter some at the roots of the tree.

14c) I created shadows for the apples, just as I did with the protagonist. I chose the Drop Shadow effect from the Blending options in the Layer Style menu (*Layer > Layer Style > Drop Shadow*). When you do this, make sure to zoom in close and focus on the element that you want to blend.

14d) These shadows did not really satisfy me, so I created some additional shadows on a new layer called "Shadow Apples." I drew these on using the Brush tool.

When I was finally happy with the apples and their shadows, I merged together all of the apple layers and called this layer "Apples at Roots."

PLAIN BACKGROUND

If you are photographing items to be cut out and inserted into a composite, use a plain black or plain white background. It will make the selection process far easier.

BACK UP

Don't forget, you can always step backwards and try different edits and different combinations of effects until you achieve the look that you want.

14a

14b

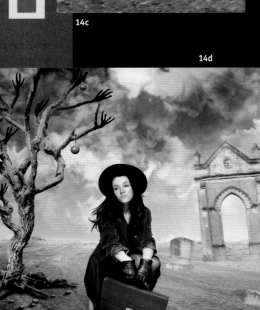

14c

14d

15: MOVEMENT OF THE SAND

Looking over my image I decided that it was lacking in movement, especially in the area of the sand. I rectified this by creating the impression of wind trails in the sand.

First, I used the Eyedropper tool to select a shade from the sand. With a light, round brush set to an opacity of 30%, a size of 450 pixels, and the color I had selected, I drew some trails moving from the left background to the right foreground. I strengthened the sense of movement by adding some Gaussian Blur (*Filter > Blur > Gaussian Blur*).

..

16: THE FINAL ADJUSTMENTS

All of the elements that I wanted to include in my picture were now in place, so I took a good look at it to consider my final adjustments.

First of all, I chose to add some light to the coat, to enhance the look of the velvet. On a new layer I selected a white brush, Overlay mode, an opacity of 48%, and a diameter of 131 pixels. Being careful not to paint over the protagonist's hair or anything else, I covered the coat and gloves.

16a) When it came to the suitcase, I created a new layer, selected the Soft Light mode, chose a red color in the Foreground Color box, and brushed over it just as I did the coat and gloves.

16b) I also adjusted the image's hue and saturation levels as well as its brightness and contrast, and applied a warming filter (*Image > Adjustments > Photo Filter*) over the protagonist. I further adjusted the contrast of the image by creating a new layer set to Soft Light mode, selecting black as my foreground color, and a brush with an opacity of 25%. I painted where I felt the image needed more contrast.

16c) You should always step away from your work for a while before deciding that the image is final. At this point, I took a break to rest my eyes and returned later, refreshed, to make my final adjustments. In particular, I cleaned up any small errors using the Eraser tool or the Clone Stamp tool. Before merging everything I saved the composition with all the layers visible, in case I needed to make any amendments in the future. I gave the contrast a quick tweak, and I was done.

The final image

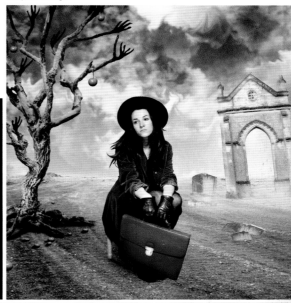

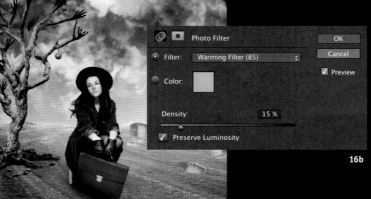

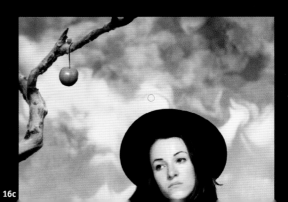

Wind Adrian Sommeling

The idea for this photo came about when I was
out walking with my son. It was a tremendously
windy day and he could barely stand up, but at
the same time he found it great fun. A seed of
thought began germinating, and before long I
found myself shooting an entire series of photos
to create the final composite.

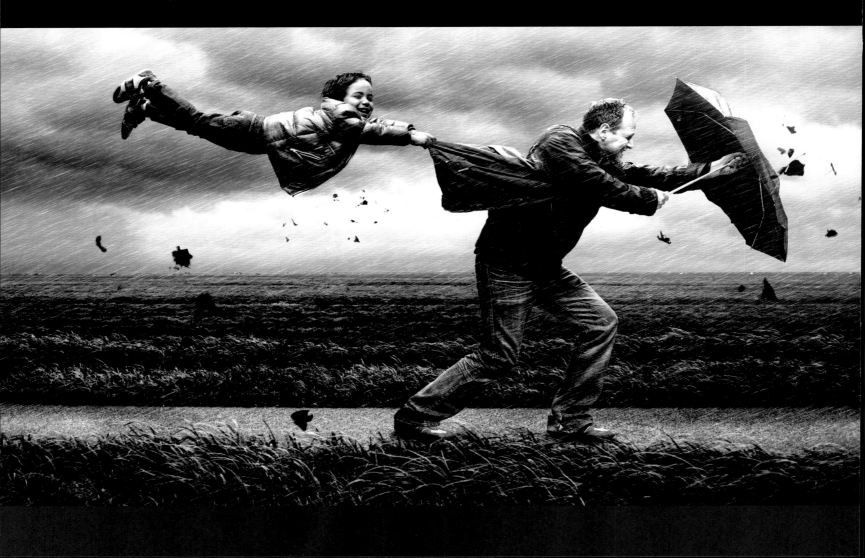

All of these images were taken specially
for use in this project.

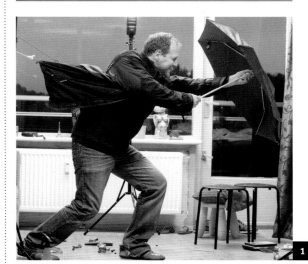

Photoshop

1: CREATING THE SEPARATE IMAGES

I needed six different photos to create
this composite. The first is of the
background, where the grass is blowing
in the wind.

Unfortunately, the clouds at that
moment weren't dramatic enough
for the look that I wanted, so I took
another photo of the sky about an
hour later.

To emphasize the strength of the wind,
I recruited my son to toss leaves into
the air, which I also captured.

The photos of my son and I were
shot at home. He was propped up on
stools and pillows while my flashes
were pointed toward the ceiling to
simulate more natural, outdoor light.

My son helped with the self-portrait
of me. He held the ropes that were
attached to my coat, making it look
as if it was being blown by the wind.
Once we had all of the photos, it
was a case of compositing the image
in Photoshop.

2: ADJUSTING THE BACKGROUND

You can see that the road in the original photo had white lines running down its middle and that there were some buildings in the background. I used the Clone Stamp tool to remove them so that they wouldn't detract from the overall image.

3: DRAMATIZING THE CLOUDS

The clouds still didn't look dramatic enough to me, so I added another layer with heavier cloud cover. I cropped the heavier cloud cover from the second sky image and copied and pasted it over the background image in a new layer.

4: BLENDING THE LANDSCAPE AND CLOUDS

So that the two layers would look more natural, I added another layer over the top, then selected the Blend mode on Overlay. Using a white-colored brush, I worked over the horizon a little to help blend them together better.

5: ADDING THE CHARACTERS

After I had cut us out from the original photos, I added us to the scene on separate layers. I also added another layer and placed it underneath the previously added layers. I drew a shadow under my feet with a soft, black brush—an important touch that makes it look as if I were really standing in that place. You could use a soft black brush to paint in a shadow by hand, or use Photoshop's Drop Shadow tool.

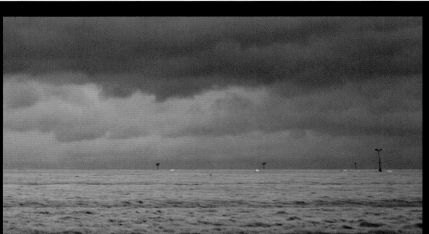

6: TURNING IT BLACK AND WHITE

At this stage the image didn't look right to me. It was too bright for something that was supposed to have been taken on a wet and windy day. To remedy this I turned it black and white by adding a Black & White Adjustment Layer over the top of all the existing layers. (See more on Drop Shadows on pages 64–65.)

7: MAKING IT RAIN

Now it was time to add some rain to the scene. I created this effect by adding a new a solid color Fill Layer and filling it with a color. Then I used the Noise filter (*Filter > Noise > Add Noise*) set to a high amount to generate thousands of tiny dots within the Fill Layer. By applying the Motion Blur filter (*Filter > Blur > Motion Blur*) I was able to turn the dots into stripes, and by using the angle selector, could control the direction of the blur.

When you've done this, all you can see is the grainy blur of color, with none of the background image you've worked so hard to create. By adjusting the Blend mode to Screen, you'll be able to view the background image covered with rain.

8: ADDING THE LEAVES

To emphasize the strong wind, I took some photos of leaves that my son threw into the air. I cut these leaves out from the background and added them in a new layer to the scene. It was simple to extract the leaves from their photos using the Quick Selection tool and then copy and paste them onto a new layer over the background image.

9: DODGING AND BURNING

The Dodge and Burn tools are likely the ones that I use the most in Photoshop, and I always apply them on a new layer over the layer that I want to change. For this composite, they proved very important because they helped to make the light more dramatic. I filled my new layer with 50% gray and selected the Blend mode on Soft Light. Then, by selecting the Create Clipping Mask I was able to ensure that my dodging and burning affected just the layer immediately beneath it, and not every layer in the composite. Then I dodged to lighten areas and burned to darken patches to get the light right. (See more on Clipping Masks on page 62.)

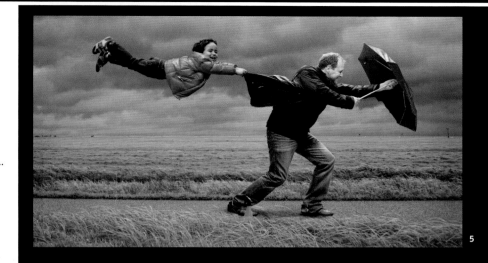

5

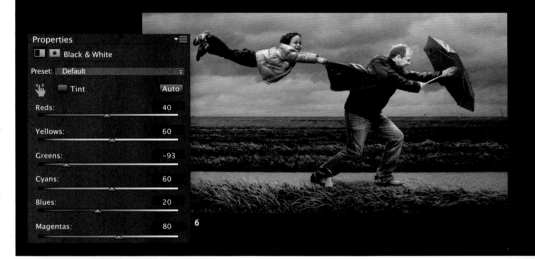

6

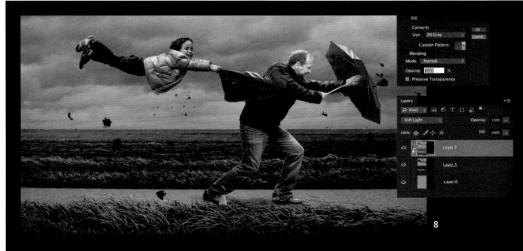

8

Natural Nature Jess Rigley

This image is part of my series titled "Natural Nature." The series features a nude woman, her nakedness complementing the natural landscape, nothing manufactured or fake. I wanted to channel my own ideas to distance the series from both fine-art nudes and erotica and decided to interpret "surrealism in the nude," as it is something which I haven't seen previously explored in any significant way. I wanted to see how I could visualize the concept, while also incorporating the natural world.

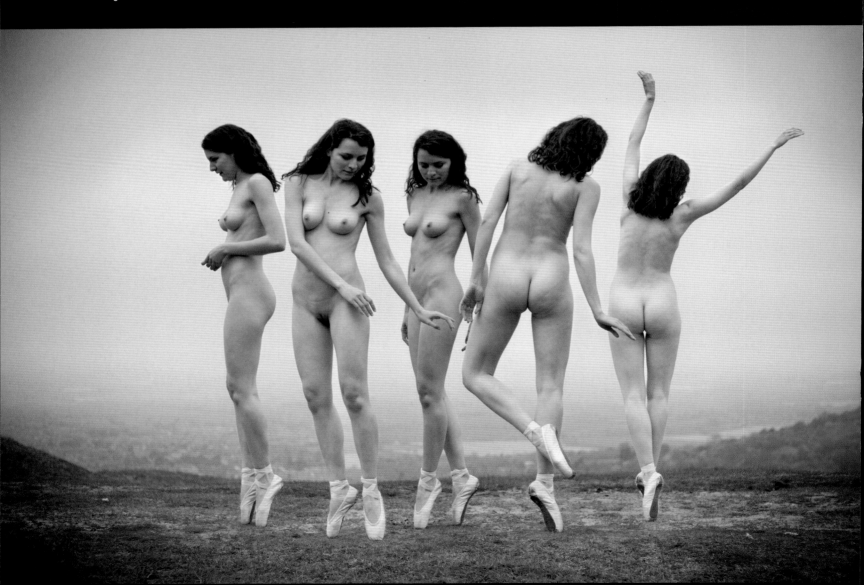

As surreal photography is a huge part of my work, I've had to learn the art of digital editing in great detail. Even though I have had some formal instruction in Photoshop, I have found that I've learned the most through my own practice and trial and error. In my eyes experimentation is a much easier way to learn to process your own images.

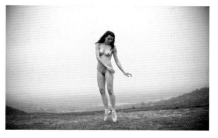

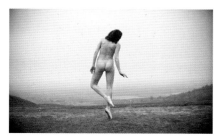

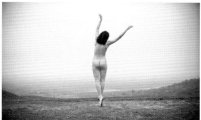

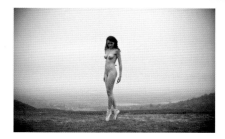

Photoshop

1: CREATING THE CANVAS

The main feature of this image is the repetition of the female figure, so I had to remember that anything applied to one image of the character had to be applied to all of the images.

I started off with a background image. I wanted to have one image where the character was already in position, and then add in more images to the scene. I selected *File > Open* and chose the images that I wanted to add into my base image.

2: MAKING THE CUT

Most often people are taught to copy the entire image over to the base image, which is sometimes the right method to use, but for this image I knew I didn't need to copy over the background for every one as I was only going to be using the female figure in each image. For this reason for each image I selected the Patch tool and created a rough outline surrounding the model without too much of the background in it.

Spot Healing Brush Tool
Healing Brush Tool
Patch Tool
Red Eye Tool

2

1

Once all of your images are loaded into Photoshop they will all open up as separate documents, so you need to have a method of placing the images onto the base image.

3: MAKING A SELECTION

Next I needed to make a selection, one image at a time, to get each of my chosen figures into my background image. To create my selection, I pressed and held down the mouse and drew a line around the figure with the Lasso tool, meeting back at the point where I started. Once I released the mouse button marching ants appeared around the selected area to indicate that I'd successfully made my selection. (The ants also show you what parts of the image your selection includes so that you can have a quick look around to see if there's anything you've missed.)

4: TRANSFERRING A SELECTION INTO THE MAIN IMAGE

I next needed to transfer each of my selected figures into the base image. There are two ways to copy a selection: going to the top bar and selecting *Edit > Copy*, or pressing CTRL-C on a Windows keyboard, or CMD-C on a Mac. I then went back to my base image and selected *Edit > Paste* to paste the selection on the base image (click CTRL-V on a Windows machine or CMD-V on a Mac). My selection appeared as a new layer on the image so I was able to place it where I wanted it. In this instance this was to the left to make room for more copies of the model.

My advice is to try to get used to using keyboard shortcuts if you can. They may be a little confusing at first, but in digital surreal photography, image-editing takes up a lot of time, so shortcuts where possible are always welcome!

5: WORKING WITH LAYER MASKS

Next I simply repeated the process of selecting the model for each of the others, and copying and pasting them onto the base image. To try to keep the composition organized I placed each layer of the model roughly into its final position. This helped me decide which image should be on the top layer and which arrangement looked best. As each of the images was placed on a separate layer, it made editing much easier.

The next step of the editing was the Layer Masks. To access these I navigated to the bottom of the Layer palette and clicked on the Layer Masks button below each separate image (it resembles a circle in a square). The purpose of Layer Masks is to give the user the ability to hide/paint out parts of the layer. For this image I used the Layer Masks to help remove the background and make the model look more realistic in context.

6: PAINTING IN/OUT THE LAYER MASKS

Once I added a Layer Mask to every layer but the base layer (nothing should happen to this one), I next needed to hide the layers.

There should be a eye-shaped symbol next to each layer; I clicked on the eye-shaped symbol to hide each layer but the base layer and the layer I wanted to work on. This made it much easier to see the effects my edits had as my layers were not overlapping.

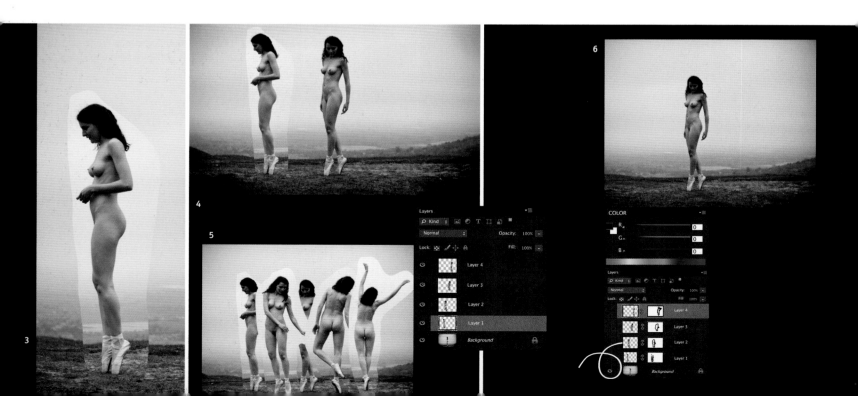

Once I did this I selected the layer containing my model, navigated to the side toolbar, and clicked the Brush tool. The Black and White tool is located at the bottom of the toolbar on the left, and is used to paint in and out the Layer Masks over each image. Selecting the black option allows you to "paint out" the image where required, and selecting the white allows you to paint back in part of the image you've previously painted out. This method of erasing I find useful as it doesn't permanently delete sections of the image, just hides the white behind the black—a great option to have if you're prone to changing your mind.

I like to use a medium-sized brush for painting in and out layers—80 pixels is typical. A brush that is too hard will give the pixes a very jagged edge and an unrealistic effect, so I like to avoid full hardness. Conversely, 0% hardness will create a fuzzy edge to your subject and parts of it will seem to be invisible, which again is something that you don't want. I used around 80% hardness here as it gave a solid edge, but still enough softness so that the model didn't look completely cut off from the background.

Next, I chose black, selected the layer mask (not the image itself), and started painting it out. To begin I wanted to get as close to the skin as possible, but not go over the skin. It's not necessary to do this perfectly—as you can see here I got close without interfering with the pixels that make up the border of the skin, and then moved around the whole body to make it consistent.

7: ZOOMING IN FOR GREATER CONTROL

Once this was done I zoomed into the image to 200%, keeping all the settings exactly the same other than the brush size. I usually decrease this by around 20 pixels, as I need more control when I'm zoomed in.

I then slowly worked around the body again, being careful not to paint out any of the skin. If you make a mistake during this step, it is very easy to just go back to the paint palette, select white, and then paint the skin back in again. Though this is time-consuming, I find it's the best way to get a very detailed end result, so don't rush it!

Most image-editors dislike being zoomed into an image this much when painting in/out, but I like to have the control to avoid the dreaded "halo effect," where visible halos appear around the outline of the subject. Zooming in to 200% helps you notice subtle flaws, thus providing a much higher-quality end result.

USE LAYER MASKS

Get into the habit of using Layer Masks to paint elements of your image in or out. If you use the Eraser tool and a few weeks or months down the line you want to change something in the image, you won't be able to. You'll need to start the image all over again!

Leave coloring until the end of your editing workflow, otherwise you may end up with lots of variations that will be difficult to composite.

Also always remember to blend the layers together if you want them to look as realistic as possible.

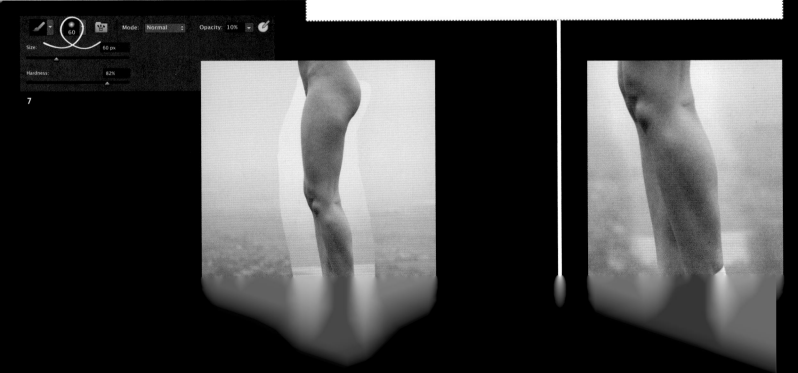

Natural Nature Jess Rigley

8: TROUBLES WITH HAIR

One problem I always face with compositing figures together is the hair. Wherever possible, always shoot hair you're planning to composite against the same background every time. This will save you both a lot of time, and from pulling out your own in frustration.

Using a brush similar to the one I used to paint in around the body, I increased the size and then the Opacity to roughly 10%. It is very easy to get carried away and start to lose hair while painting, so I like to try and blend the layer's background into the base background. This creates a slight gradient which smoothes out the pixels before you have to touch the hair, and *voilà*, the hair remains undamaged within the layer.

9: PAINTING AROUND DIFFICULT SHAPES

Painting around hands, feet, and the face—or anything with a difficult shape—can be tricky to conquer. I've found that these settings make the job easier to handle. This is a typical situation of when you have to paint around something that is a difficult shape, for example hands, feet, or the facial area. These are tricky areas to conquer, but a soft, small brush helps you get into the smaller areas with a few strokes.

This image took around three hours to get to this stage, so remember that patience really is a virtue! It does pay to get a beautiful end result.

10: MERGING THE LAYERS

Here are the black outlines hidden from the end image, the remnants of what was painted out. Once I finished the Layer Masks I copied all of the images and merged them into one. To do this I selected all of the layers, navigated to the bottom of the Layer palette, and dragged all of the layers to the layer symbol next to the bin. This duplicated all of the layers for me. I always make sure to take this step when I'm processing images.

11: MERGING VISIBLE

For the layers that weren't selected I needed to click the eye next to each layer. This turned off the layer, making it

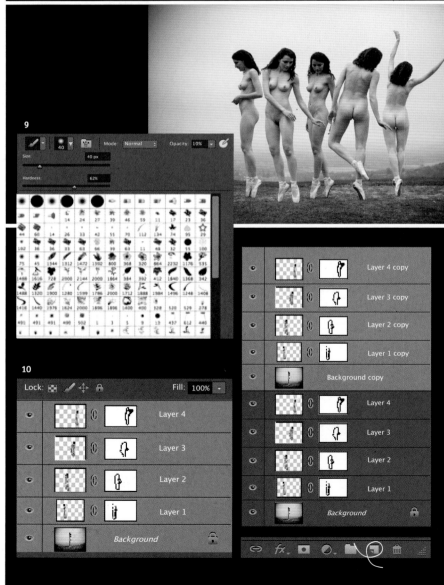

invisible. I didn't see any immediate change however as I'd already copied the images, which were sitting on top of the original layers.

I then navigated to the button at the top right of the Layers palette and from the drop-down menu selected *Layer > Merge Visible*. It's very important to click "visible," otherwise all the layers would have merged, and I wouldn't have had access to the original edited layers.

12: TWEAKING THE COLOR

Ultimately the image was now complete, but just as a finishing touch I changed the colors slightly to add more atmosphere. I navigated to *Image > Adjustments > Curves* to bring up the dialog box as shown here.

As a rule I always go to the Channel drop-down menu and edit each color separately so that I have full control over the coloring of the image. Once I had a result I was happy with, I clicked OK.

13: ADDING A VIGNETTE

13a) The next and final adjustment I made was to add a vignette to the image. This was just to help draw the viewer's eye to the models; I wanted to make the corners darker to emphasize the center. To do this I went to the side toolbar menu and clicked the Burn tool. The Brush tool adjustments are also very important. It is very wise to set the Opacity to around 8%. This sounds low, but for the mid-tones selection a setting of 8% with a large soft brush is very effective.

13b) Once my tweaks with the Burn tool were finalized, I then needed to create a new layer (*Layer > New > Layer*).

13c) A new dialog box appeared asking for the settings I wanted. I selected Overlay mode and checked the 50% gray box underneath, then clicked OK, and a new gray layer appeared in the Layer palette box. I selected this layer, made sure I still had the Burn tool selected, and darkened the corners of the image.

Once I did this I sat back, looked at my image and knew it was complete.

11

12

13a

13b

13c

VIGNETTES UNDER ADJUSTMENT LAYERS

When you add a vignette, be sure to keep its layer or layers underneath your Adjustment Layers (Curves, Levels, and so forth) to retain the correct color balance.

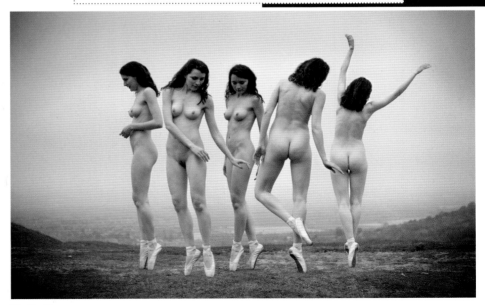

The final image

About Accepting Jon Jacobsen

Surreal photography doesn't always rely entirely on digital manipulation. Props, backgrounds, and how you set up your shots can all play a part, too. This is just what I did when I created *About Accepting*, part of a series called "Apartar" that covered the end of a romantic relationship.

This shot involved quite a lot of physical surreal effects. I used makeup to give myself an older appearance, put talcum powder in my hair to color it gray, and also constructed the eruption from my chest from papier-mâché.

After the shoot, I edited the image so that it had an aged and drained look, and used the Liquify tool to manipulate some of my gestures. I made my hairline recede and also added some wrinkles using a stock library image and the Lighten, Multiply, and Overlay blending modes.

Next I carried out some dodging and burning to even up the light and emphasize my skin, and there was a touch of color manipulation as the cold colors were toned down and the reds increased in intensity. With this final tweak, the dramatic look of the image was complete and *About Accepting* was done.

This piece represents the day when you start the process of metamorphosis, accept the reality of your situation, and begin to grow into a new self.

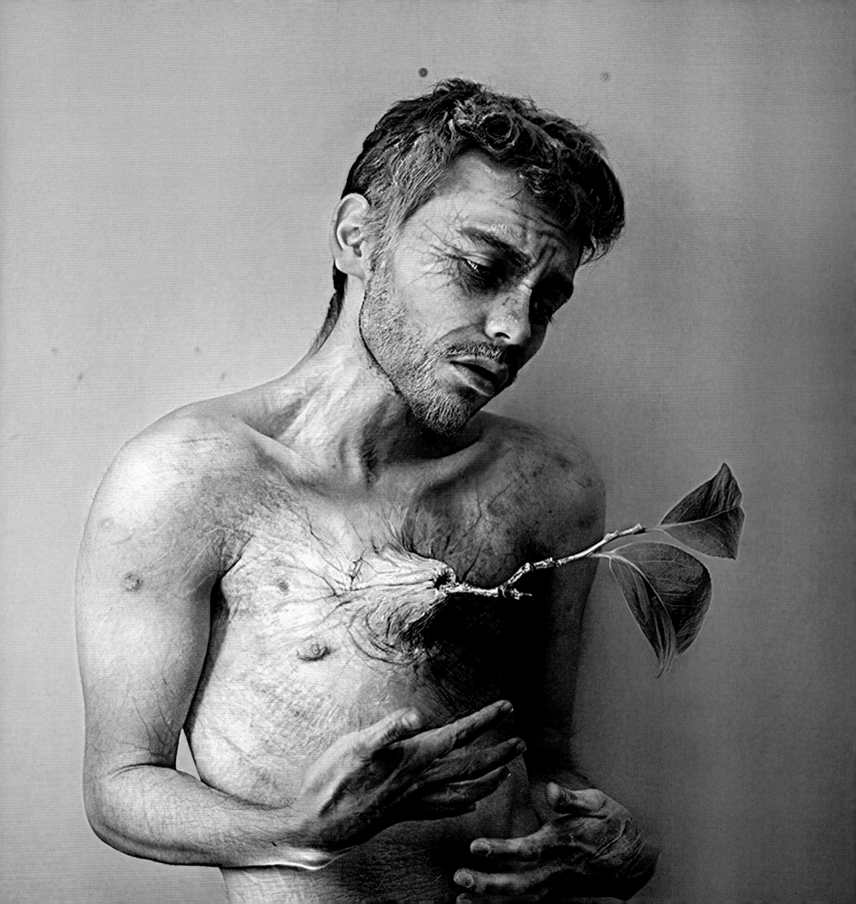

The thing I love most about infrared photography is that it makes a normal-looking world look surreal. To visitors, this pond is just an ordinary place to take your kids to feed the ducks. My photography, however, makes it look like a place from your dreams.

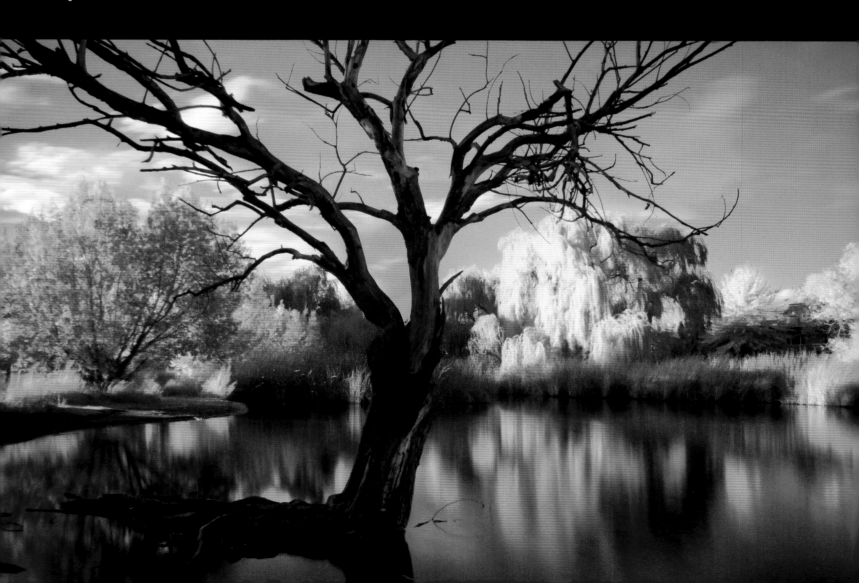

This pond is located pretty close to where I live. One of my first IR pictures was taken at this pond and now it has become my "test" spot every time I get a new IR-capable camera. The setting contains my ideal combination of sky, water, and foliage with the added bonus of the interestingly textured dead tree. For this particular shot, I lured the ducks out of the frame with bread. In other shots, I have included them. This image was taken using a Canon EOS Rebel XTi and a Canon 17–40mm $f/4$ lens. Most people will use a Hoya R72 IR filter; in this case I had a 72mm filter.

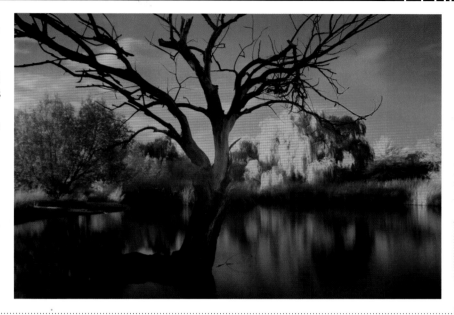

1: COMPOSING YOUR SHOT

An IR filter is so dark that it almost looks black; you can hardly see through it. For this reason, I composed and focused my shot before putting the filter over the lens. The long shutter speed required me to use a tripod, and to minimize camera shake in a similar situation you should use a remote, cable release, or the built-in timer on your camera. If you have it, a mirror lock-up is also recommended.

2: APPLYING THE FILTER

When I'd composed and focused my shot I switched to manual focus to ensure the focus didn't alter when I released the shutter.

Now I carefully screwed the filter onto the end of my lens. The 17–40mm lens zooms internally, so there is no risk of changing the composition, but if you have a lens that moves physically as it zooms, it will be very difficult to maintain any sort of zoom. In this case, you should be zoomed out as wide as your lens will allow.

3: EXPERIMENTING WITH SETTINGS

Just as with any exposure, I needed to achieve a balance between aperture, shutter speed, and ISO. The longer my shutter speed, the more blur I would see in the trees, so I experimented a little first.

For this image, I used a focal length of 18mm, and chose a sensitivity of ISO 200 to reduce the amount of noise in the image. I prefer not to shoot wide open, so I had my aperture set at $f/5.6$. With these settings, I needed a 20-second exposure. This worked out well for me because the long shutter speed allowed the movement of the water to smooth over, and gave me time to lure the ducks away from where I was shooting with bread.

4: FIRING UP LIGHTROOM

With the shooting done, I needed to turn to an editing suite to finalize the image.

When I first started to shoot IR, I used Microsoft Digital Image Suite 2006 to process my work, but this is now defunct. I currently use Lightroom, where I have saved quite a few presets to help me with my IR work.

Lightroom

5: WHITE BALANCE

Adjusting the white balance on an infrared picture is trickier than adjusting it on a normal image. When you adjust the white balance on a normal image, you are either trying to reproduce the same coloring that was in the scene as you saw it, or you change it up to produce a mood that you want to achieve. Since infrared images aren't the same as what you saw with your eyes, when you are adjusting the white balance, you are just trying to get a look that you find appealing. For me, I prefer my trees to have a whitish-pink hue to them. This particular camera produced more red than I've ever gotten with an infrared image, but the end result still focused on the hue of the trees in the background. I changed the Temperature to -47 and the Tint to -6.

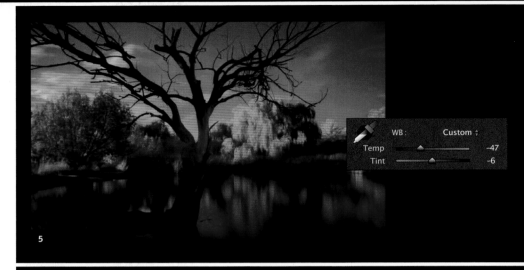

6: TONE

To achieve the tone that I wanted, I pushed up the Exposure a touch, to 0.6 and the Shadows to 8; meanwhile the Blacks got moved to 5, and the Contrast boosted by 7.

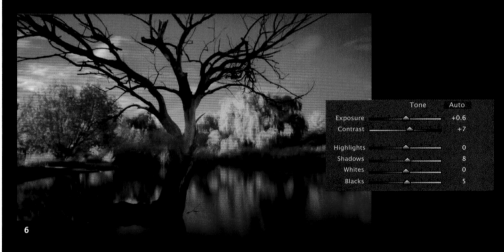

7: PRESENCE

Here, I also pushed up the numbers to increase the intensity in the colors. Clarity went to +29, the Vibrance to +13, and Saturation to +8.

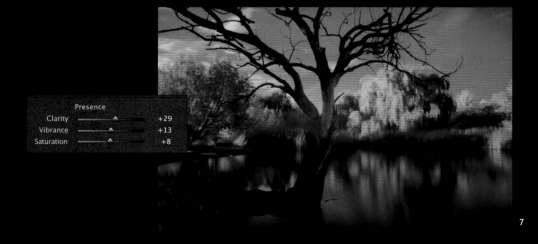

8: SPLIT TONING

In the Split Toning menu, I changed the Highlights Hue to 128 and the Saturation to 40; I also adjusted the Shadows Hue to 108 and the Saturation to 22.

Getting the colors right is a matter of experimenting. I usually slide the Saturation slider to the middle and then move the Hue slider back and forth looking for the sweet spot. Then I move the Saturation back and forth until I find the look I'm trying to achieve.

..

9: SHARPENING

Once I was done with all of that, I opened up the Detail menu and changed the Sharpening to 19, the Masking to 10, and the Luminance to 14. You need to be careful not to over-sharpen your image, as an over-sharpened image is very harsh on the eyes and not pretty to look at.

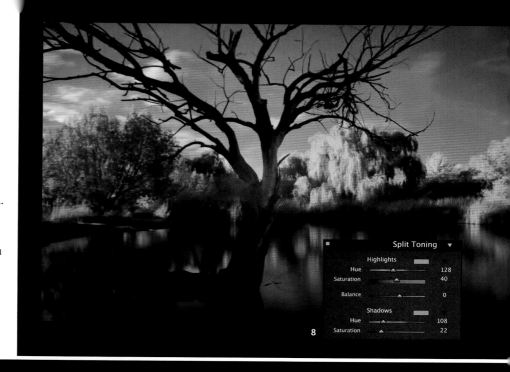

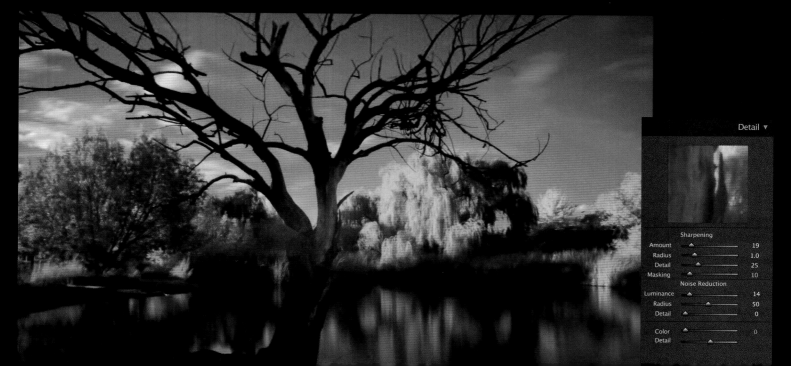

10: REMOVING THE HOT SPOT

There are a lot of theories as to why hot spots (areas of odd brightness in an image) occur so often in IR images. The current thinking is that it is due to the particular lens you use. Regardless, if you end up with a hot spot in an image, it can be a pain to get rid of. Check out this list of lenses that are and aren't affected by hot spots at DPanswers.com.

You can see the hot spot quite clearly in this image: it's the large pale lilac "bruise" in the center of the frame. I was able to fix it using a combination of brushes.

FIRST BRUSH SETTINGS

FIRST BRUSH SETTINGS

EXPOSURE: -1.56	BRUSH SIZE: 34.1
CONTRAST: 61	FEATHER: 44
CLARITY: 29	FLOW: 100
SHARPNESS: 34	

I placed the brush directly over the hot spot and clicked once, applying a circular stroke.

SECOND BRUSH SETTINGS

SECOND BRUSH SETTINGS

For the second brush the settings were much simpler:

EXPOSURE: -0.58	FEATHER: 44
BRUSH SIZE: 3.2	FLOW: 45

With this smaller brush size I moved over the area of the trunk that had a bluish tint to it and also over the foliage to the left that still looked a little "hot."

THIRD BRUSH SETTINGS

After applying the brush to those areas, I used the Erase function with the following settings:

EXPOSURE: -0.58	FEATHER: 25
BRUSH SIZE: 16.4	FLOW: 36

I lightly erased some of the brush strokes around the foliage that had gotten too dark and also in the spots that I had brushed outside of the trunk.

11: DISSATISFACTION

Something that happens to me is that once I have done what I think is the final edit, I'll look at the picture again the next day to see if there is something else I want to tweak on it. For this image, after I was done with my original editing, I felt the color balance wasn't quite right and it was still too dark, so I went back and made the following changes:

COLOR BALANCE SETTINGS

TEMPERATURE: -63	BRIGHTNESS: 12
TINT: -20	SHARPENING: 43
EXPOSURE: 1.24	MASKING: 22
FILL LIGHT: 25	LUMINANCE: 18

12: CLEANING UP

Then I went over the image at 100% to look for any dust spots or dead pixels. This particular camera had several dead pixels, so I used the Spot Removal tool, set to Heal, to remove them.

13: FRINGING

Lastly, I noticed that the image had some edge issues on the branches. This was solved by setting the Defringe to All Edges.

Love at First Sight Shon E. Richards

Some years ago I was planning a huge dinner for a family celebration. The problem was that though I enjoy eating, I certainly never considered myself a cook. I knew what I wanted to serve, but needed to consult my father on how to put it all together.

I had all the ingredients and some minor direction on the steps I needed to take, but no real clue about the "how to" and "how much." When I asked my father what to do his response was, "I can't tell you all of the measurements because I don't know. You just have to do it until it's right."

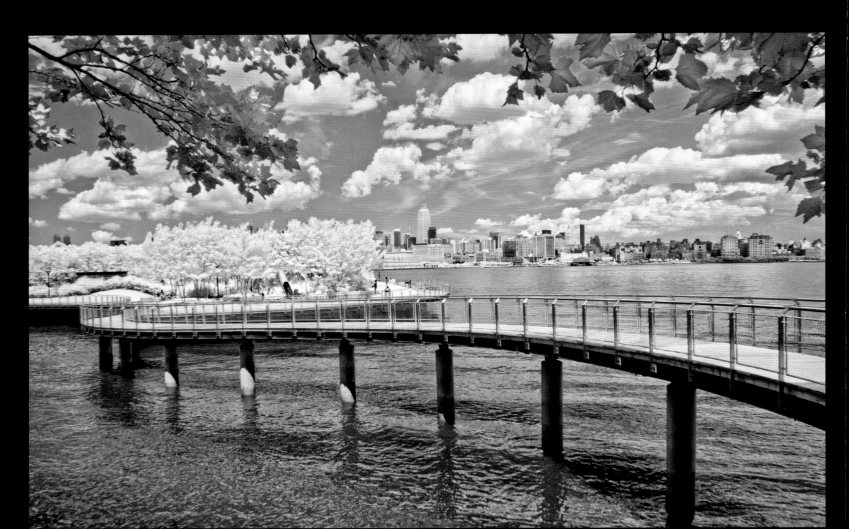

I ended up doing just that—I added what he said to add and tasted a bit, then put my own little twists on it here and there. Years afterward, I'm still begged to make the dish that once intimidated me so much.

It's the same with the creation of surreal images. I'll attempt to give you all the instructions necessary to recreate the effect of what I've done here, but in the end, for your own work you just have to "do it until it's right," as my father said. You'll need a vision of your final goal, to taste as you work, and to add or subtract different ingredients as you go along.

I capture all of my IR images on an infrared-converted Nikon D70 that I purchased online. If you don't have an IR-converted camera, you can of course capture IR images using filters on your regular camera.

Typically, I shoot Raw in Aperture Priority mode with a sensitivity of ISO 200, and make adjustments depending on the amount of sunlight available. For IR photography, I love to capture scenes with lots of foliage and a sky full of puffy clouds for a bit of drama.

BASE IMAGE

I took this IR image in Hoboken, NJ because I felt like in its natural state it told a story that I could easily emphasize with the fantasy element afforded by IR editing. From the tree leaves that shade the foreground of the picture to the bridge winding to a place that begs to be explored to the cityscape across the waters . . . the story begins with the viewers, and continues to unfold as far as they choose to travel with it.

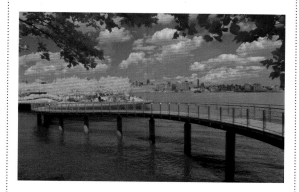

TOOLS

Photoshop

IR CONVERTED

If you find yourself shooting IR a lot, you might decide to get a camera converted for IR use. It can significantly streamline the process. Just remember, once a camera has been converted, it cannot be used again to shoot ordinary images.

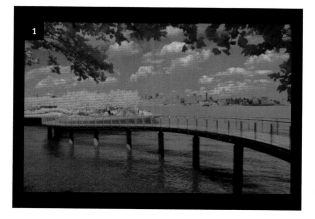

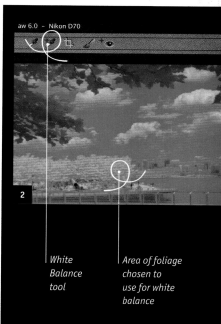

White Balance tool

Area of foliage chosen to use for white balance

1: OPENING YOUR FILES

Since all my images are captured as Raw files, I need special software to view the .NEF files. I use ViewNX2 which can be downloaded for free on Nikon's website. Once I had chosen the picture I wished to edit, I opened the image in Adobe Camera Raw, which is part of Photoshop.

2: ADJUSTING THE WHITE BALANCE

Camera Raw allows you to make lots of adjustments to your images, but I use it primarily to adjust the white balance before moving on to Photoshop.

To do this, I clicked on the White Balance tool icon on the top left corner, selected an area with the balance I wanted to use, and just touched that area with the White Balance tool. Usually, I would use an area in the foliage that has the amount of brightness I want, and the Raw processor will then make the necessary adjustments.

Once you are satisfied with the white balance you might want to toy around with some of the other settings or just click Open Image to move forward to the next step in the process.

3: SWAPPING THE CHANNELS

Once I'd opened my image in Photoshop and working in the Background Layer, I swapped the red and blue channels with each other using the Channel Mixer. To do this, I went to *Image > Adjustments > Channel Mixer*.

I selected the Channel Mixer and in the Red Output Channel I switched the Blue to 100% and the Red to 0%. Then I did the same swap with the Blue Output Channel by switching the Red to 100% and the Blue to 0%. Here's the image with the swapped out colors.

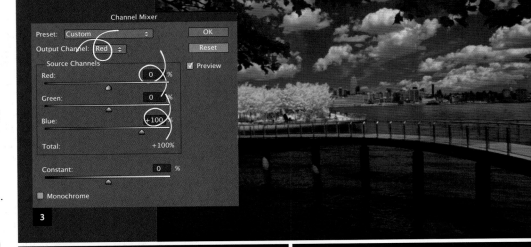

4: CREATING A DUPLICATE BACKGROUND LAYER

Next I created a duplicate of my Background Layer. I selected *Layer > Duplicate Layer,* but alternatively you could drag the layer you wish to copy onto the Duplicate Layer icon at the bottom of the Layers palette.

5: MAKING SELECTIVE COLOR ADJUSTMENTS

Once I had my duplicate layer the first thing I did was to make some color adjustments based on my vision of the final image. I did this by selecting *Image > Adjustments > Selective Color*.

5a) I sometimes play around with the blue and cyan to make them a little softer by subtracting from the magenta (which adds green) and subtracting from black (adding more white), but mainly I make adjustments to the neutrals.

5b) For this image, I created a place where the foliage was slightly warmer with hints of red and magenta. I also brightened it a bit by taking a decent amount of black out of the neutrals.

I like my photos to be very "punchy" with great detail; next, I used a little trick to achieve my desired effect. I like to edit my images with HDR Toning—an adjustment introduced with Photoshop CS5 that is only usable with a flattened image. So first, I flattened my layers by right-clicking on an open layer and selecting Flatten Image. Then I saved the image as a JPEG by selecting *File > Save As*, named it *Love at First Sight*, and saved it one more time.

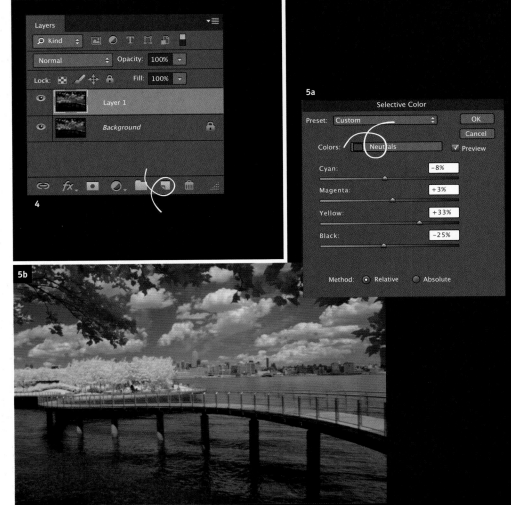

6: BRINGING OUT THE HDR

Once I'd saved the JPEG version of the image I returned to my active screen in Photoshop. (Don't close anything in Photoshop after you've saved the JPEG, you'll want to continue working on that original, newly-flattened version.) I selected HDR Toning (*Image > Adjustments > HDR Toning*) and began to make my next adjustments. There are a variety of options you may use in HDR Toning, but I always play around with the settings to get the amount of detail, light, and saturation that I want.

Once I was satisfied with the settings (shown here) I'd selected, I clicked OK to open up my new image.

6

7: TONING THINGS DOWN

The photo now had a lot of extra detail—actually, too much detail for my liking. I went over the top intentionally, but on balance I decided to reduce some of the punch.

I went to the folder where the JPEG version had been saved, dragged that image onto the Photoshop screen, and placed it on top of my HDR edit. When I did this, I made sure that it was placed evenly over the image below it. If you are working on this step and notice that the top image is misplaced, you can adjust it by clicking on the layer that is not currently on, using the Transform tool, and making the necessary adjustments.

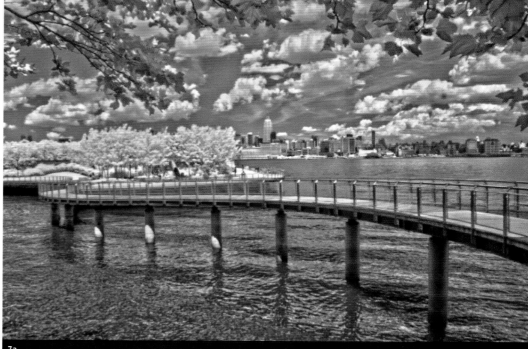

7a

8: DUPLICATING THE BACKGROUND LAYER

8a) I next made a duplicate of the Background Layer as I did the first time, so that if I made any mistakes, my original would be preserved. I then reduced the opacity of *Love at First Sight* until I achieved my desired level of detail. This is different for each image I work on; you've got to just "do it until its right."

8b) To save this new image without affecting any of the existing layers, I pressed and held down CTRL-Alt Shift-E (CMD-Alt-Shift-E on a Mac) with the top layer highlighted. This created a flattened image of the layers while leaving the originals untouched. I could have renamed this layer, but for the time being I left it as Layer 1.

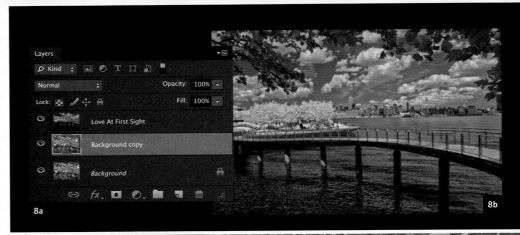

9: ADJUSTING THE SHADOWS AND HIGHLIGHTS

On another duplicate layer, I adjusted the shadows and highlights using the Shadows/Highlights tool (*Image > Adjustments > Shadows/Highlights*).

Once I'd made the adjustments to my liking, I clicked OK and then reduced the opacity of the new layer until I got the blend that I was looking for. Next I merged the new layer with the one below it by right-clicking on the upper layer and selecting Merge Down.

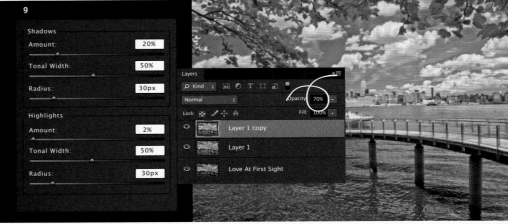

10: OVERLAY

I had more or less achieved my desired results by this stage, but I still wanted to make a few more tweaks. The next step was to duplicate my new layer and set the duplicate's blending mode to Overlay. Overlay is a popular option that is often used to add more contrast and saturation. However, it can give too "punchy" an effect, so in this example I reduced the layer's Opacity to 15% once I'd changed its blending mode. I then merged it with the layer beneath it.

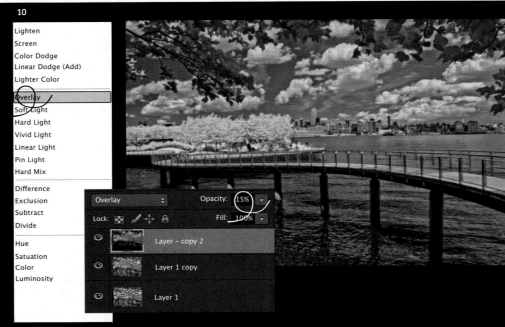

SAVE AS A PSD FILE

Remember to save your work as a PSD file as you go along for added security against losing the progress you've made so far.

11: EXPERIMENTING WITH LEVELS

To add yet more punch, I like to experiment with the Levels tool (*Image > Adjustments > Levels*). For this image, I used the Auto adjustment, but I often choose options from the Presets list or even make my own manual adjustments. Once I'd made my selection, I clicked OK, and as I'd done before, reduced the opacity of the layer to my liking. This time, I reduced the Opacity to 46% and merged it with the layer below.

Again, you may choose to use CTRL-ALT-Shift-E to compress the work you've done without touching the previous layers.

12: REVISITING SELECTIVE COLOR

Using a duplicate of the new layer, I revisited the Selective Color option for a bit more tweaking.

I didn't want such hard blues in my image, so I softened the cyan and blue by adding more green (subtracting from magenta), and also adjusted the black levels of both to my liking. I added a touch more contrast to the photo too by going to the black section and pushing it to 8%.

13: BENDING THE CURVES

Next, I used the Curves tool to experiment a bit (*Image > Adjustments > Curves*). I chose to slightly intensify the light and shadows on a duplicate layer by adjusting the curve.

After clicking OK, I reduced the new layer's Opacity to 50% and merged it with the one beneath it.

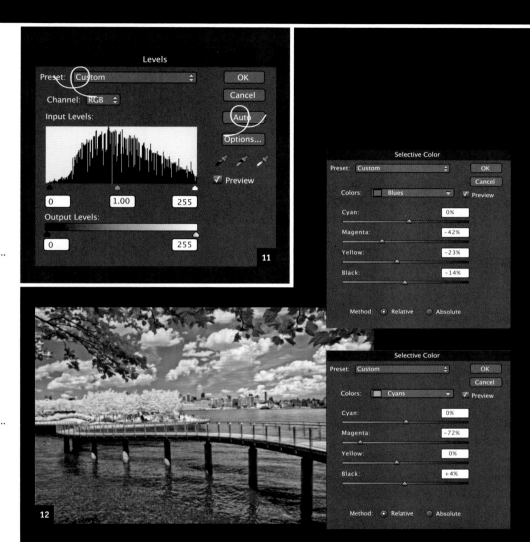

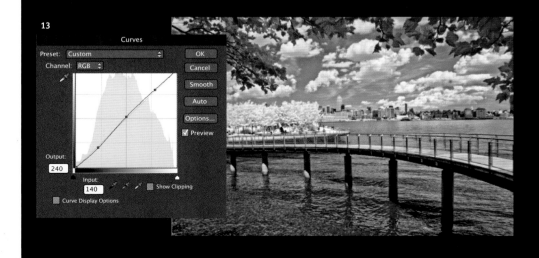

Love at First Sight Shon E. Richards

14: DODGING AND BURNING

My image was almost complete, but not quite. I next used some dodging and burning techniques to draw the viewer's focus to where I wanted it to be. This was done by darkening, or burning, the areas of the photo that I wanted to draw less attention to, and lightening, or dodging, the areas I wanted to make stand out.

I tend to do my dodging and burning on separate layers, and also use these layers to give a bit more depth to the photo by burning details such as the shadows in the leaves, grass, or a building located behind another building. Here, I wanted to give more drama to the clouds by making the bottoms of them and some of their swells a bit darker and dodging their fronts and sides. To create Burn and Dodge Layers, I performed the following steps:

14a) I created a new layer and selected *Edit > Fill* on the upper left side of the screen.

14b) I changed the Contents to 50% Gray and made sure the Blending was set to Normal and 100%. Then I clicked OK.

14c) Once I had set the blend mode of this 50% Gray layer to Overlay, the layer appeared transparent. Next I used black paint to darken areas, and white paint to lighten areas. I used a soft paintbrush with an opacity of about 10% so that the burning and dodging was very minimal and subtle.

14d) I used as many layers as was necessary to achieve the look that I wanted. I just kept tasting and testing! You can adjust the opacity to your liking, and don't forget to name your layers to help keep track of them.

In this image, I burned the shadows of the waves, the shadows of the bridge in the water, portions of the beams of the bridge, areas of the trees, and also the clouds. I dodged areas like the reflections of the trees and buildings in the water, and parts of the trees where rays of sunshine were peeking through. I added a little shine to the water by dodging areas where natural light bounced off it.

One of the most important places that I brightened was the bridge. I then added a small patch of light near the end of the bridge. I did this to give the eyes somewhere to travel and also to give them a resting point (but not necessarily an endpoint).

14a 14b

14c

14d

15: CLEANING UP THE DUST SPOTS

15a) All that remained for me to do was to make a compressed version of my image (CTRL-ALT-Shift-E on a Windows machine, CMD-ALT-Shift-E on a Mac), clean off any dust spots on it, flatten the layers, and save my final copy of *Love at First Sight*.

15b) You could use either the Clone Stamp tool or the Spot Healing Brush tool to clean up dust spots. I used the Spot Healing Brush because it's simple. Once this tool was selected, I right-clicked and chose my size of brush and level of hardness. I used a brush at 50% hardness for this. I enlarged my screen using the magnifying glass from the toolbar so that no or very few spots escaped me. I simply clicked on the spots I saw and the Spot Healing Brush tool corrected the area.

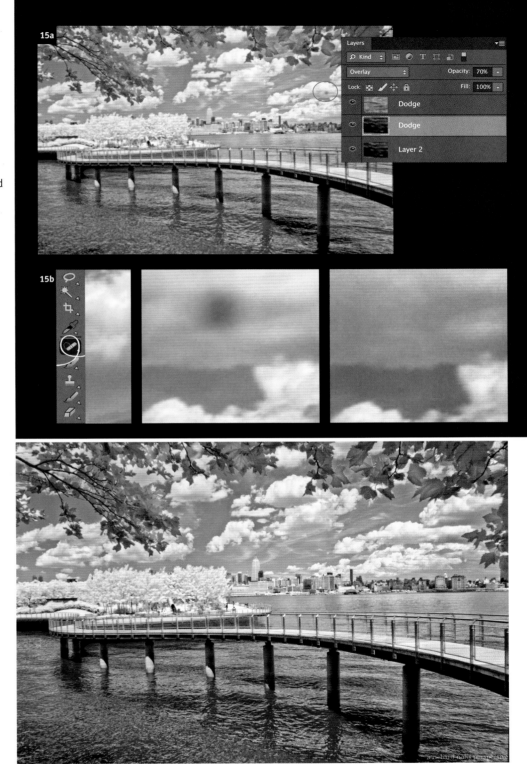

The final image

Foreboding Krishan Gungah

I used two photographs for this image: one diamond-studded skull that had the texture that I wanted, and one photograph of a winter forest path. I used GIMP software for the effects.

The skull needed to have a white, cloudy look. To achieve this, I converted the original into a monochrome image, then applied two effects: Motion Blur at a 90 degree angle, followed by Motion Blur Zoom. These effects can be found under the Filters tab in GIMP. The blur parameters can be adjusted until you are satisfied with the image's new look, while the zoom breaks any solid texture and gives the impression that the skull is moving toward the viewer.

I next layered the skull over the winter forest path and adjusted its parameters so that it blended in perfectly with the forest image. I needed the skull to appear "natural" and not artificial, and luckily enough, the two trees opposite formed the eyes and the rest fitted perfectly. Once you have the combined image, you can adjust the contrast if required.

While this image was a lucky fit, it will not always be possible for you to place your images in a composition so easily. It's always a good idea to try to keep an eye on a particular element in your scene or setting, and to experiment with overlaying different images on it.

I love to find and photograph peculiar shapes in nature that resemble faces. However, coming across those that are especially dark, spooky, and apparition-like is rare, so I decided to create my own.

Swimming Palace Bethany de Forest

Surreal photography made with a pinhole camera has its benefits. When people ask me how I manage to create such magical-looking images without Photoshop, I tell them that I would probably have a hard time creating them with Photoshop! I create all of my surreal photography by first creating a physical diorama, the "scene" within which the action takes place, and then by using a simple pinhole camera to record the image. There is no digital phase in the creation of my surreal images until the very end of the process when I scan my analog slide-film. If I use Photoshop, it's for color correction or to remove any dust spots, stray wires, or mirror edges.

In this section I concentrate on explaining how I create my surreal pinhole compositions, rather than providing an in-depth tutorial on how to make a pinhole camera. There is a wealth of material online and in print explaining how to do this, and though the process is very simple, to make your own surreal images with pinhole photography you'll need to experiment and create a few cameras first. Above all, be patient—pinhole is an artform in itself!

Pinhole cameras are the simplest form of camera there is, and have the simplest lens—one that is easily made yourself. All you really need is a light-tight box (the camera body into which film is placed), and a small piece of "shim," or thin sheet metal which then has a tiny "pinhole" made in it to allow light through (the camera lens). To create sharp images, the lens needs to be made out of metal, which lets you make the smallest and finest pinhole in it possible—brass shim or aluminum shim (taken from an aluminum drinks can for example) are ideal.

For step-by-step tutorials on how to create your own pinhole cameras, the following website provides excellent guidance:
www.pinholephotography.org

1: THE PROCESS

My process starts with an idea, or with a material I want to work with. Usually I have several ideas at once and I work on them simultaneously.

1a, b) Building a setting, something that is usually constructed inside a box, can take as little as a day or up to a month, mostly depending on the construction materials I use. If I'm working with fresh fruit and vegetables, or anything else perishable, I need to work fast. 1a) and 1b) shown here showcase some of my fresh food creations.

1c) Conversely, glass constructions made using the Tiffany technique (a method for creating stained glass developed in the late 1800s, often also referred to as the "copper foil method") can take months.

The inspiration for *Swimming Palace* started with an arch of epoxy resin I made and studded with the ball bearings from a bicycle.

1d, e, f) At some point I made a connection between the arch and the interiors of Hungarian bathhouses, where visitors can play chess while bathing. The architecture of these buildings is magnificent, and of course there's always a lot of water.

2: PUTTING TOGETHER THE STORY ELEMENTS

I hardly ever use human figures in my work. Small creatures, such as insects, are much better. They add a story element to the dioramas, as well as a sense of scale and a means by which to draw the viewer into the image. The actors in the cast of *Swimming Palace* were fish and shrimp.

2a) It was styrofoam packing material that determined the shape of the pools. One of these boxes was shaped more or less like an Olympic pool and I decided to make this more obvious by adding the typical orange-and-white lines indicating the lanes. The orange of the fish swimming their laps and bright blue of the pool formed a good contrast. In the other pools, the shrimp are treading water, as if it were their first swimming lesson.

2b) The whole process is more or less an action-reaction way of working. My studio consists of racks full of objects and articles that I've collected through the years, and these inform my designs.

2c) At some point I decided that I'd created the scene that I wanted and the diorama was ready to be photographed. I use a pinhole camera, which is the simplest camera available; in fact so simple it doesn't look like a camera. This last factor is essential to my work. I use a lot of mirrors in my dioramas and the camera is reflected in them, but as it's hardly recognizable as a camera I'm easily able to disguise it, blending it into the scene. Here are some examples of various pinhole cameras I've made.

3: USING THE PINHOLE CAMERA

One crucial quality of a pinhole camera is that it lacks a focus point. Everything in the image is in focus (or a little bit out of focus). It's possible, then, to photograph very close-up while at the same time keeping the background clear. This gives a strange, alien sense of scale and perception, and makes the dioramas look gigantic. It's very easy to alter focal length with a pinhole camera: the closer the hole is to the film, the wider the angle is. I like using a very wide angle, about 160 degrees.

3) When it came to shooting this image, I placed the camera in the diorama box and closed the box with the last mirror. As with most pinhole photography, I had no idea what the camera could see as there was no viewfinder to look through—I couldn't even see into the box. I turned on the light, which beams down from above, and set my stopwatch.

4: EXPOSURE TIMING

Exposure times for a pinhole camera are far longer than for an ordinary camera—up to 19 minutes is not unusual. It's vital, therefore, to make sure that nothing on the set moves. For the first shoot, I take a series of images with scaled exposure times. For example, for this piece I took a series of one, two, four, six, and eight-minute exposures. When the film was developed I determined which exposure time was optimal. I often restyle the set or change the lighting until I am satisfied with the result.

When I work with a pinhole, I can't see what I'm doing, so a great deal of the process is out of my control. When creating this image, as is the case with all the images I make, it was trial and error.

5: SELECTING, SCANNING, AND EDITING

From a selection of quite a few shots, I chose the best ones and scanned them. This is the first point at which a computer is involved. I use slide-film (color positive film) because of its contrast and intensity in color; basically, what I try to do when editing digitally is to reach the same intensity of color and brightness that I see in the original slide.

Finally *Swimming Palace* was complete. I sent it out to have a Lambda print made and mounted it on a dibond aluminum panel with an acrylic glass layer.

The final image

Winter Soul Dariusz Klimczak

My inspiration for *Winter Soul* came on a foggy morning in the countryside near my village. As I was driving I saw a herd of horses grazing in a meadow. The trees straggling across the horizon looked to my mind like combs. Intrigued with the surrealism of this image, I decided to create a piece that reflected my vision, using actual comb-shaped illustrations.

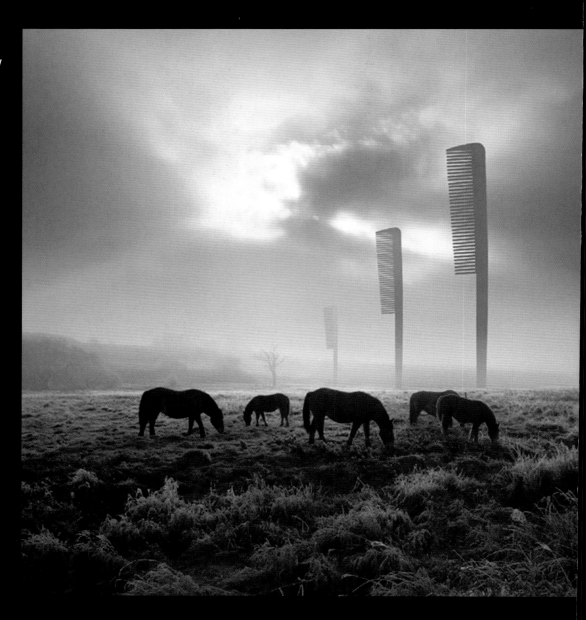

I took these photographs specifically for use in this project, while the comb was simply one I photographed against a bright background and cut out carefully in Photoshop.

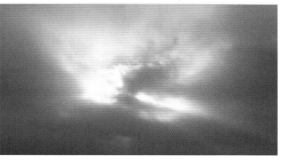

Photoshop

1: ERASING THE SKY

My first step was to open the background image in Photoshop and to crop out the sky, as I had some more dramatic clouds from a different image that I wanted to incorporate instead.

2: CHECKING THE DIRECTION OF THE LIGHT

In selecting a new sky, I needed to ensure that the direction of the light was consistent between the two images to create a realistic effect.

3: CHANGING THE CROP

I decided that I wanted a square crop for this image, but I also decided to enlarge, rather than reduce, the overall area of the image. This gave the effect of fully centering the horses, as shown here.

4: ADDING THE CLOUDS

Using an auxiliary line to help me determine the position of the sun, I pasted in the new sky.

5: BLENDING THE TWO IMAGES

The delineation between the two images was both obvious and far too harsh, so I blended them with much more subtlety by changing the blending mode to Soft Light, reducing the opacity, and using the Eraser tool set to a soft brush on the horizon, where the imported sky meets the base image. This helped to soften the join and allow the detail from the lower image to show through.

6: THE COMBS

I created the comb shape by photographing the dark comb in close-up against a bright, uniform background, which made it easy to cut out from the background with the Quick Selection tool. When I had cut out the comb I saved it so that it could be used again in the future. Then I copied and pasted it onto a new layer and removed half of the teeth to give it a better shape. Then I applied some Gaussian Blur (*Filter > Blur > Gaussian Blur*) to it, to help give the impression that the comb was shrouded in mist.

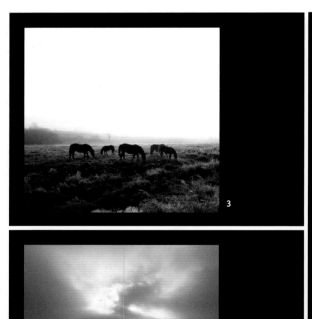

3

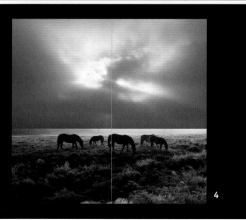

4

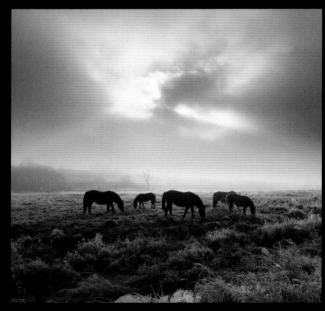

5

6

7: DUPLICATING THE COMBS

I copied the comb onto several new layers to make editing them individually easy. Then using the Transform tool I resized each of them, and positioned them as a series, fading off into the background. I applied a touch more Gaussian Blur to each, and painted in some haze to the background to create a sense of depth and atmospheric perspective. I then reduced the opacity of the foremost comb to 80%, decreasing this more for each one to ensure that the further away the combs were intended to be, the more obscured by mist they appeared.

8: CONVERTING TO BLACK AND WHITE

My last step was to convert the image to black and white. The method I use to convert my images to black and white differs almost every time I do it, but in the case of this piece I used the red channel output, which I always find gives the softest effect. First, I duplicated the image and then converted it to black and white. I then created a new duplicate layer and in the Channels panel selected the red channel. I reduced the opacity of this layer to 50%, and then I flattened the image. My next step was to duplicate the layer, set the Opacity to 10%, and then apply the Equalize function (*Image > Adjustments > Equalize*). Finally, I adjusted the Levels and the Curves to ensure a large dynamic range over the whites, blacks, and grays.

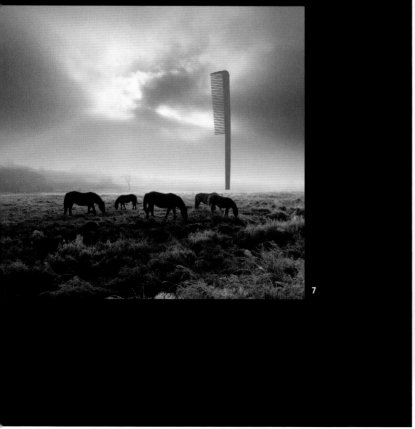

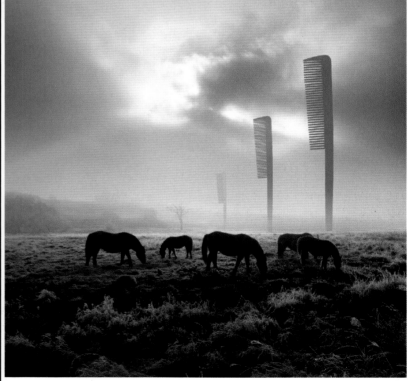

The final image

Come Join Us Andrii Bondart

A Slavic mermaid, also known as a rusalka, is nothing like Disney's Ariel; she is a dark, sinister, undead creature. According to Ukrainian mythology, an unmarried girl would turn into a rusalka after committing suicide by drowning in a river or a lake. Later, these mermaids would lure any passing males into the water and tickle them to death. For this piece I wanted to depict a young lady on the verge of committing suicide with rusalkas surrounding her, trying to convince her to join them. I worked with two models on this piece: Emma was cast as the character of the young girl, and Gala (who is much paler), posed with her arms upright to be used for the mermaids.

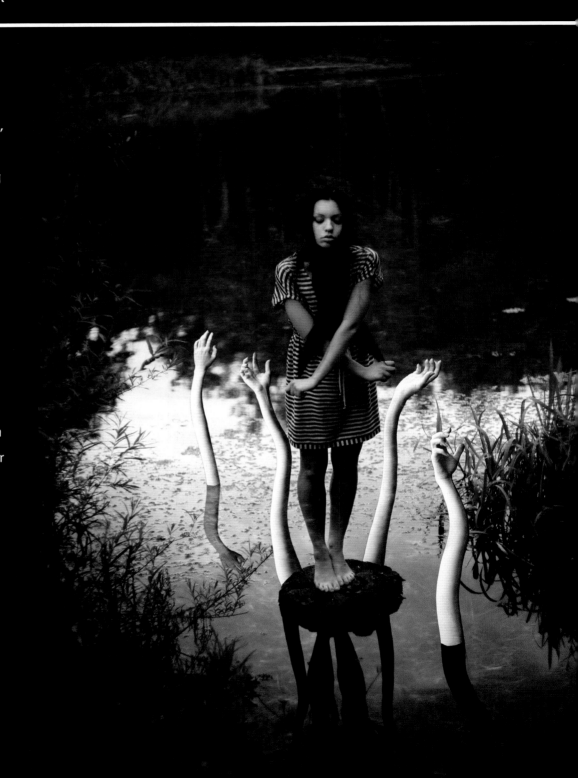

I shot these images with a Canon EOS 5D and a vintage Soviet Gelios lens. What the images lack in crispness, they make up for in painting-like softness.

TOOLS

Photoshop

1: CLEANING UP THE BASE IMAGE

The background image needed to be cleaned up of passers-by, bits of trash, and even some mosquito bites and bruises on the model's legs. I did this using the Patch and Healing Brush tools.

2: CROPPING THE HANDS

2a) I photographed Gala's arms against a blue background, which made them simpler to cut out. To make this process even easier, I highlighted the blues and decreased the yellows in the image (*Image > Adjustments > Selective Color*).

2b) By using the Magic Wand tool, I was able to select the blue background, and then invert the selection (*Select > Inverse*) to isolate the hands.

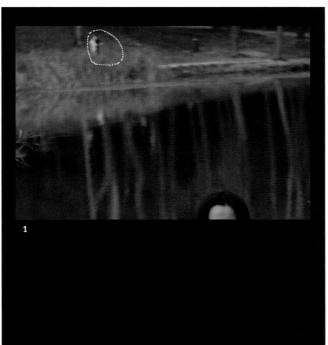

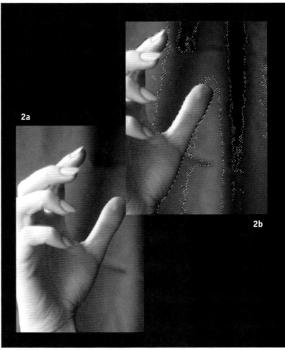

3: MOVING THE HANDS

3a) I selected the hands, moved them onto the base image using the Move tool, and resized them as intended with the Free Transform tool (*Edit > Free Transform*).

3b) I ensured that they looked pale in comparison with the base image by balancing the color and reducing the cyan while slightly boosting the magentas and yellows (*Image > Adjustments > Color Balance*).

4: FRANKENSTEINING THE ARMS

The term "frankensteining" refers to the process of cutting out and copying bits and pieces of a model to create a final body composite. This method is often used to create levitation images or to add new limbs onto a subject. Here, I used the technique to boost the surrealism of the image by making all of the waving arms echo the twisted trees and their reflections in the background.

4a) The "donor tissue" used to extend each twisted arm was copied from the lengths of the arms themselves.

4b) I selected the forearm section of each arm using the Lasso tool and copied each forearm onto a new layer. At this point I made sure that I named every layer to avoid possible confusion.

4c) Next, I twisted each arm with the Free Transform tool, and erased the extra parts with a soft Eraser tool. As soon as the extended segments of arms and hands blended together perfectly, I merged together their respective layers.

CONTENT AWARE EXTEND

Depending on the complexity of the body part that you are compositing, it might be possible to use the Content Aware Extend tool to elongate it. You can read more about using the Content Aware Extend tool on pages 58–59.

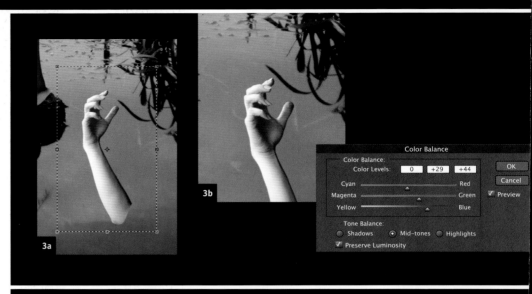

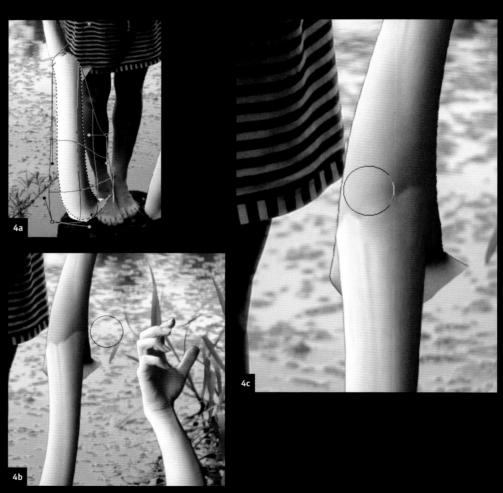

5: LIQUIFYING THE ARMS

When all of the manipulations were finished, I twisted the arms even more using the Liquify tool (*Filter > Liquify*).

6: EDITING THE ARMS IN THE CENTER OF THE IMAGE

6a) I first reduced the opacity of the arms before I selected the wood on the base image using the Magnetic Lasso tool.

6b) Back on each respective layer I erased any superfluous areas with the Eraser tool.

7: EDITING THE ARMS ON THE FAR RIGHT AND FAR LEFT OF THE IMAGE

This next set of arms were trickier to clean up.

7a) With the opacity of the layers set to 50%, and using the Eraser tool at 100%, I erased the excess flesh where the arm emerged from the water.

7b) I then changed the Eraser's hardness to 0% and its Opacity to 20% and used it on the stub end of the arm to replicate submersion.

6a

6b

7a

7b

8: ADDING REFLECTIONS

In order to increase the realism in this composition, I needed to recreate the reflections the arms would make in the water.

8a) The first step was to make a copy of each arm layer, which I did by selecting *Layer* > *New* > *Layer Via Copy*. Then, I flipped the arm vertically using Edit > Transform > Flip Vertical to create a mirror image.

8b) Next, I used the Perspective tool (Edit > Transform > Perspective) to try and mimic the angle of distortion proportional to the one we can see in the actual reflection of the female figure.

8c) Then selecting *Image* > *Adjustments* > *Hue/Saturation*, I darkened the image and changed the Hue to a less saturated yellowish-green.

8d) Finally, I altered the opacity of the layer to 70% and erased the bottom part of the hand to match the contour of the original hand sticking out of the water.

9: LIGHT AND DARK BALANCE

Next, I made sure to save a backup file with all the layers kept separately. Once that step was complete, I merged them all together.

I created a new layer via the Copy command and set the layer mode to Multiply with opacity at 48%. Then with the Eraser at 30%, I erased the parts I wanted to be lighter—the face, parts of the lake, and the hands.

10: ADDING A VIGNETTE

I then merged the layers, created another copy of the layer, and added a vignette with the Flashlight mode available under *Filter* > *Render* > *Lighting Effects* (Point Light mode could also have been used). After tweaking the effect's opacity I merged the layers again.

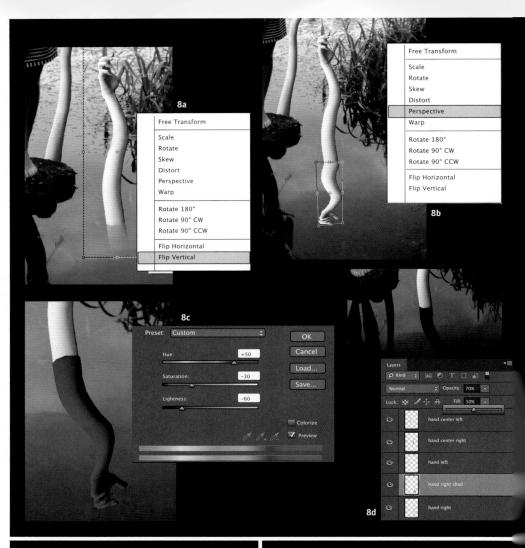

11: ADDING TEXTURES

I tend to use textures every now and then, and it's always fun to create your own. For this piece I used a simple image I'd taken of some grass as the basis of my texture.

11a) In a separate window I desaturated the image, duplicated a layer and placed it in Multiply mode, and then flipped it vertically.

11b) I then merged the layers, dragged the image into my composite piece, and used the Soft Light mode.

11c) The effect was a cool glow throughout the finished piece that water usually casts on objects near it, though I've erased parts of the texture from the model's face.

12: LAST TOUCHES

After adding the texture I decided to do some final tweaking to the brightness and contrast using Curves (*Image > Adjustment > Curves*). Adding a bit of grain (*Filter > Filter Gallery > Texture > Grain*) with the Intensity set to 12 and Contrast to 50 also made the final image look crisper and sharper when printed.

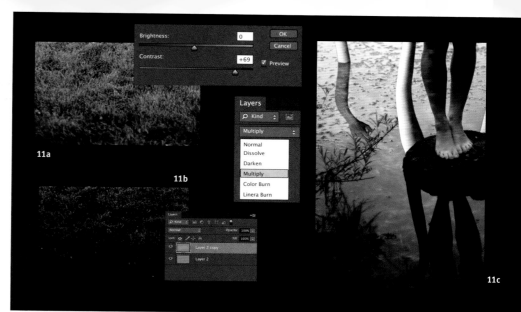

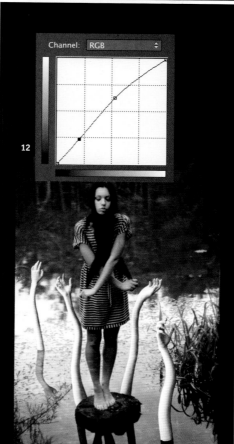

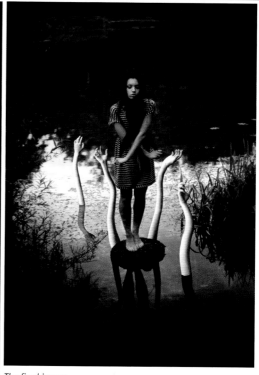

The final image

Headache Christophe Kiciak

I suppose everybody sometimes feels internally like a stranger, even though they might be in a friendly place. Something simply gets disconnected from reality, and suddenly everything around us feels meaningless. A kind of dream occurs: voices and sounds get distorted in the background, eyes stare at nothing. Then all of a sudden someone asks, "What are you thinking about?" Answering a question like that honestly is difficult. The usual answer is a commonplace: "Nothing . . ." Answering like this is much easier than trying to actually explain such complex feelings of alienation, but for this project I decided to try to create a picture that would accurately depict this feeling.

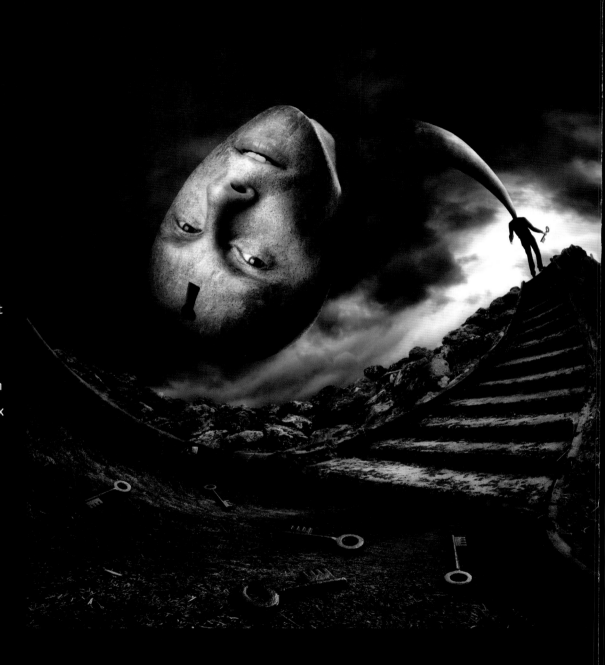

These were all images shot specifically for the creation of this project.

Color Efex Pro 4

Photoshop

1: CREATING THE CANVAS

First I needed to create my main canvas. For this project, I set up a square document of 5616 × 5616 pixels, but you can use any size you like. You're limited only by what your computer can handle.

2: IMPORTING THE SKY

I then simply added the photo containing the sky to a new layer, and positioned it so that the bright part was in the upper right corner of the canvas.

New

Name: Untitled–1 OK
Preset: Custom Cancel
Size: Save Preset...
Width: 5616 Pixels Delete Preset...
Height: 5616 Pixels
Resolution: 240 pixels/inch
Color Mode: RGB Color 16 bit
Background Contents: White
Advanced Image Size:
 180.5M
Color Profile: ProPhoto RGB
Pixel Aspect Ratio: Square Pixels

1

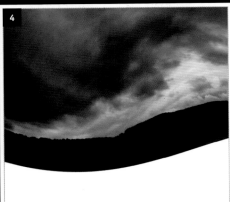

Create a new group

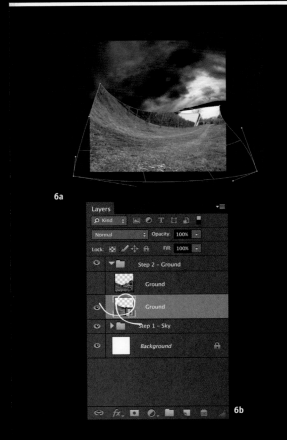

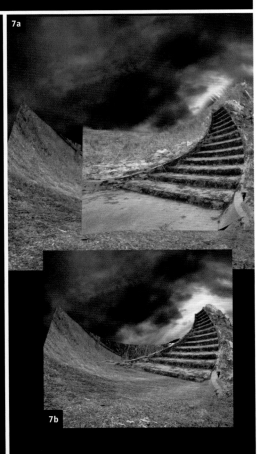

3: DISTORTING THE SKY

The fun began here. I distorted the sky creatively, using Photoshop's Warp tool (*Edit > Transform > Warp*) to create these curvy shapes. All of the Transform tools are great for different things, so feel free to use whichever option you want in your own work.

4: MODIFYING THE SKY

I then adjusted the tint of the sky. You can do this using various different tools, but for this image I used a Hue/Saturation Adjustment Layer.

I continued by darkening some parts and brightening others—adding these enhancements is totally optional, and how far you go depends entirely on your taste level. There are plenty of ways of editing a stormy sky, but my preferred method is to add a new layer, change its blending mode to Soft Light, then gently brush some black or white (using a round brush with 0% hardness, 5% Opacity) to darken or brighten various areas.

5: KEEPING TRACK OF YOUR LAYERS

I created a group and named it conveniently as "Step 1—Sky," then placed all my layers in it. (Sorting your layers is a great help when they start to add up.)

6: ADDING THE GROUND

6a, b) I created a new group called "Ground," and added a first layer: my photo of the path. As for the ground, I transformed it using the Warp tool.

7: INSERTING THE STAIRCASE

7a) Creating the staircase was tricky. I had to use two photos and blend them together to obtain the size I wanted. I manipulated the stairs as I saw fit and tried to position them on the canvas so that the topmost step sat just by the brightest part of the sky, leading the eye naturally upwards.

7b) Next I added a Layer Mask to my active layer, and painted in black to mask out some small undesirable elements of the image. I took my time to do this accurately as I knew it would give me a better final result.

8: THE ROCKS

In order to create the pile of rocks on the left side of the picture, I created a new layer group called "Rocks" and added to it four individual pieces of the base image I'd taken of moss-covered stones. I used the Lasso tool to select the four different areas on my base image, added the selections to the new "Rocks" layer, and blended them together. I then blended the melded-together rock pile into my main image, and finally, made sure to add the "Rocks" group above the path in the layers hierarchy, but under the staircase. To do the same kind of job in your own work you could either use Layer Masks, or the Eraser tool if you're comfortable with it.

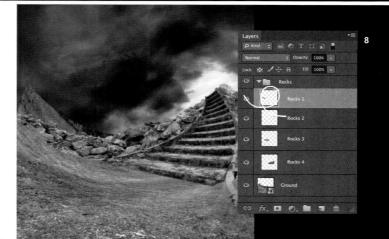

9: FINALIZING THE GROUND

I now finalized the layout of the ground by adding some borders to the staircase and the rocks (just like before, I used a selection tool to grab parts of what I needed from other photos and pasted them into my main scene). I had all of the elements, so it was just a case of moving, adjusting, and deforming all the separate parts to obtain a foreground that looked credible. I took my time to check all the joins between the blended parts to avoid visual inconsistencies.

Using a large number of Adjustment Layers in conjunction with Layer Masks, I adjusted the foreground to make it more dramatic. I wanted some harsh contrast, a desaturated mood, and strong, dark tones.

10: PHOTOGRAPHING THE HEAD

To incorporate the head into the scenery as realistically as possible, I shot a self-portrait with strong lighting coming from behind to simulate light coming from behind the clouds in the main picture.

11: PREPARING THE HEAD IMAGE

In Photoshop I manually masked the head as accurately as possible (I tend to use a graphics tablet for this kind of work as I find it more intuitive than the mouse). Ignoring my hair, I created the mask as if I were bald, then used the Stamp tool to copy and paste some facial skin to cover my hair. I then placed the final head as a new layer in the main image.

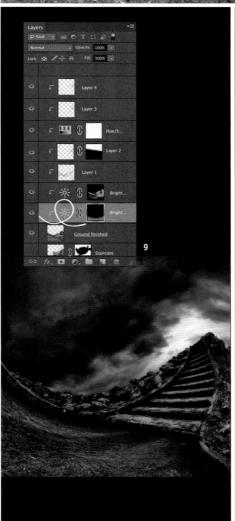

12: INSERTING THE HEAD IMAGE

12a) I positioned the head in the scene, desaturating it partially so that the skin was not too pink in comparison with its direct surroundings.

12b) I created the twisting neck with the Stamp tool. I didn't worry about being very accurate, just simply copying and pasting skin texture, then using the Eraser tool on the edges of the neck to adjust its shape.

13: ADDING SHADOWING TO THE HEAD

Next I added some shadows and highlights to the face and neck: I wanted the bottom part to be dark, and the upper part to be brighter. I achieved this by creating another new layer, changing the blend mode to Soft Light, and gently painting some black or white where needed. I used a very soft round brush at 5% Opacity, and tried to be very patient and accurate.

I made sure to apply the Adjustment Layers to the head as Clipping Masks, so that they adjusted only the head, not the rest of the composition.

14: TEXTURIZING THE HEAD

Finally, I applied some texture to the skin, simply photographing a wall with an interesting texture and pushing the saturation a bit to obtain a grungy look.

I put the texture in a new layer above the head and neck, and changed the blending mode to Overlay. I then added a Layer Mask to it and painted some black on the mask where I didn't want the texture to appear, such as on the eyes and teeth. I also made some other minor tweaks, such as adding a new layer in Color Blend mode and painting some red around the eyes for a more disconcerting look.

15: ADDING THE BODY

15a) This step was simple, since all I needed was a silhouette. I took a photo of myself against a strong light, then masked out my body.

15b) I wanted to adjust the posture, bending it slightly, so I decided to try using the Puppet Warp and Liquify tools; these are very powerful, and, to a degree, made it easy to move an arm or a leg.

Also as the body wasn't dark enough (a bit too colorful for my taste), I simply added new Adjustment Layers to desaturate it and lower its brightness.

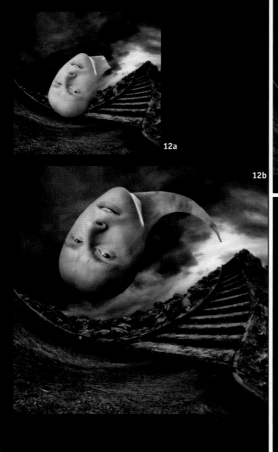

12a

12b

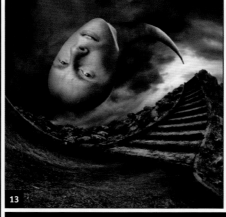

13

14

15a

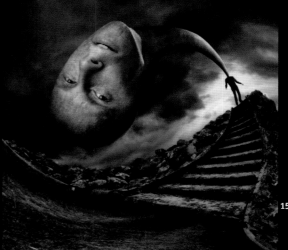

15b

16: SCATTERING THE KEYS

16a) I took several photos of an old-fashioned key, remembering for consistency to use the same lighting setup as the previous shots.

16b) Next I masked the keys out, pasting them into the scenery. I used the Free Transform tool to adjust the sizes and perspectives of the keys as needed. In the main image I positioned five keys on the ground, then one last one in the character's hand.

I also made sure to create shadows for each key. For this, I simply duplicated the layer containing the key photo, turning it black (*Image > Adjustments > Exposure*), blurring it a little (*Filter > Blur > Gaussian Blur*), and positioning it slightly under and to the left of the key. I then repeated the process for each key.

17: EXCISING THE KEYHOLE IN THE FOREHEAD

I also created a keyhole in the forehead of the character. This was tricky to do; I needed to take my time and be patient.

There were many methods I could have used to get the result I wanted, but I decided to paint the keyhole directly onto the forehead using a standard round brush. I wanted the hole itself to be pure black, and the "sides" to be drawn using the dark skin tones already in place.

I also could have used a photo of a real keyhole to guide me. It would have been easy to put the photo in a layer above my work on a low opacity so that I could still see what I was doing.

18: TIDYING UP

At this point I was almost finished with the image; all I needed to do was to finalize the tones. I used a Photoshop plug-in from Nik Software called Color FX Pro 4. Here are the tweaks I made using the plugin, and some alternative methods of getting the same effect using Photoshop or another image-editing program:

I added some extra contrast to the image. With Photoshop or another image-editing program I would recommend using Curves or Levels in a new Adjustment Layer to get a similar effect.

I added some more contrast to the corners with Color Efex Pro 4. To get this effect in Photoshop or another image-editing program I would recommend painting in some black using a soft brush at low opacity.

I also raised saturation of the reds and blurred some of the objects' edges (especially the edges of the keys) so that they didn't look so much as if they'd been pasted into the scene. The same tools in Photoshop or another image-editing program will give you the same effect.

I was now satisfied with how my image looked. My advice to all surreal photographers is not to hesitate to experiment—not only is it a great way to learn and improve, it's also a huge amount of fun.

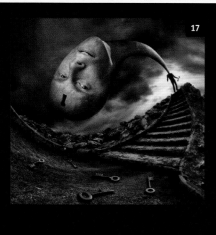

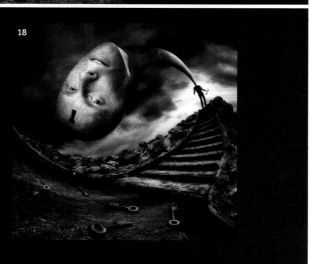

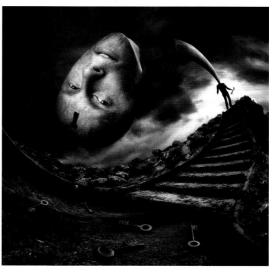

The final image

Learning to Fly Nikolai Gorski

I shot this photograph in the art nouveau Printemps department store in Paris, in April 2010. Technically, it's a panorama made from three separate frames taken with a Nikon D90 camera and a Sigma 10-20mm lens. The images were then developed using the Hugin panorama stitcher.

This image almost never saw the light of day. I wasn't convinced that the panorama would come to anything much after stitching it together, and ignored the shots for almost nine months. When I did finally process the panorama, I still wasn't happy with the result, and archived the image. But a lightning strike of inspiration came in the form of the Pink Floyd song, *Learning to Fly*. Suddenly the words of the song and the image of the staircase had merged themselves together in my mind—the stairs were attempting to fly. So I returned to the panorama, and within about 40 minutes, I'd produced the final version.

I rotated the image clockwise 50 degrees, converted it to black and white, and dodged and burned here and there to emphasize the subject.

For me, the image resembles a bird attempting to fly, but other viewers see a fly or a moth, a teasing tongue or a Möbius strip. It is, though, a perfectly surreal image: a dreamlike step into the imagination, where reality has been skewed—quite literally—and as the viewer looks at it, they search for a familiar interpretation.

Swan Lake Eve Livesey

Swan Lake is an image that reminds me of the aspirations of human beings and the dedication and desire that are required to make your dreams come true. The dancer seems fragile but strong, and the mirroring of her posture with that of the swan along with the softness of the textures adds a wonderful, delicate surrealism to the scene.

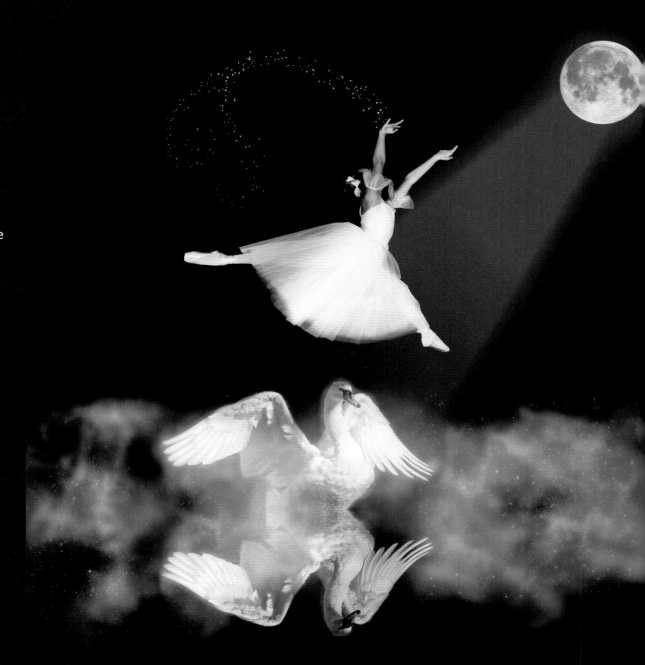

Whether you already have your own or you need to find images from a stock agency, spending the time to find exactly the right images pays off in the end as you'll spend much less time editing the images. I chose this ballet-dancer photo from Photl.com as when I imagine aspiring ballet dancers I think that their ideal ballet must be *Swan Lake*. I chose this photo because there is such a wonderful feeling of motion in the dancer's leap. The swan image is my own, one I'd previously manipulated to achieve a magical, twinkling effect.

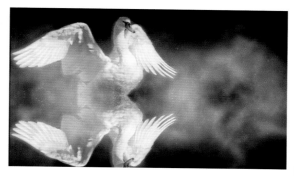

Above: Ballet Dancer © Studio CL Art, photl.com

Photoshop

1: CREATE A NEW FILE

I felt a square image was ideal for this composite, so I created a document measuring 6000 × 6000 pixels with a resolution of 300 ppi. I set the color mode to 8-bit RGB and the background contents to transparent, which I knew would help when I cut out the elements of the composite.

2: ADD ELEMENTS

When I created my file and built up the composite. "I opened the first image to be included (the dancer) and cropped it to exclude as much of the background as possible.

Then I transfered this layer into the new document using the Move tool. Now I had two layers: the transparent background which I titled Transparent Background, and the ballerina photograph. I find it very helpful to name my layers.

3: CUT OUT THE MODEL

I next cut out the ballerina. A method of cutting out common for pre-CS3 versions of Photoshop is to use the Eraser tool, slowly erasing around the edge of the subject and changing the size of the brush head with the + and - keys as necessary. This is something of a traditionalist's approach, but does give great manual control.

In versions of Photoshop from CS3 on, you can select the Quick Selection tool via the toolbar, and with a large brush click once in the center of your subject. Photoshop automatically detects the edges of the subject and makes a selection for you. I used this method, and to refine my selection, clicked (or dragged on) any areas of "spread" bleeding outside the edges of my subject, shift-clicking on parts I'd missed, and reducing the brush size with the - key as my refinements became ever more precise.

When using the Quick Selection tool, note that as you hold down the Shift, the central minus symbol switches to a plus sign to indicate you're about to add to the selection rather than reduce it.

4: SOFTEN THE IMAGE

Once I removed all of the background, I set the Eraser tool's brush to a larger size and the Opacity to 5% and went over the whole model with the Eraser tool. This softened the edges of the image and made it look less "cut out."

The edges of the tutu were already semi-transparent, but by using a large brush set to 30% Opacity I was able to allow the new background to show through the net.

5: ADD THE SECOND ELEMENT TO THE COMPOSITE

Next I needed to add the second element to my composite. In this case, it was a photo of a swan that I'd already treated with a filter to give it a dreamy look. I opened the file and added it to my composite as a new layer using the Move tool.

6: SCALE AND HARMONIZE THE IMAGES

At this stage, the proportions of the ballerina and the swan needed to be adjusted in order to look right in the final image. I scaled the ballerina and the swan on both layers using the *Edit > Transform > Scale* option. I positioned them with the Move tool. I then realized I needed to harmonize the tones and colors of the ballerina and the swan. I started by desaturating the image to match the tone of the ballerina with the swan (*Image > Adjustments > Hue/Saturation*).

A diffuse glow is a good touch; I experimented with just how much I wanted to add (*Filter > Distort > Diffuse Glow*).

7: ADD A BACKGROUND

As the image seemed to have evolved into monochrome, I decided to add a plain black background. To do so, I selected the Background layer, then filled it black using the Paint Bucket tool, though I could also have created a solid color layer.

8: BLEND THE LAYERS

Now that the two main elements of the composition were in place on the black background I needed to blend them together to make them look as though they were one photo. Because it would look strange with part of the image being warped and the rest left unwarped, I chose the *Edit > Transform > Warp* command to extend the background of the swan image to the right, at the same time ensuring that I didn't distort the swan in the process. The dashed arrows show the movement already made, and the two control points that still need to be moved.

Next I added some mist to the left of the swan using a glittery smoke brush. If I was concerned about making a mistake, I could have done this on a separate layer. You can thin out and blur mist using the Eraser and Blur tools.

9: CORRECT THE LIGHT

Next, I wanted to correct the light on both elements of the image so that it looked consistent, as if it were falling from the same direction with the same degree of intensity. I decided to include the full moon as the purported light source, which enhanced the dreamy feel of the composition. Adding another layer, I used a moon brush purchased under license from obsidiandawn.com to place a full moon in the top right corner of the frame. A moon brush can be used to paint (or almost stamp) a moon onto your scenes, and in this case its inclusion helped to balance the composition.

..

10: DODGE AND BURN

I then created another layer and added a light beam from the moon using a Light Beam brush, positioning and sizing the beam with the *Edit > Transform* options.

Taking into account how the light was falling on the ballerina and swan, I used the Dodge tool to lighten and the Burn tool to add shadow to their layers, enhancing the realism of the effect. There are many ways of assessing where the light should fall on a subject, but my most trusted method is to create a new layer and sketch lines from the light source onto the subjects using the Pen tool. I then delete this layer when I'm done with it.

..

11: FINAL COMPOSITION AND A TOUCH OF MAGIC

Looking at the composition, I felt it needed to be more balanced, so I added some magic dust to the left side using a glitter brush purchased from obsidiandawn.com. I also softened the ray of light by reducing the Opacity to 29% on the Layers palette.

When I was happy with my image, I saved it as a PSD file with all its layers intact, allowing me the option to use the cut-out elements in another composition or make alterations at a later date.

Finally, I flattened the image using the *Layer > Flatten Image* option and saved it as a JPEG.

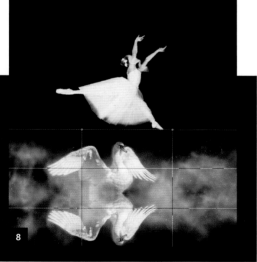

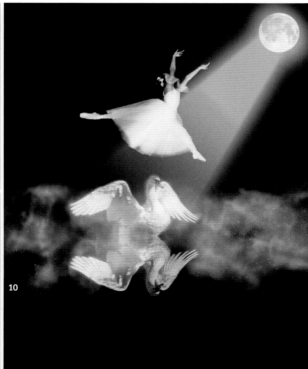

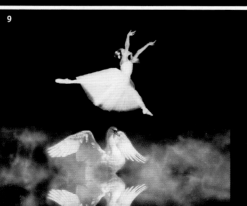

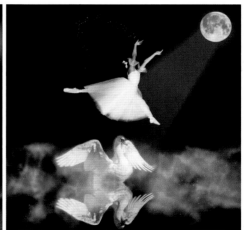

The final image

Untitled Sarolta Bán

The concept behind this image
was to make an image that
had a light and playful mood,
something almost weightless—
like a child might feel. I thought
a seesaw could symbolize this,
but by adding the butterflies the
image was turned into a surreal
scene with layers of meaning.
Usually my ideas come to me
while I'm working; it was no
different in this case.

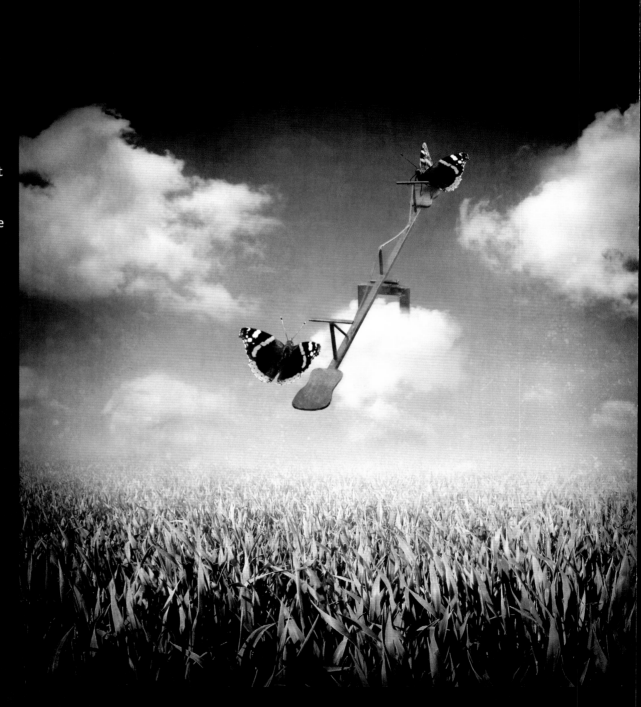

These images were all taken on a summer vacation, so without any chance of reshooting anything, I had to find a way to work with what I had. I took the photo of the seesaw at Lake Balaton in Hungary, at a playground by a beach where I used to play a lot when I was a child.

Ps

Photoshop

1: CUTTING OUT THE SEESAW

First, I cut out the seesaw from its background using the Polygonal Lasso tool. Once I had made the selection I duplicated the layer, inverted the selection, and deleted the surrounding grass. I could have used Layer Masks, but I prefer to keep it simple and work using only what I really need.

2: RESIZING THE SEESAW

The seesaw was originally a double seesaw, but I reduced it to a single one quite easily. All I had to do was to cut out the superfluous extra bar, resize things a little, and move the left upright in closer to the rest.

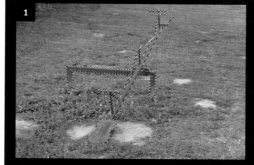

3: CUTTING OUT AND RESIZING THE BUTTERFLIES

I used the same cutting-out process for the butterfly photos. Then it was simply a case of experimenting and trying to find a good size and placement for them against the seesaw.

Untitled Sarolta Bán

4: FLOATING ON A CLOUD

4a) To further the aura of lightness I thought that the seesaw should be in the air, and found it looked best placed on a little cloud. So the seesaw would be visible against a blue sky, I changed it from blue to red using the Replace Color tool (*Image > Adjustments > Replace Color*).

4b) I created the cloud from several photos I had of clouds, experimenting until I achieved the form that I wanted, and then layering it with the butterfly-seesaw group. To ensure that the combination of seesaw and cloud looked real, I decreased the opacity of the cloud around the legs to give it a transparent appearance.

5: CREATING THE BACKGROUND

My pictures are mostly squares, so I cropped the background image for the scene into a square-shaped composition. Then I added some light layers by creating a new layer, painting with a soft white brush where the image needed it, and blurring it with Gaussian Blur (*Filter > Blur > Gaussian Blur*). Next I changed the layer mode to Soft Light, reduced the opacity, and used this over the center part of the sky and horizon.

5a) After the light, I added a soft vignette with the Gradient tool. To do this I created a new layer and selected the Gradient tool from the toolbar.

From the gradient picker on the Options bar I selected the Transparent effect and set the Opacity to 30% in Normal mode (I could also have used Multiply mode).

5b) I dragged the cursor from the edge of the image toward its center, covering about a third of the image. I then repeated this for all four edges.

REPLACING COLOR

> If you need a refresher course on how to replace colors, take a look at the guide on pages 60–61.

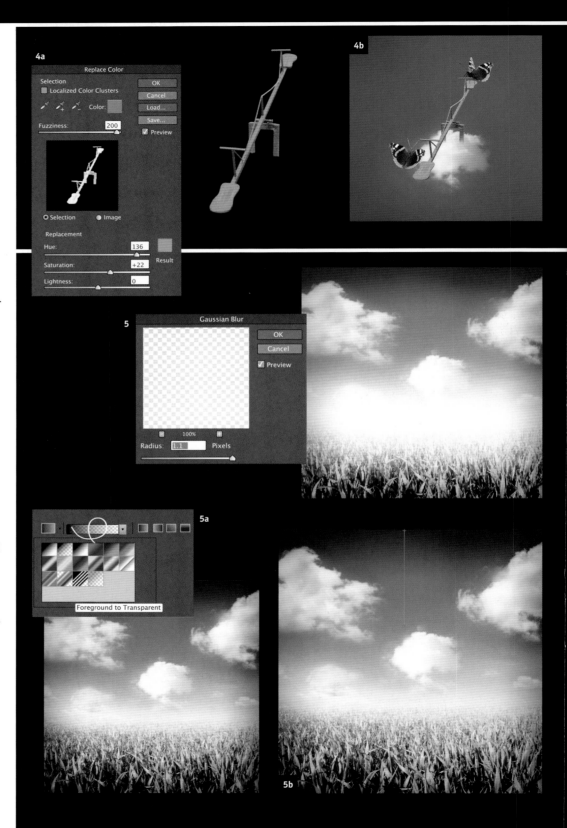

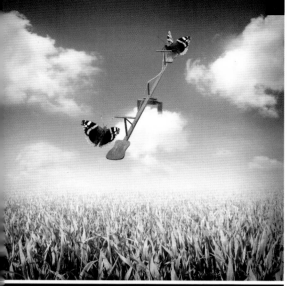

6: ADDING THE BUTTERFLIES

Next I placed the seesaw-butterflies-cloud group onto the background. With hard-edged cut-out elements, like the seesaw and the butterflies, it can be good to use the *Layer > Matting > Defringe* option, set at one pixel, for better blending.

The butterflies needed some shadow, especially the upper one. I placed the shadows on new layers between the seesaw and the butterflies, painting with a small black brush where the shadow would naturally appear, and adding a touch of blur. When doing similar work you will probably find that you can achieve the best natural-looking effect by playing with layer modes, opacity, and soft deleting.

7: COLOR ADJUSTMENT

After putting all the elements into place, I started the color and contrast adjustments. I felt that the color version of this picture was too much, so decided to convert it to sepia.

I created a new Fill Layer (*Layer > New Fill Layer > Solid Color*) and selected a gray tone from the color picker for it. The ability to choose from so many tones and shades allowed me to apply the right effect to the image. Note that if the mode is set to Normal it will cover the background image entirely, but by changing

the mode to Color and retaining the opacity at 100%, the background image will be revealed with a beautiful sepia effect. You can intensify this with the addition of some texture.

It's also possible to create a sepia effect by inserting a new Black and White Adjustment Layer (*Layer > New Adjustment Layer > Black and White*), and placing a Photo Filter Adjustment layer over the top of that (*Layer > New Adjustment Layer > Photo Filter*). Then from the drop-down select Sepia (or Deep Yellow).

8: ADDING TEXTURE

Adding texture (for example by layering a photo of some paper over the image, applying some Gaussian Blur, and then playing with the layer modes and opacity), can create interesting color and lighting effects. In this case I added several different textures from my archive, importing them into Photoshop and layering them over the composite. Then I manipulated them by adding some blur and by adjusting the layer modes and different opacities until I had an effect that I thought worked.

If you don't have your own texture photos, you can add texture effects from Photoshop by applying a textured filter such as Grain (*Filter > Filter Gallery > Texture > Grain*). You can then adjust the type and degree of grain to your preference.

9: FINALLY

Lastly, I adjusted the color and contrast to achieve the look that I wanted, and *Untitled* was complete. My advice to aspiring digital surreal image-makers is to remember that you can add as many Adjustment Layers as you need—keep working until you achieve exactly what you want.

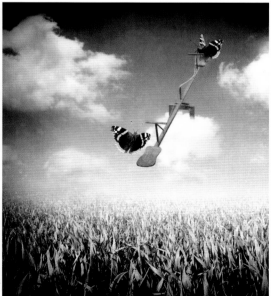

The final image

Dear Deer, You Don't Belong Here! Stella Sidiropoulou

Dear Deer, You Don't Belong Here came from a moment's inspiration. The creation of the image wasn't the difficult part; rather it was ensuring the emotional connection of the elements in the photo so that the result wouldn't be some ordinary Photoshop work. I wanted an image that anyone would see with pleasure again and again. That's what I imagined, and I hope what I achieved.

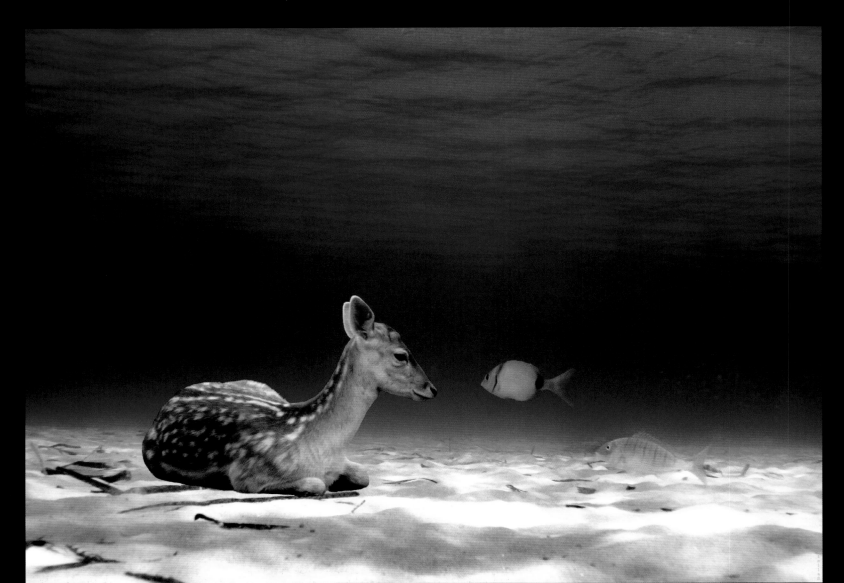

The underwater photos where shot with a Pentax Optio WG1 in Chalkidiki, Greece. The sea there is fabulously clear, and I was instantly captivated by the underwater world. The photos of the deer were taken with my Canon EOS 550D in Xanthi, Greece. The hotel where I was staying had a small zoo nearby, and the deer were there, relaxing and being so beautiful I just had to photograph them.

Photoshop

1: CREATING THE CANVAS

1a, b) My first step was to import my background image into Photoshop and use the Lens Correction filter (*Filter > Lens Correction*) to straighten the horizon.

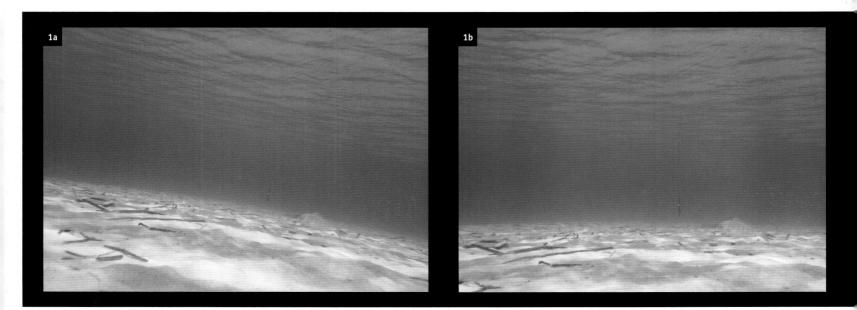

Dear Deer, You Don't Belong Here! Stella Sidiropoulou

2: SELECTING THE DEER

I next selected the deer on the right side of the photo using the Quick Selection tool. If you need to tidy up the selection, you can always use the Refine Edge tool. (See more on the Refine Edge tool on page 57.)

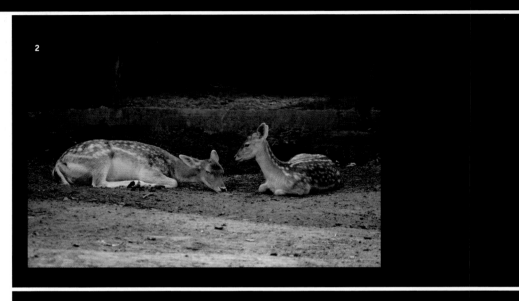

3: PLACING THE DEER

3a) When I had decided where I wanted the deer in the composition, I copied and pasted it onto the background image (*Edit > Copy; Edit > Paste*). It would still be easy to move if I thought its placement didn't look quite right, though.

3b) I then selected the copy of the deer and rotated it on its vertical axis so that it was facing into the composition, rather than looking out of it. To change its orientation I right-clicked on the selected element (in this case the deer) and then chose Flip Horizontal from the menu.

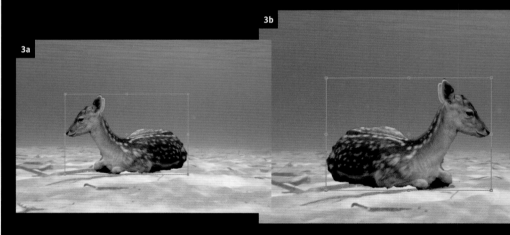

4: ADDING THE FISH

I copied and pasted the fish into the scene using the same method as for the deer. Then I straightened them using the Free Transform tool. You'll find the Free Transform tool in the menu when you right-click on the image.

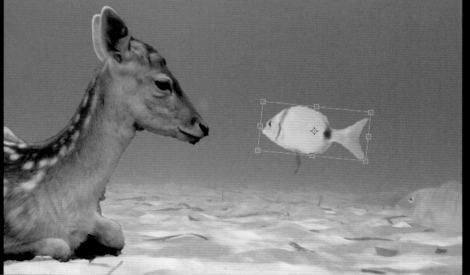

5: CLEANING UP THE IMAGE

When all of the elements were in place, I used the Clone Stamp tool to tidy up the background around the inserted images. This helps to ensure that the different elements blend into the composite seamlessly, and don't appear too super-imposed.

It isn't an easy process, but I prefer to use the Clone Stamp tool because I feel that when using it I am in total control of the edits that I'm making.

..

6: INTENSIFYING THE COLOR

Now the image was ready for final processing. In particular I thought that it needed to be bolder, so I used HDR toning (*Image > Adjustments > HDR Toning*) to boost the intensity of the colors. If you don't feel confident using HDR toning or don't want to flatten your image (HDR toning only works on flattened images), there are many other ways to increase color intensity in Photoshop. I use HDR toning because I like the results that it gives, but you might want to consider adjusting the saturation or tweaking the color balance.

Upon completing my surreal image, the last step was to name it. I settled on *Dear Deer, You Don't Belong Here*! I think it looks as if the fish is trying to stare down the deer and send him back where he belongs. The final image wasn't what I'd imagined before I began the composition, it came to me as I worked through the process. It's not so unusual for inspiration to strike as you're processing. But then again, it happens the other way around, too!

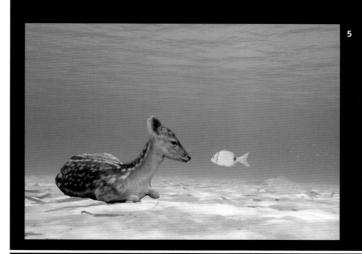

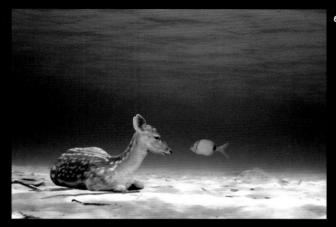

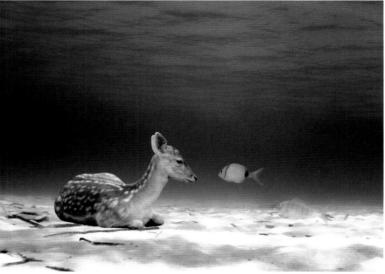

The final image

Memoirs Lisa Karlsson

When creating *Memoirs* I wanted to portray how I see memories, which is that they are like windows to past experiences and feelings.

I see memories as a kind of organized chaos that includes experiences and feelings arranged by time. A wall full of windows felt like the perfect symbol for this: closed windows representing locked-away memories, and those wide open for the ones you want to revel in. The idea also pleased me as even though a window might be closed, what is inside is still visible; thus every experience and memory a person has still shapes them as an individual. The possibility to open and close windows symbolizes both the choice of when to remember, and the choice of when to learn from your experiences.

But the picture alone was still no more than an image of a building—I needed a portrait for the concept to become more visible. I started experimenting with lighting to get the right kind of silhouette for the portrait. After many attempts I hit on an arrangement that had harsh light falling from the side, and so I managed to achieve with a self-portrait the melancholy feeling I wanted.

In Adobe Photoshop I merged my portrait with the base image, placing the self-portrait layer on top, and setting the blending mode to Screen. I used a soft Eraser tool on the self-portrait layer in the parts where I wanted the image of the building to shine through completely—for example, on the right eye. I also used several layers of Curves in specific areas to enhance the shadows and highlights.

And with that last adjustment, *Memoirs* was done.

The origin of this image owes a lot to serendipity. One day I happened to be looking through a series of pictures taken in Copenhagen some years ago, and on finding this picture of a building, an idea took root. The concept of memories had been on my mind for quite some time, but it wasn't until I found this picture that the idea took solid form.

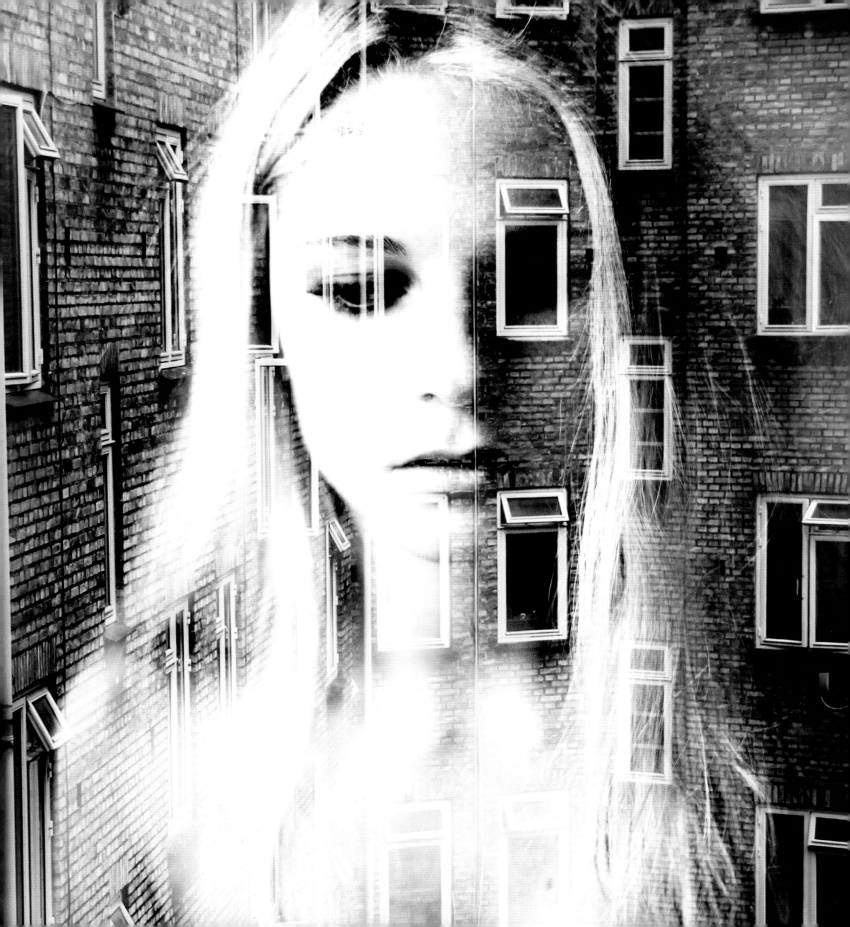

To Dream the Dream of Seagulls Marc Ward

Albert Einstein once said that "Reality is an illusion, albeit a very persistent one." In my work I use real images to produce illusionary and surreal composites. Sometimes I go in search of specific objects to photograph, and other times I search my library of collected images to find the perfect pieces to assemble something new. This example is the result of the latter process.

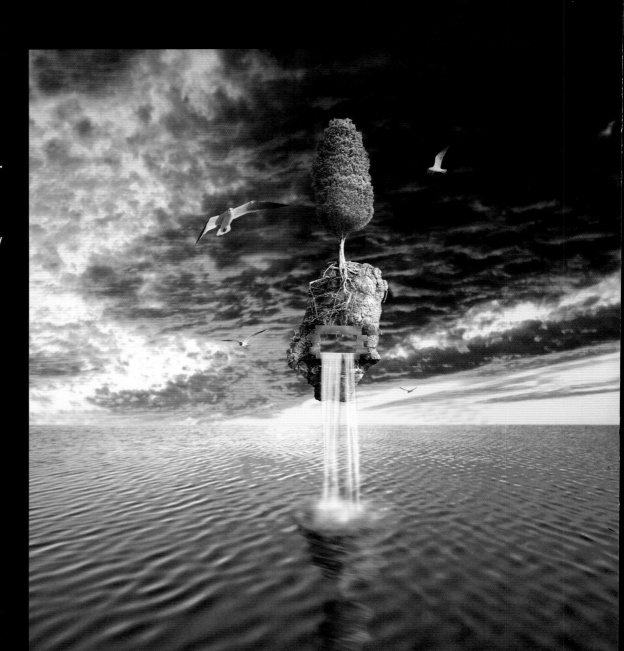

I keep a large photographic collection of "things." Photos of clouds, water, animals, and other interesting objects take up large sections of my hard drive. They are the toolbox that I use to assemble my images. Many of these component images have been prepared for compositing by being "deep etched," or removed from their original backgrounds, before I save them. This way, I have a large selection of images ready to be inserted into composites as and when I need them.

Photoshop

How light reflects and how it falls on objects is the key to making composite images that feel and look right. Pay attention to your light's direction and how it lands on your subjects. If all the light sources and directions don't match, the viewer will feel a sense of unease and not accept the vision you're trying to create.

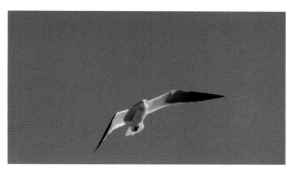

1: THE BACKGROUND

1a) I started with a background made up of sunset clouds that I shot quite by chance one day while out for a drive, pulling off the road to point my camera at the sky.

1b) My next step was to enlarge the canvas to make room for the foreground by going to *Image > Canvas Size*.

1c) With the canvas enlarged, I inserted the water image that was shot from a boat at sunset into the newly created space. The two combined formed the background.

..

2: THE TREE

The image of the tree was shot at the same time as the lake; as you can see, I had already removed it from its background. I did this by using the Lasso tool; once I'd made the selection I duplicated the layer, inverted my selection, and deleted the extra landscape that surrounded the tree. On my new layer I centered the tree on top of the sky and water background.

..

3: THE HOLE IN THE ROCK

A small window that I'd shot while in Barcelona was then placed on top of the rock at the base of the tree. Next, I merged together the window and tree/rock layers. This allowed me to erase the inside of the window so that there appeared to be a hole in the rock. If the two layers were not merged, I wouldn't have been able to erase all the way through the rock.

..

4: THE REFLECTION

4a) The reflection of the rock and tree was a copy of the tree-and-rock image that had been previously placed beneath the original, but inaccurately as opposed to perfectly covering the other. My next step was to apply a Motion Blur filter (*Filter > Blur > Motion Blur*), to give the illusion that the reflection was being cast on moving water.

4b) I adjusted the angle of the blur to match the direction of the water and then experimented with the intensity of the blur to get the amount I wanted.

4c) I then reduced the opacity of the image in the blending layer to make the image seem to become part of the water.

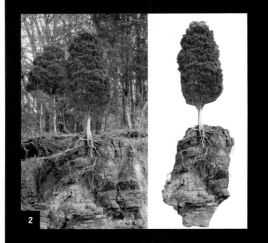

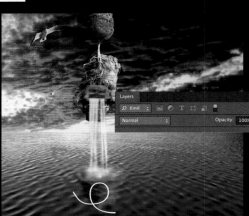

5: THE WATERFALL

The waterfall was deep etched from a shot of a waterfall near my home. I positioned it so that it appeared to be flowing from a window in the rock. By using the Transform function I elongated the waterfall so that it flowed all the way down to the water below. On a new layer, I then took a white-colored brush and created some splashes of water where the waterfall ended.

6: THE SEAGULLS

6a) I shot the seagulls from a balcony on the Gulf Coast of Florida. As previously, I'd already removed these birds from their backgrounds ready to be placed in the image. I positioned each bird (as with all other components) on its own layer so that they could all be moved around easily or removed according to the needs of the composition.

6b) To make it seem as if the seagulls were receding into the distance, I reduced the opacity of their layers. This put the impression of a haze of atmosphere between the birds and the viewer and helped achieve a feeling of depth. This is a technique that works for any element of any image that you want to present as possessing some depth.

The final image

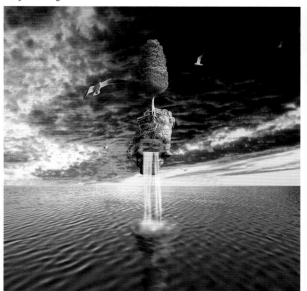

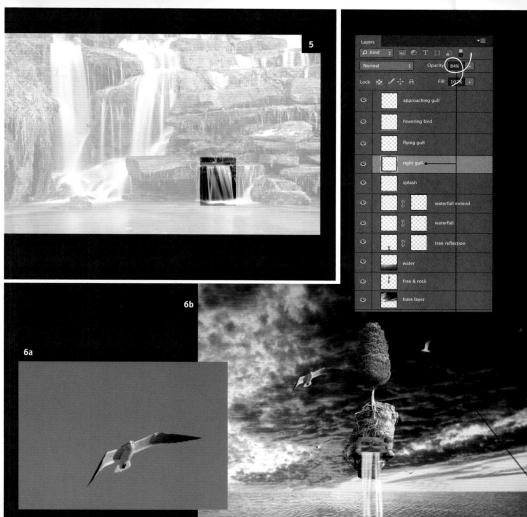

CHECKERBOARD

Any time that you see a checkerboard background you are working on a transparent layer that can be placed over another layer. The checkerboard will disappear when these type of images are placed over or on top of another image.

The Spectators Miss Aniela (aka Natalie Dybisz)

The Spectators is a composite image made up of four shots of the model, Bella Grace, sitting in the chairs of an abandoned theater. The image was shot during a workshop where I was demonstrating surreal techniques and how to achieve interesting results with composites to a group of students.

The technique of cloning a figure, or "multiplicity," is very simple. In this case the technique was applied at the post-production stage, but in order to get a good result it was important to shoot the images in a particular way. This kind of shoot requires a certain amount of preparation, keeping the final image in mind.

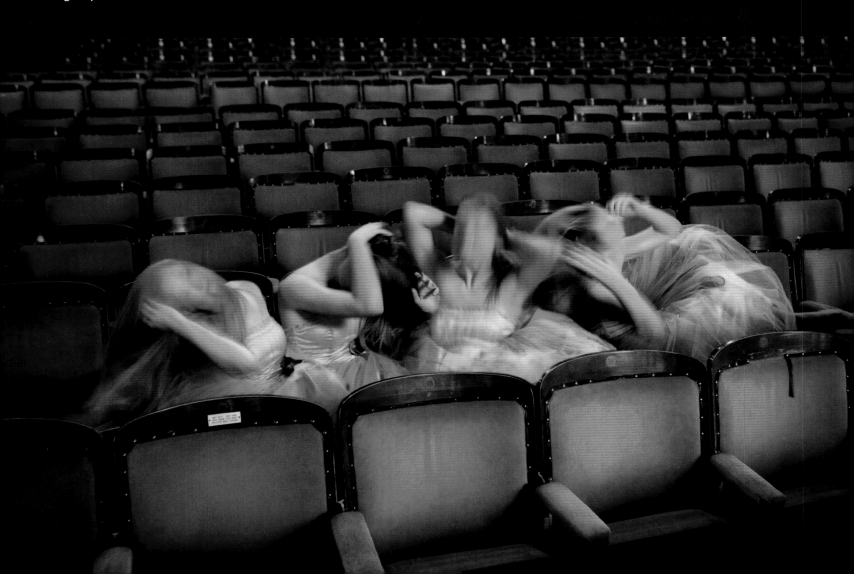

The technique used to create the multiple figures was very straightforward. I had Bella sit in each seat in turn while I kept my camera locked down on the tripod, and chose camera settings that allowed for motion blur in-shot so that her facial features and limbs would be distorted. I generally do not like to fake blur in post-production, so I try to make a decision on the spot about whether or not I can achieve it in-camera.

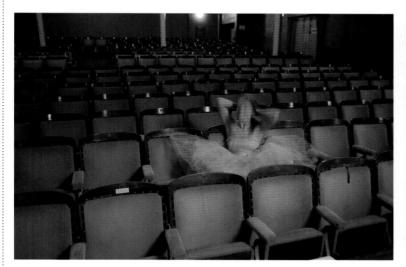

TOOLS

Photoshop

The Spectators
Miss Aniela (aka Natalie Dybisz)

1: GETTING THE ANGLE

First I chose the angle at which I wanted to shoot. Once I had done so, it was important that I kept the camera still in this position, and did not move it throughout the shots. This meant that I had to pick the right composition to keep the consistency.

I wanted to shoot close to the seats, so I erected my tripod at a high angle, but from a height at which I could still see the face of the model, Bella, without feeling as though I was too high above her. I also chose a particular angle, titled slightly to one side, so that the chairs moved across the frame diagonally, giving the impression of depth without turning the portrait into a profile shot.

All of these choices were made on the spot. I only realized their importance when I shot an image in the same seats at a subsequent workshop, which didn't work as well.

2: THE MODEL

The images were taken at $f/3.5$ and ISO 400, with a shutter speed of 1/5 second, using only the ambient light. By the end of the shoot I'd taken about 20 different shots of Bella in various seats and poses, all with the same composition in-frame.

3: THE MASTER IMAGE

In Photoshop, I chose an image that would be the main picture onto which the other figures would be placed once cut out. For the master image I chose the shot of Bella in a central position—the shot I liked the most. If you end up doing something similar in a project of your own, an alternative method I'd recommend would be to start with a "blank" shot of the scene. Starting with this blank slate and beginning to build your figures from scratch gives you a usefully large amount of flexibility.

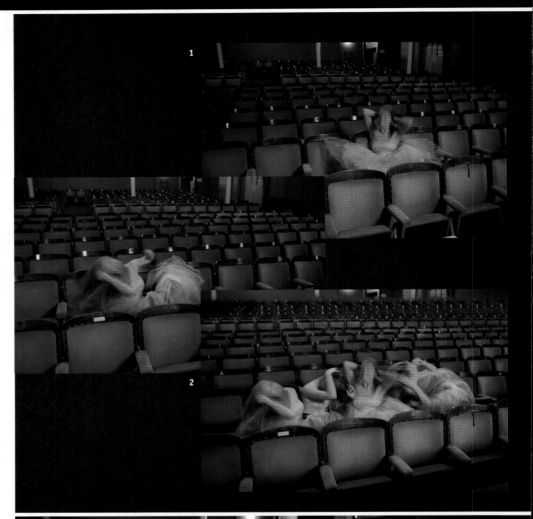

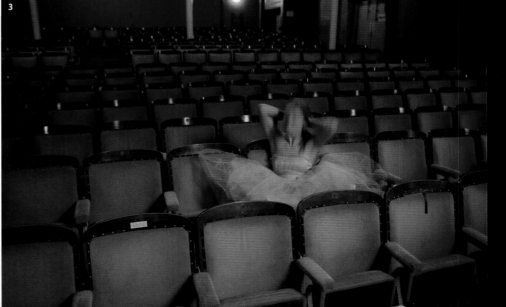

4: CUTTING OUT THE SECOND FIGURE

4a) Opening up a second picture, I used the Pen tool to place a series of points around the figure (not too close to the edges), and then completed the path by clicking the first point I had made.

4b) To cut out the piece without taking any of the background with me, I made sure that the Pen tool settings on the Options bar were set to Paths, Pen tool, and Add to Path Area. To make a selection from this point, I navigated to Paths next to the Layers palette (if you cannot see the Paths option, select Window in the Options bar at the top of the screen, and make sure Paths is checked). I then was able to see the work path I'd created with the Pen tool. Click on this with the CMD key (on a Mac) or CTRL key (on a Windows machine) pressed down, or right-click and choose Make Selection.

The marching ants now appeared around my figure, and I made a new layer from this via *Layer > New > Layer*. The marching ants then disappeared and the new layer appeared in my Layers palette. This new layer contained just the figure, duplicated from the background.

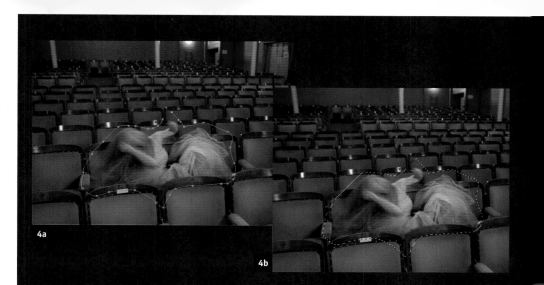

5: MOVING THE SECOND FIGURE

My next step was to select the Move tool and click onto the figure, holding it down and dragging it straight onto the master image. By holding down the Shift key while I did this, the figure landed in the same place it was shot, as the images were taken without the camera moving. However, I still had to deal with the inevitable edges around each new layer once placed, as there will always be subtle exposure differences between images.

6: THE OTHER FIGURES

For each new figure-containing layer I added a Layer Mask by clicking the mask icon at the bottom of the Layers palette and selecting the Brush tool. (On black, this erases the layer and on white, it brings back the layer.) I selected a small feather-edged brush and erased away the edges of the new layer so that it fit in with the image seamlessly.

I did this for each and every new Bella I added to my master composite. I placed the figures roughly to begin with because my main aim was to figure out how many figures

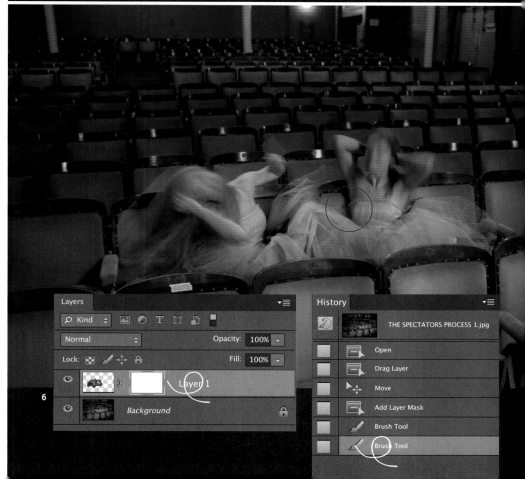

The Spectators Miss Aniela (aka Natalie Dybisz)

7: GETTING THE NUMBERS RIGHT

Although the post-production stage was straightforward, it was also a little fiddly. This was because I had so many choices from which to make a combination of the ideal number of figures. When I make a multiplicity composite, it is not the novelty itself of having multiple figures that I thrive on. The key for me is in creating an interesting shape within the frame. It is about achieving the right placement to form a particular line and motion between one figure and the next. In this case, because of the blurred ghostly poses, I wanted to achieve a pleasing flow between the figures, with a depth and shape to them as the viewer's eye moves across the frame.

Some of the figures could be moved from one seat to another, which added further choice. Once I had a range of figures, I toggled the visibility of each layer by pressing the eye symbol next to the layer in the Layers palette to work out the final choice and positioning.

8: PERFECTING THE BACKGROUND

I settled for four figures in the end, considering that any more was overcrowding. Other important changes were to give a slight crop, make the chairs retreat into infinity, and eliminate clutter at the back of the theater. I made these edits by merging everything to a top layer (once all the main compositing work was done) by pressing CTRL-ALT-Shift-E if using a Windows machine, and CMD-ALT-Shift-E on a Mac. I also could have flattened the whole image and saved it as a new file. Then, I used the Clone Stamp tool to carry on the lines of chairs to the edges of the frame. Later versions of Photoshop have a predictive Clone view, which allows you to align the Clone Stamp into place before cloning. This helped me to align the chairs as I swept the brush across.

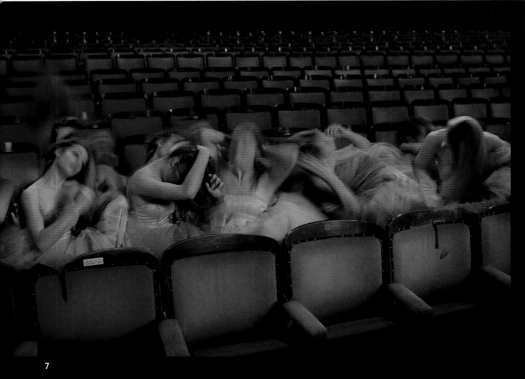

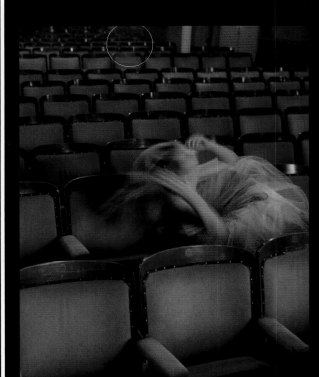

9: SAVING THE IMAGE

As with all my images, especially constructed trick-composites, I made sure I saved the file with all the layers intact as a PSD file, in case I wanted to go back to it later. After I had flattened the image, I saved it as a separate file (TIFF) and worked on the overall color adjustments.

...

10: COLOR ADJUSTMENTS

10a) I could see that because the colors throughout the picture were quite pale and light it was a good candidate for some tonal adjustments. I used the Curves and Color Balance tools to deepen the tones and play on the color scheme of black and red in the image.

10b) I also decided to enhance the color of the dresses by drawing a selection around the figures and adjusting the colors slightly in Hue and Saturation, making them slightly bluer.

10c) Finally, I added vignetting by going into *Filter > Lens Correction* and subtly adjusting the sliders to draw the focus of the scene toward the subject.

...

11: THE FINAL IMAGE

Inspired by the semi-derelict quality of the theater setting itself, I wanted this image to be an eerie scene of multiple figures, each alike and moving similarly, but in a frenzied way that suggested a possession or something similarly inhuman. I also liked the bold primary colors, and the combination of red, green, and vivid skin tones.

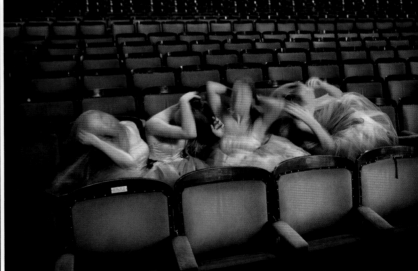

The final image

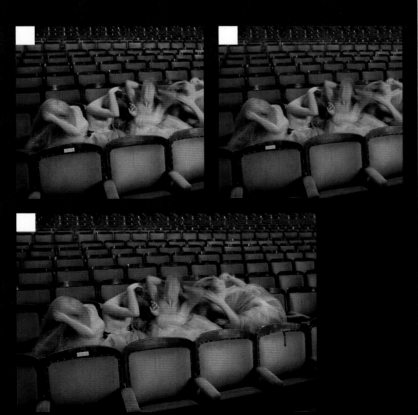

Glossary

ACTION—A series of steps performed with regularity, saved as a shortcut in Photoshop.

ADJUSTMENT LAYER—A layer devoid of image content, but housing effects that alter the appearance of the content of other layers in the "pile."

APERTURE—The opening behind a lens that allows light to pass through it and reach the film or sensor.

APP—Short for application: a program that can be run on a computer or smartphone; word-processing packages and photo-editing suites are both types of applications.

BRIGHTNESS—The relative lightness or darkness of an image.

CLIPPING MASK—Effectively a digital paperclip that ensures effects within a particular layer are applicable only to the layer to which the clipping mask is directly attached.

COMPOSITE—An image constructed using elements from a collection of different images.

CONTRAST—The range in difference between light and dark tones in an image.

CROSS-PROCESS—The act of processing slide reversal film with color negative film chemicals, and vice versa, to give unusual color effects.

CSC—Short for Compact System Cameras (or CoSyCa): a camera that, like a DSLR, benefits from interchangeable lenses, but rather than having a mirror and an optical viewfinder, has an electronic viewfinder, thus making it smaller and lighter. They are also known as mirrorless cameras or MILCs (mirrorless interchangeable lens cameras).

CURVES—A tool in an editing suite that allows fine control over the brightness, contrast, and tonal range in an image.

DIORAMA—A three-dimensional miniature scene.

DSLR—Short for Digital Single Lens Reflex: a camera that uses a mirror to provide you with a real-time view of a scene via an optical viewfinder.

ƒ/STOP—The measurement of the variable opening in a lens that allows light to pass through it and to the sensor.

FEATHER—The ability to soften the edge of a brush or selection, which helps to prevent the selection looking "cut out."

FILL LAYER—A layer that contains a block of color, a pattern, or a gradient.

FILTER—A tool used to alter, manipulate, or distort the image, either optically or digitally.

FISHEYE—An extreme wide-angle lens, providing a 180 degree view of a scene.

HISTOGRAM—A graph indicating the distribution of pixels in an image from light to dark.

HUE—The attribute of a color defined by its dominant wavelength and therefore position in the visible spectrum. Hue is what we normally mean when we ask, "What color is it?"

INFRARED—Also abbreviated as IR. Light of a wavelength longer than visible light, starting with near-infrared at approximately 750 nanometers.

ISO—Short for International Standards Organization: a numerical value given to the sensitivity of photographic paper, or digital sensors to light.

JPEG—Short for Joint Photographic Experts Group—a universally recognised photographic file format.

LAYER—The digital equivalent of a transparency that can be laid over an image to alter its appearance.

LAYER MASK—A mask applied over a particular layer to hide or reveal elements within it.

LEVELS—A tool in editing suites that allows control over the brightness, contrast, and tonal range in an image.

MEGAPIXEL—Roughly equivalent to one million pixels, also the term used to describe a camera's resolution.

MICROSTOCK—A collection of images, usually royalty-free, sold on a "pile them high, sell them cheap" basis and therefore ideal for use by individuals and small businesses.

MONTAGE—A composite image created by combining and superimposing different pictures and designs.

MULTIPLE EXPOSURE—The action of exposing a frame of film twice or more to produce a trick-like or surreal-looking image. A multiple-exposure effect can also be achieved using a digital camera.

OPACITY—The degree of transparency of a layer or tool.

PATH—A line or shape created by the Pen tool (in Photoshop); a closed path can be turned into a selection.

PHONEOGRAPHY—Photography created using a smartphone.

PINHOLE CAMERA—A simple form of camera, without a lens, that exposes photographic paper or film via a tiny hole.

PIXEL—The smallest controllable element of an image.

PLUGIN—A small program that can be bolted onto an existing application to add functionality.

POST-PRODUCTION—The act of adjusting images after they have been taken.

PRESET—A preselected set of variables that can be applied to a particular tool or function.

PSD—Photoshop's native file format.

RAW—A file format that preserves extensive image information and allows you to manipulate your photographs using editing software.

RESOLUTION—The level of detail in an image, measured in pixels or dots-per-inch (dpi and ppi).

SATURATION—The intensity of a color or hue.

SENSOR—An electronic chip that converts a light pattern into an electronic reading, thereby creating a record of an image.

SHUTTER SPEED—The period of time for which the shutter remains open and allows light to reach the sensor or film.

SMARTPHONE—A cellphone with computing ability.

SURREAL—Unreal or dreamlike in appearance.

SURREALISM—A 20th-century artistic movement founded by André Breton and based on the principles of unlocking the subconscious and expressing oneself through unreal and dreamlike creations.

TIFF—Short for Tagged Image File Format: a loss- image file format used extensively in the publishing and design industries.

TILT-SHIFT—A lens that projects an image circle wider than the sensor of the camera on which it is mounted, and can tilt or shift for various effects.

TOY CAMERA—Cameras that usually have plastic bodies and lenses that produce images typified by light leaks, vignetting, odd contrast and exposure, and chromatic aberration.

THANK YOU

For Josh—who reminds me to believe in at least six impossible things before breakfast

This book would never have been possible without the generosity and creativity of the contributing photographers as well as the support of the Ilex team—Tara Gallagher, Adam Juniper, Natalia Price-Cabrera, and the supremely talented designers—and that of my regular crew of counselors, cajolers, and cheerleaders. Thank you.

Thanks are also due to the following for their kind permission to include images: Apple Europe, Canon UK, Haje Jan Kamps, Nokia, Olympus UK, Pentax UK, Photojojo, Samsung UK, and Sony Europe, as well as Olympus UK and Pentax UK for the loan of equipment.

ADRIAN SOMMELING

Adrian is a photographer based in the Netherlands.
www.adriansommeling.com

AMY WEBER

Amy is an artist and teacher. She graduated from Western Washington University and majored in art education; from there she continued her art education by getting a master's degree through Lesley University in Curriculum and Instruction in the Arts, and later received a National Board Certification in Early Adolescent Young Adult Art. She has taught in secondary schools for 16 years and has been creating art since she can remember.
www.webby10.deviantart.com

ANDRII BONDART

Andrii was born 22 years ago in a country that does not exist anymore. His hometown is a charming old European town with a glorious past, but with a not so beautiful present.

In 2005 he won the Elworthy scholarship, which enabled him to study in England for two years. Among five other A-levels he took Art and Design at Chigwell School—a place that became his personal Hogwarts. He really wanted to stay in the UK and was accepted into six different universities, however for financial reasons he could not accept any of these offers and moved back to the Ukraine.

He currently lives in Kyiv, Ukraine and after obtaining his master's degree in Dutch at the National Linguistic University, he works as a photographer and an illustrator.
www.bondart.me

BETHANY DE FOREST

During art school (Utrecht, the Netherlands) one of Bethany's main activities was creating settings, which she then photographed. Her objective was to create a "realistic" imaginary world. With an ordinary camera the images remained too distant . . . but with a pinhole camera she was able to capture this feeling.

Her inspiration stems from objects she finds or materials that appeal to her. Often her ideas contain elements from fairytales. The story is neither conventional nor predictable though, and the images can be interpreted in many ways.Being a pinhole photographer, her view of the world is quite deformed. She looks at her everyday surroundings with a pinhole eye. Sugar cubes are like bricks and chicken feet are tree-trunks.
www.pinhole.nl

CHRISTOPHE KICIAK

Christophe is 34 years old and lives with his wife in a small, lost between a river and a forest, to the west of Paris. He works in IT security in a large city. While this has nothing to do with photography, creativity is often required to hack into applications and systems; perhaps this kind of "out-of-the-box" thinking shows in his images.

Christophe found photography in June 2009; before then, he didn't have a camera, any post-production skills, or general knowledge about the creation of an image. The attraction lay in the ability to satisfy his thirst for technical perfection, but simultaneously create something beautiful.
www.1x.com/artist/christophekiciak

DARIUSZ KLIMCZAK

Dariusz Klimczak, was born in 1967 in Sieradz, Poland. He's an independent journalist, painter, and aphorist (Grand Prix winner of the seventh edition of Aphoristic Contest in Nowy Targ, 2005). For the past 25 years, photography has been an important part of his life, but it became his true passion a few years ago. He is currently a freelance photographer. He prefers square frames and black-and-white pictures, but doesn't shun color. In his photomanipulative work, he seeks out moods, jokes, and universal symbols, which can make the viewer stop and contemplate, or laugh.
www.kwadrart.com

EVE LIVESEY

A former retail IT Consultant, Eve decided to pursue photography in 2008 and since then her photos have appeared in numerous journals, magazines, and websites. She currently works as a freelance photographer and digital artist in Madrid, Spain providing free stock photos on DeviantArt and SurrealPSD, and sells her photos on Getty Images and Dreamstime.
www.evelivesey.com

GWLADYS ROSE

Born in 1988 in Orleans, France, Gwladys began to practice photography at 17 years old, always on a self-taught basis. She has never attended photography, infographic, or drawing courses. But when she discovered the power of artistic creation, she was immediately eager to improve her technique. As a longtime fan of surreal art, she trained herself on Photoshop CS3, mixing different images to create imaginative worlds. Many of Gwladys' creations express a sense of melancholy and its beauty, which she believes is a reflection of her personality. Zlidlaw Beksinski is a major inspiration. Looking towards the future, she would love to improve her digital painting skills to enable her to combine them with photographic elements.
www.gwladysrose.com

JANINE GRAF

Janine likes belly dancing, cappuccinos, the smell of old books, comedy, the color orange, and movies about gladiators. Her camera and tool of choice is the iPhone 5, as it's a camera and darkroom all in one. As for subject matter, she tends to gravitate toward subjects that allow for whimsy; she likes to have fun! Her photography has been exhibited in art galleries across the United States and in Europe and featured on various websites.
www.flickr.com/photos/janine1968
www.iphoneart.com/janine1968

JESS RIGLEY

Jess has been photographing since she was a child, and has recently finished her first year of studying Editorial and Advertising In Photography at university. Initially fashion photography appealed to her, but nowadays she continuously plans and shoots both personal and commercial projects, covering fashion, wedding, family, portrait and commercial photography.
www.jessrigley.4ormat.com

JON JACOBSEN

Jon is a fine-art photographer and designer from Quintero, Chile. He took up photography at the age of

15, and is now known for his surreal and narrative style projected in different graphical contexts like fashion editorials, reports, interviews, and his authorial work in self-portraits and conceptual portraits. He currently resides in Santiago de Chile.
www.jon-jacobsen.com

JULIE DE WAROQUIER
Julie is a French photographer born in 1989 and also a student of philosophy. She creates surreal and dreamy pictures to explore the inner realities of the human mind.
www.juliedewaroquier.com

KRISHAN GUNGAH
Kris is based in Surrey. He graduated from Surrey University in 2010 and it was during his time there that he developed his photography skills, having joined the photography club as well as many online art communities. He started shooting with a mobile phone, shooting everything and anything that caught his attention. After graduating to a digital camera he started exploring macro photography before finally settling down with monochrome photography. He hasn't looked back! His interest in surreal photography is a relatively recent addition, with his inspiration derived from various supernatural TV shows, movies, and music as well as nightmares!
www.lostknightkg.deviantart.com

LISA KARLSSON
Lisa's interest in photography began when she got her first camera at age seven. Her interest grew as she started taking photography classes in 2009, and sharing her work at DeviantArt and Flickr. She is currently studying photography at Gothenburg Vocational University in Sweden.
www.cargocollective.com/lisacarolina

MARC WARD
Marc left his native Central Florida in the early 1970s and moved to East Tennessee, where he earned his Bachelor of Studio Arts degree.

During his college years, he bought a camera to shoot his three- and two-dimensional artwork and became the photographer for the college newspaper. Marc's first forays into the darkroom were to put students' heads onto babies' bodies, have tanks attacking the library, and put

administration bigwigs into compromising positions. This was a time before the PC and Photoshop, and meant hours spent in the darkroom, airbrushing and rephotographing cut-out images, developing and making prints.

A few decades later, he's still creating composites, but now with the help of Photoshop. Some of these have won national and international awards and have been featured in numerous publications and books. Marc and his wife own the Spirit of the Hand Gallery in Dandridge, Tennessee.
www.marcwardphotography.com

MARIA KAIMAKI
Maria is a teacher, a perpetual student in all things that interest her and (for the last four years) a landscape photographer by passion. Photography has opened a door to a whole new reality for her, a new way of seeing and appreciating the world, a new philosophy and way of life. In photography you learn to focus on what's significant excluding from your frame insignificant or ugly elements. That's something photography has taught her about life.
www.mariakaimaki.com

MEGAN WILSON
Megan is an aspiring young photographer from Winnipeg, Manitoba, Canada.
www.flickr.com/photos/m-wizzal

MISS ANIELA (aka Natalie Dybisz)
Natalie "Miss Aniela" Dybisz is a fine-art photographer based in London, UK. Her work has been exhibited worldwide, with six solo shows to date. Her photography career began while still at University, when she was sought to speak in the US for Microsoft and at Photokina, and offered gallery shows in London and Madrid. As well as constantly producing her own personal work, she runs the international "Fashion Shoot Experience" and is the author of two books.
www.missaniela.com

NIKOLAI GORSKI
Nikolai is a Russian photographer, who currently works in Paris. Among his favorite themes are portraiture and architecture, especially staircases.
www.endegor.deviantart.com/gallery

PAULA COBLEIGH
Paula Cobleigh is a Pacific Northwest photographer who enjoys all aspects of the photography world. She can be

found shooting everything from waterfalls and animals to infrared and high-speed studio work. Paula was intrigued with IR photography and has used many different cameras and techniques to achieve images that are surreal and unique. The main theme throughout her gallery is images that are full of color.
www.paulacobleigh.com

SAROLTA BÁN
Sarolta is a photographer from from Budapest, Hungary. She began her career as a jewellery designer, but later discovered digital image manipulation and realised this was where her passion lay. She enjoys using ordinary elements and by combining them, creates narratives.
www.saroltaban.com

SHON E. RICHARDS
Shon E. Richards is founder and lead photographer for The Richard Nohs Perspective. Though currently based in Long Island, NY, Shon travels both locally and abroad capturing people, places, and things in his own unique way.
www.facebook.com/RichardNohs

STELLA SIDIROPOULOU
Stella Sidiropoulou is an instrument and automation technician in the chemical industry as well as a freelance photographer. She lives in Thessaloniki, Greece. She started photographing in 2006 and especially enjoys taking images with an emotional impact.
www.fotoblur.com/people/stellsi

TRACY MUNSON
Tracy Munson is a punk-rock listening, animal sheltering, book reading, nature loving, zombie killing, picture taking, red wine drinking, bunny hugging uber-goddess! She's a former English major, current Veterinary Technician, aspiring iPhoneographer, and blogger living in Toronto with a large man and a small dog.
www.80sgirlart.com

VANESSA PAXTON
Vanessa Paxton is a professional photographer currently living in Toronto, Canada. During her off hours she likes to get back to what really drew her in to photography: image manipulation and the surreal.
www.vanessapaxton.com

There are hundreds of websites dedicated to Photoshop resources, from brush Presets to tutorials guiding you through the process of creating an earth-shattering explosion, as well as hardware and software options. Here are some recommendations to get you started.

MICROSTOCK AGENCIES

For the purposes of producing a surreal composite, you might find yourself looking for a specific image that you don't have in your own collection. These microstock agencies are the first place to search, but be sure to read the terms of use and ensure you have the correct rights.

- Bigstock: **bigstockphoto.com**
- Dreamstime: **dreamstime.com**
- Fotolia: **fotolia.com**
- iStockphoto: **istockphoto.com**
- Shutterstock: **shutterstock.com**
- Stockfresh: **stockfresh.com**
- Stock.xchng: **sxc.hu**

RESOURCES

Backgrounds, brushes, plugins, and textures are available from a plethora of sources willing to share their resources. These are a few of the best.

- Adobe Exchange: **adobeexchange.com/?promoid=DIOCO**
- Background Labs: **backgroundlabs.com**
- Brusheez: **brusheezy.com**
- CG Textures: **cgtextures.com**
- DeviantArt: **browse.deviantart.com/resources**
- Texture King: **textureking.com**

SOFTWARE AND HARDWARE

Some bits and pieces that might make your photo-taking and editing easier.

- Nomad Brush: **nomadbrush.com**—manufacturer of styluses for use with touchscreens
- Photojojo: **photojojo.com**—retailer of innovative photo kits and accessories
- Triggertrap: **triggertrap.com**—manufacturer of universal camera trigger devices and software applications
- Wacom: **wacom.com**—manufacturer of graphics tablets

TUTORIALS

Whether there's a basic principle that you just can't seem to master or we've set your passion alight and you want to learn more, there is a veritable host of tutorials waiting for you. Here are just a few of the sites offering some of the best.

- Planet Photoshop: **planetphotoshop.com**
- Photoshop Café: **photoshopcafe.com**
- Photoshop Roadmap: **photoshoproadmap.com**
- PSD Tuts: **psdtuts.com**
- Smashing Magazine: **smashingmagazine.com**
- Worth 1000: **worth1000.com**